9/18/01

Dear nAncy,
I hope You Enjoy this!
Love
Margaret

W9-BET-617

Art
and
Healing

rt
and
Healing

Using Expressive Art

to Heal

Your Body, Mind, and Spirit

Barbara Ganim, M.A.E., C.H.C.

Three Rivers Press • New York

Grateful acknowledgment is made to New World Library
for permission to reprint an excerpt from MAPS TO ECSTASY by Gabrielle Roth.
Copyright © 1998.
Reprinted by permission of New World Library, Novato, California.

Copyright © 1999 by Barbara Ganim

All rights reserved. No part of this book may be reproduced or transmitted in
any form or by any means, electronic or mechanical, including photocopying,
recording, or by any information storage and retrieval system, without
permission in writing from the publisher.

Published by Three Rivers Press, 201 East 50th Street, New York, New York 10022.
Member of the Crown Publishing Group.

Random House, Inc. New York, Toronto, London, Sydney, Auckland
www.randomhouse.com

THREE RIVERS PRESS is a registered trademark of Random House, Inc.

Printed in the United States of America

DESIGN BY LYNNE AMFT

Library of Congress Cataloging-in-Publication Data
Ganim, Barbara.
Art & healing : using expressive art to heal your body, mind &
spirit / Barbara Ganim. — 1st pbk. ed.
p. cm.
1. Art therapy—Popular works. 2. Creation (Literary, artistic,
etc.)—Therapeutic use—Popular works. 3. Imagery
(Psychology)—Therapeutic use—Popular works.
4. Psychotherapy—Popular works. I. Title.
RC489.A7 G36 1999
615.8'5156—ddc21
98-44782
CIP

ISBN 0-609-80316-6 (pbk)

10 9 8 7 6 5 4 3 2 1

First Edition

Dedicated to Lili

In Memoriam:
JEANNE NORSWORTHY
September 25, 1935 to December 14, 1998

A Note to Readers

For those of you who choose to use expressive art to help you heal a physical condition, ailment, or disease, please keep in mind that this process is in no way meant to be a substitute for conventional medical treatment. Expressive art is a powerful healing process. When used with traditional forms of treatment, it can help you to release the stress-producing emotions known to cause immune system deficiency. It can also help you maximize your body-mind's ability to work harmoniously with any form of prescribed treatment. In addition, expressive art can help you release the negative thoughts and fears that can block your body's ability to heal physically, emotionally, and spiritually.

Contents

Contents

Acknowledgments

I am so grateful to the many people who have been in my life to influence and guide me in the direction that led to using art for healing myself and others.

It all began many years ago when Mariah Martin, a visionary and now friend, told me something that at the time I could not understand: "You will help people heal with images, and express their soul through images." Now I do understand. Thank you, Mariah, for your insight; it opened my eyes.

My deepest appreciation goes to Liliana Costa for her supportive friendship, unending patience, and expert editorial direction and hands-on assistance through every phase of this project. Her wisdom and counsel kept me focused and enabled me to meet my deadlines.

I have been so fortunate to travel my path of healing and learning with Susan Fox, my friend, soul sister, and colleague of over thirty years. Our friendship began with art, and our work together to teach others how to use it for self-expression and healing has been one of the greatest joys of my life. Her help locating many of the artists and doing our art and healing workshops and classes together made this book possible. Thank you, dear friend.

I am convinced that without the wisdom and insight of my agent, Julie Anna Hill, the manuscript for this book would still be sitting on my desk shelf gathering dust. And again, I have to thank Mariah Martin, for she and Spirit guided me to you. You are not just an agent, you have indeed become my muse.

I also wish to thank Edward Taub, M.D., for his encouragement and support with this book. And I want to convey my appreciation to Michael Samuels, M.D., and Mary Rockwood Lane for writing the foreword to this book. Also a thank-you to Mary Carroll Nelson, my first source of inspiration in this field, and a beacon of light on what seemed like a dark and lonely road many years ago when I first discovered the power of art to heal. You showed me that I was not alone.

I also want to thank those people whose help made writing this book so much more manageable: Michele Brennan from the University of Pennsylvania, Nicholas Capasso from the DeCordova Museum in Lincoln, Massachusetts, Jon Moscartolo and Jeanne Norswothy. And my appreciation also goes to Leslie Meredith from Random House for her belief in this project and Laura Wood for her expert editing, and Jessica Schulte for making the final stages of this project a pure pleasure.

And finally, I must thank and express my deepest gratitude to each of the wonderful artists who were willing to allow me to share their work and their stories. Your efforts have greatly added to the richness of this book.

Foreword

Healers are now discovering that art, music, dance, and poetry have profound healing effects. Doctors and nurses are working with artists and musicians to heal people of all ages with many conditions, including cancer and AIDS. These healers have found that art and music, when combined with traditional medicine, are powerful tools. Hospitals all over the world are incorporating art into patient care. The most sophisticated university medical centers are now creating art hospital programs that invite artists to work with patients, which literally changes the hospital environment. These programs bring the artists and musicians into the patients' rooms or have the artists perform in atrium spaces. The patients watch and experience the exhilaration of hearing a symphony or seeing the beauty of an exhibition, or they paint, play music, or dance themselves with the artists. Art and music crack the sterile space of fear the patients live in, and they open it to the joys of the human spirit. The spirit freed then helps the body heal. Art frees the immune system so it can function at its best, relieve pain, heal depression, and raise the spirit.

Art and healing have always been one. In fact it is now known by neurophysiologists that art, prayer, and healing all come from the same source in the body; they are all associated with similar brain wave patterns, mind-body changes, and they are all deeply connected in feeling and meaning. Now we are rediscovering this and can use art and healing as a healing modality. Nature has been viewed in many cultures as having two opposite energies: male and female, day and night, rational and intuitive. Art and healing are also manifestations of these two basic energies. When they merge with intent, you make art to heal and heal to make art. We make the process of healing and making art one. As a metaphor, a union occurs, like an explosion, in the moment of merging. The person is taken out of their ordinary time and space into sacred time and space where they can see themselves and their world differently. When we make art to heal, the creative spirit within us is awakened and

takes us to who we are when we go inward, which brings out her song as ours. When we dream and make art of the dreams, we are taken home, taken to the place of healing and healed. Art brings out our inner healer, which changes our whole physiology, and our spirit, mind, and body heal.

If the force is love, and the voice the soul, and its language art, and its product healing, where are we going? How is art coming into the medical center, healing coming into an artist's studio? With awakening comes rebirth. With death and emptiness comes an opening of the heart; and into our open hearts now comes art and healing. Into the hearts of the artist yearning for meaning comes healing. Into the hearts of the healer looking for meaning and emotion, a language comes; it is art. And art is becoming the doorway into the realm of the heart. It is the tool for transformation that we now seek. It is what opens and what changes. When a patient's bedside in a cancer ward is visited by an artist, musician, or dancer, and that patient lets himself or herself move into the other land, and lets a piece of art come out into the world, and then cries and is touched for the first time since being in the hospital, a healing has taken place. We have reached the place of return, the enchanted place of openness, feeling, emotion, and release. We have opened our hearts to love.

Art as a doorway, the vehicle through which an open heart can enter medicine, is very real. And medicine as an invitation, a reaching out, a need, draws the artist in and lets them love too. Love needs a lover and a loved one, and healing needs a healer and a person who needs healing; the bridge between them, the invisible connection, is art, the language of love.

Mary Lisa Kitakis, an artist in residence at Art in Medicine, University of Florida, says the reason for art in healing in the world today is really simple. "Either you can sit at home or in a hospital, ill, depressed, in the darkness, or you can make a wonderful painting, dance, sing, or play or listen to music. Is there a choice?" Art and healing together are the art of the future and the medicine of the future. It is art and medicine as one, it is here now. Come dance with us now, come into the world of the artist-healer, come.

Art and healing,
the sacred spiral
turns, it spins and rolls

It takes us deeper
and deeper . . .
into our own hearts
into healing ourselves
others, and the earth
come.

—Michael Samuels, M.D., and Mary Rockwood Lane, coauthors of *Creative Healing: How to Heal Yourself by Tapping Your Hidden Creativity*

Art
and
Healing

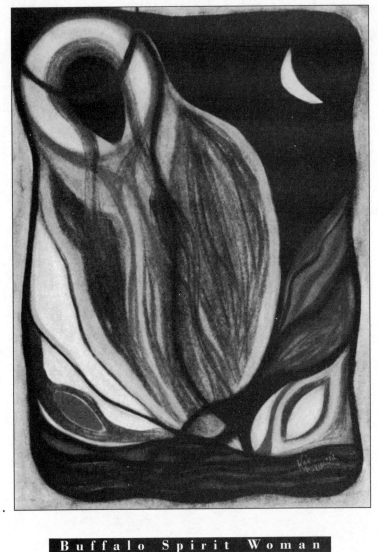

FIGURE 1-1.

Buffalo Spirit Woman

KATE SIEKIERSKI

"My work is focused on healing the wounds of my childhood to empower my adult self. In this painting, Buffalo Spirit Woman looks over me with love and compassion as the different parts of myself begin to heal and emerge—they come out of hiding. She's a loving, warm, encouraging, and powerful gentle spirit."

The Power of Art to Heal

There is a growing movement nationwide among contemporary artists and nonartists alike to use art to heal the body, soothe the mind, and transform the spirit. Through the ages, artists have known intuitively what others are just beginning to discover: creating a visual image on paper or canvas, with clay or through any art medium, can produce physical and emotional benefits for both the creator and the viewer. And now thanks to extensive research in the fields of split-brain functioning, visualization, and psychoneuroimmunology (study of the emotions on the immune system), we are finally able to understand how this powerful healing tool can be used by anyone, even those without the slightest trace of artistic ability, to create profound changes in their lives and activate healing at the deepest levels.

Psychotherapists, medical caregivers, and educators have rediscovered art as a way to heal the emotional wounds created by our internal feeling of fragmentation as well as by our sense of separation from others. Medical science has revealed that when we heal our emotional wounds, we also heal the wounds of the body. As a result, art is being used successfully to reduce the physiological stress that causes immune system dysfunction by enabling patients to connect with negative, painful, or fearful emotions that are known to trigger that stress. Once these emotions have been accessed through guided visualization, the emotions can then be released by expressing them in imagistic form through drawing, painting, sculpture, or collage.

The mere act of releasing these emotions through art enables the immune system to return to a state of full functioning.

Art can also supplement traditional medical treatments such as chemotherapy, hemodialysis, and radiation by helping patients condition the body-mind to work harmoniously with the physical and emotional effects of their treatment. Those patients who were taught how to use art and imagery to work within their body to visualize and enhance cellular and metabolic healing, as well as directing their body to accept and work cooperatively with their medical treatments, had better results than those who did not.

But you don't have to seek professional help to use this powerful healing tool for yourself. This book is a step-by-step guide that will start you on your own path of healing and transformation. First you will learn how to use guided visualization to reach your body-mind's inner communicator—imagery. Then by tuning into this imagery and expressing it through art, you can relieve emotional stress, which will begin the process of healing your body as well as changing the way you think about yourself.

THE DEVELOPMENT OF HEALING ART

For the last twenty years, researchers have been focusing their attention on the role that visualization, inner imagery, and art might play in the healing process. Techniques were developed to help people visualize images that would fight their cancer, clear clogged arteries, strengthen a diseased heart, boost their immune system, lower blood pressure and pulse rate, and restore the ability to move that was lost through strokes and accidents. The results of these studies—conducted nationwide and in Europe at some of the world's most prestigious medical schools and research clinics—were phenomenal. People whose diseases or afflictions were diagnosed as terminal began making remarkable recoveries using visualization when no other form of medical treatment would help. Further studies, such as those conducted by Dr. Carl Simonton (see *Getting Well Again* by O. Carl Simonton, M.D.), showed that the results were even more beneficial when patients used art to express their visualized healing images. Although the medical community at large was slow to respond to these research implications, a growing number of hospitals and medical centers throughout the country began adding supplementary treatment programs in visualization and what was being called "healing art."

Eventually, healing art expanded to include images that expressed an individual's feelings and emotions, particularly those emotions that were considered stressful to the physical body. That gave birth to the more universal term "expressive art," which helped to distinguish healing art from its more conservative cousin, art therapy. Art therapy traditionally places more emphasis on the product, that is, the artwork itself, as being an important diagnostic tool the therapist can use to evaluate a client's emotional state. In contrast, expressive art emphasizes the artistic process as a means of emotional expression and release. In expressive art, the client's artwork is not used as a diagnostic tool because it is believed that only the person who created the work knows the meaning inherent in the work.

ILLNESS AND EMOTIONS

While most people seem readily able to accept the idea that drawing the image of a tumor shrinking or dissolving can trigger the body to respond to the drawing's autosuggestion, I have found that many have a hard time understanding how expressing one's feelings and emotions through art can help them to heal. The one question I am asked the most is: "What do my emotions have to do with my illness?" Although it has not always been so, I believe the answer is now clear.

In the last few years, research in the field of psychoneuroimmunology, which studies the effect of the mind or the psyche on the central nervous system and the immune system, proved what many psychotherapists and doctors have long suspected—negative thoughts and painful, fear-based emotions cause physiological stress that results in immune system dysfunction. A dysfunctional immune system is unable to protect the body from abnormal cell growth and the destructive influences of external environmental factors such as viruses, bacteria, and chemical pollutants. Over a prolonged period of time, physiological stress can result in an environment within the body in which healthy cells will begin to malfunction and ultimately cause illness and disease.

Carl Simonton, M.D., who began some of the earliest research back in the 1970s on the use of visualization and art in cancer treatment, introduced a model called the Mind/Body Model of Cancer Development, which demonstrated the effect of stress on the immune system. When trying to explain his concept to my clients, I found it helpful to simplify that model into the following equation to clearly illustrate the connection between emotions and illness:

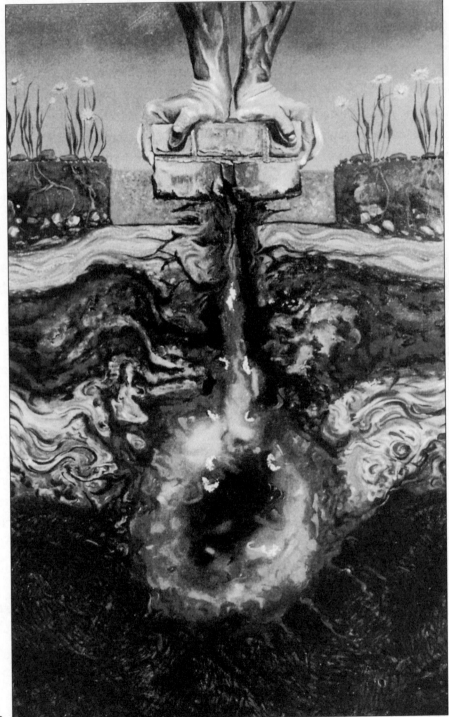

FIGURE 1-2.

Negative Thoughts, Painful, or Fear-based Emotions → Stress → Immune System Dysfunction + Time = Illness or Disease

According to Dr. Simonton, we will begin to heal when we relieve the body of the physical stress that compromised the immune system in the first place. In the past, verbal psychotherapy was the method of choice to release negative thoughts and fear-based emotions. But expressive art has now been found to be even more effective.

Split-brain research, which focuses on the functional differences between the right and left sides of the brain, reveals that we think and process our experiences, feelings, and emotions as images first and words second. The body's senses and the right side of the brain take in all of our experiences and the corresponding emotions as images first, and then the left side of the brain translates those images into verbal thoughts. In addition, researchers discovered that imagery is the body-mind's internal form of communication. The body responds to an image of a thought or an idea first, before it responds to the words that describe that thought or idea.

Split-brain research also substantiated that while our verbal memories are stored in the left side of the brain, our imagistic associations of all the emotions we've experienced are stored in the right side of the brain. If emotions are held in the body-mind as images, then imagery rather than words would be the most direct route to get in touch with these painful emotions, and then to release the images of these feelings and emotions through art.

Repression

JEANNE NORSWORTHY

"When a person doesn't know how to safely express anger, a person begins to warp, to see through distorted eyes, to torture his own immune system with demons real and imagined. The energy expended to hold down the upwelling magma of rage may explode through all precautions and destroy everything the person sought to protect. The mind, the spirit, and the body become weakened by the stress, the immune system begins to fail, setting the person up for the major diseases we all fear, such as cancer. Yet as soon as a person learns to safely express that anger, he can not only release the terrified inner child curled up within, but can also reap the pure gold that is the reward and strength of being honest."

Patients taught how to access their own imagistic perception of feelings and emotions, both past and present, and release them through art felt better physically as well as emotionally. Many of the patients who had been through years of traditional verbal psychotherapy were astounded by the difference they experienced when they used art to express their feelings rather than words. Issues they had been working on but were never able to resolve in verbal therapy seemed to dissipate when they expressed them in a drawing, painting, or sculpture. The same was true when people used dance and movement or music and sound to express their feelings.

Expressive art is now considered, by medical caregivers and psychotherapists, to be one of the most powerful, as well as cost-effective, self-healing tools available today of all the "alternative therapies." Expressive art is something you can learn to do for yourself, unlike acupuncture or massage therapy, where you have to pay a practitioner for each session. Once you learn how to use expressive art to heal, you can continue to use this powerful self-healing technique on your own, for the rest of your life.

USING THIS BOOK

Doing the exercises in this book can help you whether you have a specific illness you would like to heal, or you simply want to learn how to take charge of your own emotional reactions so that you can remain physically healthy. Just by reading this book, you will learn how to reconnect with your own inner language of imagery and understand its messages. That knowledge enables you to discover a wisdom deep inside yourself that will help you change your life and your health.

This book is set up to guide you, step by step, through the process of healing with art. The six, self-guided learning sessions will take you through the basic principles of using imagery and expressive art for healing and transformation. Each session will present a specific focus for your healing work, along with a set of exercises and guided visualizations to help you access and express your inner imagery using a variety of art mediums. These exercises are accompanied by self-dialoguing questions designed to help you probe and understand the meaning of your artwork. In addition to learning how to create healing art, this book will teach you how to understand your inner language of imagery so that you can begin to tap into the inherent wisdom of your body, mind, and spirit.

Throughout this book you will be introduced to other artists and nonartists who

are using art to heal their own physical, emotional, and spiritual wounds, as well as to some people who are using art to heal others. I believe that their stories will inspire you, and that their work will touch you and help you to heal at the same time.

I have included in the back of this book a list of the artists whose work will be featured here, in case you might wish to contact any of them. I have also included, in resources, a listing of national organizations that sponsor and promote healing art, as well as schools, colleges, universities, and institutes that offer degree and nondegree programs in healing with the expressive arts.

As an artist, counselor, expressive art therapist, and teacher, I have traveled my own path of healing with art and helped many others do so as well. The beginning is exciting and promising, the path is inspiring, but most importantly, the work is enlightening. Once you begin to express your inner imagery through art, you will never see yourself or your world in the same way again.

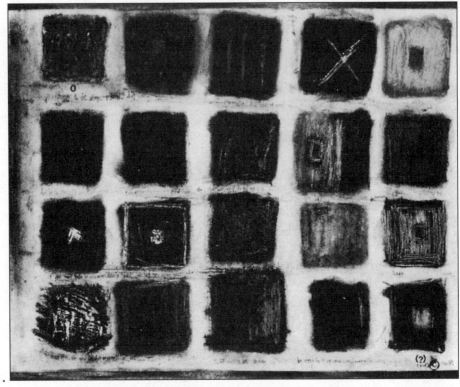

FIGURE 2-1.

19 Steps of Pain

CLAIRE CHEW

"I was diagnosed with Ewing's sarcoma in the winter of 1987. At the time, I had just completed my first quarter in college. I spent the next one and a half years battling for my life. Art became a way for me to release what I was feeling. 19 Steps of Pain documents all the different emotions and changes I have experienced through my process of healing. Each square depicts a certain emotion. The nineteen squares begin from the dark, negative space I felt inside—anger, denial, grief, sorrow, emptiness—to a more positive note of acceptance and hope. It has taken me eight years to accept my life and go on living, without guilt or pressure to make up for lost time. Not a day goes by without some reference to this part of my past, except now, I am living in the present."

How to Begin Using Art for Healing

You Don't Have to Be an Artist to Use Art for Healing

When I tell people that they don't have to be an artist to learn how to use art to heal, I get my share of raised eyebrows. But it is absolutely true! Even if you have never picked up a pencil to draw or used a paintbrush to splash color across a canvas, you can use art to heal yourself. In fact, it's often the people who *don't* know how to draw who have the best results with this process. Unlike trained artists, they aren't preoccupied with how something ought to look. When artists take one of my art and healing workshops, I usually have to ask them to use their nondominant hand in the beginning, just to keep them from getting too attached to the artistic merits of their work.

"What if I'm terrible at this?" most people ask when they are just beginning. The answer is: there is no such thing as terrible—even stick figures will give you all the information you will need to understand what your body-mind is saying through its imagery. So even if you believe that you have no talent at all, just remember that this is your inner critic talking, and there isn't a person alive who wouldn't be better off *not* listening to their inner critic. Talent is nothing more than desire turned outward. Many people called Van Gogh, Picasso, and Jackson Pollock untalented. Since you are reading this book, you must have the desire to embrace this form of expression.

FIGURE 2-2.

You do not have to draw any better than this to use art as a healing tool.

FIGURE 2-3.

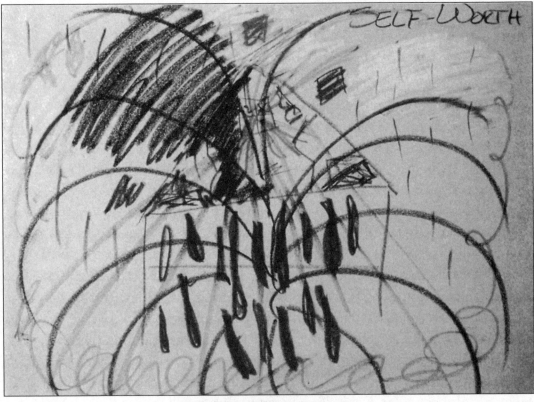

Self-worth

CARROL CUTLER

If someone gave you this book, then perhaps that person sees in you the spark of desire that you have been reluctant to recognize in yourself.

EXAMPLES OF HEALING ART

To give you an idea of the kind of work my clients and students do in my groups and workshops, I have included some examples of their work in this next section and in other places throughout the book, to help you see the kind of emotional expression that this process can elicit.

The lower drawing on page 10 (Figure 2-3) was created by Carrol Cutler, a woman in one of my cancer support groups. It was done in response to an exercise in which the group was asked to pick a feeling or emotion they were presently experiencing that they felt could adversely affect their ability to heal. After a brief guided visualization to get them in touch with how this feeling or emotion felt inside their body, they were asked to imagine what this sensation would look like if it were an image. They were then asked to draw that image. In this drawing, Carrol expressed her sometimes overwhelming feeling of a lack of self-worth. Just drawing this image, getting it out on paper, made her feel better.

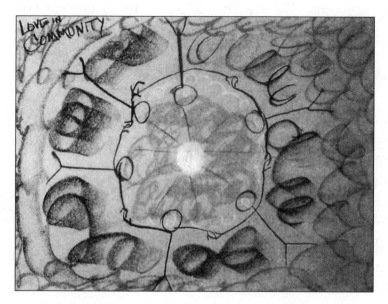

Love in Community

CARROL CUTLER

FIGURE 2-4.

Carrol Cutler also did the drawing on page 11, Figure 2-4, which she titled *Love in Community.* She did this drawing as part of an exercise to express an image that represented what she felt was her soul's purpose in this lifetime. "My purpose," she said, "is very clear to me in this image. I am here in this world to facilitate love within the community." As she talked about this image and what it meant, she began to realize that she was happiest when she was helping others to join together as a group. "In order to heal," she said, "I think this drawing is trying to tell me that I need to be doing more of this work again. And I'm not doing it in my present job. I need to change directions, to get back to working with groups as a teacher and facilitator."

She was absolutely correct when she said that her drawing was telling her what she needed to do in order to heal. Our imagery will not only express what we are feeling, but it will also tell us how to heal painful emotions or what we need to do differently in our lives to help us feel better. (Also see Figure 2-5, opposite page, for another drawing by Carrol Cutler, *Tree of Light.)*

In the next plate, the collage *Fear & Faith* was created by Christina Vivona, one of my graduate students at Salve Regina University, where I teach art therapy.

"This is called a mandorla," Christina said, "which involves creating two circles that overlap. Each circle represents our opposite qualities. In this exercise, we were told to fill the circles with images that expressed these opposite qualities, which for me were fear and innocence. We were then told that the images we envisioned emerging within the overlapping space would offer insight as to how to resolve the conflict caused by the split of our opposites. The left side represented my fears, and the right side depicted the absence of my fear, which I began to see as innocence and naivete. The space in the middle, where the two circles intersect, revealed, as I discovered by creating this collage, my faith. That was the resolution of the split. It is only through faith that I can heal and repair the inner conflict caused by my fear and innocence."

In addition to the client and student work I was able to use in this book, I was fortunate to locate many professional and nonprofessional artists throughout the country who were using art to heal themselves and others. As I chose the artwork for this book, I attempted to include an expansive range of work that not only demonstrated a variety of techniques and approaches—from abstract to realistic— but also showed a selection of work that represented all levels of artistic skill. In

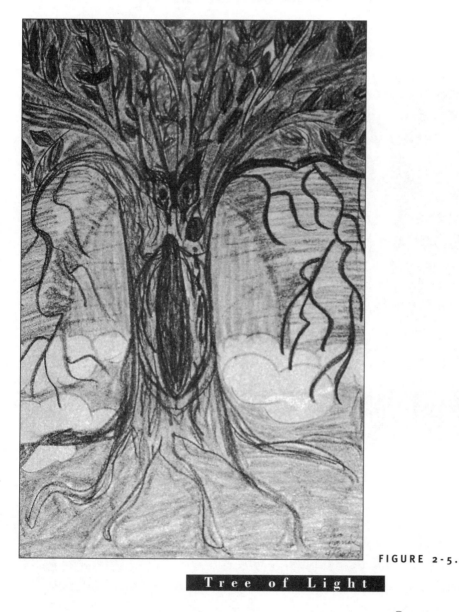

FIGURE 2-5.

Tree of Light

C A R R O L C U T L E R

"I drew this when I needed to feel more grounded. I was uncertain where my roots were. The image of the tree came to me, and as I began to draw it, I started to see it as representing the seasons of my life. When I drew the roots in the sky, at first I didn't understand what they meant. Then I realized that my grounding was in my spirituality, and my roots were in God."

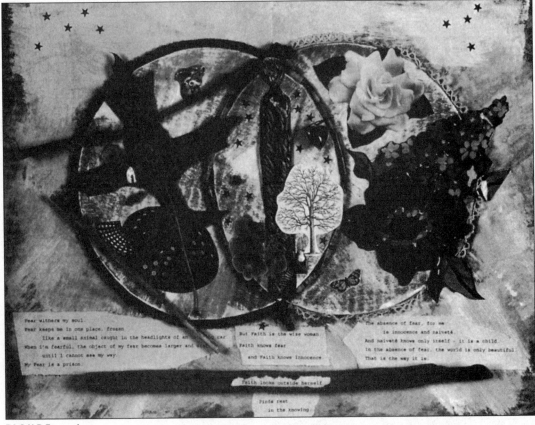

FIGURE 2-6.

Fear & Faith

CHRISTINA VIVONA

Left circle: "Fear withers my soul. Fear keeps me in one place, frozen like a small animal caught in the headlights of an oncoming car. When I'm fearful, the object of my fear becomes larger and scarier until I cannot see my way. My fear is a prison."

Right circle: "The absence of fear, for me, is innocence and naivete. And naivete knows only itself—it is a child. In the absence of fear, the world is only beautiful. That is the way it is."

Overlapping space: "But Faith is the wise woman. Faith knows fear and Faith knows innocence. Faith looks outside herself and there finds rest in the knowing."

doing this, I hope that those of you who feel that you have no artistic training or skill will understand that this healing process is not about creating *works of art,* but rather, it is about creating art *that works for you.* And those of you who are professional artists or aspire to be so will be inspired and encouraged by those artists who have found a place in the art world for this kind of work.

There *is* a market for healing art, and it is growing by leaps and bounds. However, you should know that the professional artists featured in this book are very clear that their work is not about commercial gain; it is created strictly with the desire and intention to help others through their work. They feel just as gratified whether they sell their work, get it placed in exhibitions, or give it away, because they know that any avenue that allows their work to be seen and experienced by others will help affect and perhaps heal those who see it. And maybe the very fact that these artists are not motivated by money as their end goal is exactly why so many of them have so readily found financial success, because they are doing work that comes from their hearts and souls. And I believe that when we do the work our soul was put here on this planet to do, success—however we define it—comes effortlessly.

Getting Started

Getting started on your own path of healing and transformation begins with some initial preparations. You may have to purchase art materials if you don't already have them, and set up a healing space where you can do this work. This next section includes a list of the art materials you will need, some suggestions for setting up your workspace, the benefits of working with a therapist as you do your healing work, and tips on how to use music with the book's exercises and how to pre-tape the guided visualizations that accompany the exercises.

Art Materials

If you are an artist, you may have most of the materials you will need to start doing the exercises in the next chapter. However, you may want to glance at the list below, just in case there are some items you may not have. For those of you who are unfamiliar with art materials, I've divided the list into two parts: the basic materials you will need to get started, and a list of optional materials you may want to try out as you develop your artistic skills and build confidence.

BASIC START-UP MATERIALS

- A spiral notebook or blank book to use as a healing journal
- 18-inch-by-24-inch pad of white drawing paper (paper size is optional, but I do suggest you work with larger rather than smaller paper)
- 1 large box of crayons
- 1 box of pastel chalks in assorted colors
- An assortment of colored pencils
- An assortment of colored markers with various-size points
- Drawing pencils—HB, 2B, 3B, 6B (the numbers and letters indicate the hardness or softness of the lead)
- 1 white drawing eraser

OPTIONAL MATERIALS

- 1 box of oil pastels
- Box of watercolor paints
- Watercolor mixing palette
- Watercolor brushes—several sizes
- Plastic trays for mixing paint and holding water
- Set of oil or acrylics paints, brushes, a palette, and several stretched canvases
- 5, 10, or 25 pounds of Plasticine clay, or any kind of clay that does not harden, to allow reuse—even children's clay will do
- Several fine-point black drawing markers
- Scissors
- 1 bottle of white glue or clear glue
- A collection of found objects, such as shells, twigs, leaves, dried flowers, stones, jewelry, ribbons, cotton balls, string, and confetti
- A collection of assorted fabric swatches of different textures, such as lace, velvet, burlap, satin
- Assorted bottles of colored glitter and colored sand

At the beginning of each exercise, I will suggest a particular art medium that I feel is best suited to the exercise, but keep in mind that you are always free to select whatever medium feels best to you at the moment.

YOUR HEALING JOURNAL

Most of the exercises in this book will be followed by a series of self-dialoguing questions that will help you process your artwork. You will be instructed to respond to these questions in what will be referred to as your healing journal. The list of basic start-up materials recommends a spiral notebook or a blank book for this purpose. As you begin writing in your healing journal, I suggest that you date each entry, so that you can look back days, weeks or months later and track the development of your healing work.

USING MUSIC

If you like music and find that it helps you focus, you may want to select or purchase a few tapes or compact discs of soft, gentle instrumental music that you can listen to during the guided visualizations and while you are doing your artwork.

Be careful not to select music that is too rhythmical or jarring. I have found that certain types of classical pieces, especially Mozart, and what is called New Age, or mood music, are quite conducive to contemplative work. Nature tapes also serve as wonderful background sounds. I particularly like recordings of mountain streams, ocean waves, falling rain, babbling brooks, and chirping birds. It's wise to avoid using music with lyrics, because words can keep you in a left-brain operating mode. In addition, some people find that musical lyrics are autosuggestive and subconsciously direct their imagery.

SETTING UP YOUR HEALING SPACE

Try to find a quiet place where you can work. The most ideal situation, of course, would be a studio, an office, or a room in your home that's all yours. However, a corner of your living room, bedroom, or basement will do. The most important consideration in selecting your healing space is that it offers you a sense of privacy and solitude when you work. It's also nice if you can leave your art materials out between sessions. Having to set up everything each time you intend to work can be a real barrier to maintaining a regular and consistent schedule.

Think of your special healing space as a sacred place in which you will not only heal the wounds of your body and mind, but will also be connecting with the deepest part of yourself—your soul. You may want to design your healing space to

include some carefully chosen objects, furnishings, or personal memorabilia that are meaningful and comforting, such as photographs of loved ones, a chair or table that you associate with an important part of your past, flowers or plants, shells or driftwood, or even childhood toys, jewelry, or stuffed animals that express who you are and who you wish to become as the healing takes place.

MAKING TIME TO DO YOUR HEALING ARTWORK

To get the most out of this process, consistency is vital. Just like any goal that you undertake, whether it's exercise, diet, or meditation, it only works if you make the commitment to pursue your goal on a regular basis. You might want to try scheduling an hour or two, once a week or every other week, and set aside a specific time that you know will not conflict with any other activities in your life. It helps to write this time schedule down on your personal calendar and also your house calendar if you live with others. There are those who find it helpful to think of this time as if it were a class they plan to attend each week. Some people even set up their schedule for a specific number of weeks.

USING THE GUIDED VISUALIZATIONS

I recommend that you pretape the visualizations that begin each of the exercises in this book. It makes it much easier to concentrate on your inner imagery when you don't have to think about what to do next. It is vital if you do decide to pretape to take the time to pause wherever you see *(Pause)* indicated in the written visualization. You will have to judge for yourself just how long that pause should be. It may need to be several seconds or as long as a minute or two. It will really depend on what the visualization is directing you to do at that particular place, and how long you think you would want to focus on that directive without being immediately led to the next one. So read the visualization through carefully first before you attempt to pretape it. If you don't feel comfortable taping the visualizations, then simply read through the visualization preceding each exercise, close your eyes, and silently guide yourself through each step.

WORKING WITH A THERAPIST

You will find that using guided visualizations can bring up a lot of long forgotten emotions that may trigger unexpected reactions. If this occurs, you may need some

professional help to sort through it. You may want to consider seeing a psychotherapist or counselor while you are doing your healing artwork, or at least have someone available with whom you can consult if the need arises. If you are already in counseling, ask your therapist if you can process the work you do in these exercises with her or him. Your artwork can be an extremely valuable addition to verbal therapy.

As you begin to express your imagery through art, you will discover your inner voice—the voice of your heart. With that voice to guide you, a voice that speaks in imagery not words, you will create healing art that will transform your body, mind, and spirit.

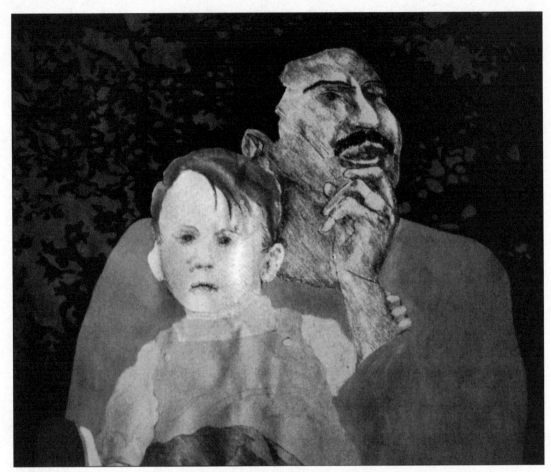

FIGURE 3-1.

Father and Son

JON J. MOSCARTOLO

"My son was born with a rare form of dwarfism. I was overwhelmed with the responsibility of what this meant. All of my fears for him have proven correct, but I did not understand that the child is father to the man. My years of grieving and pain through the experience of fathering my elder son has made it possible for me to work with families living with HIV/AIDS. My art and my work with these families have given me peace."

Expressing Your Emotions Through Imagery

Imagery is the body-mind's inner language. Art is the voice or expression of that language. Using art to express what your body-mind is saying will enable you to connect, perhaps for the first time, with your deepest feelings and emotions. Negative and fearful emotions can torment the mind, damage the body, and suppress the spirit, thus blocking the path to physical and emotional healing. Expressing these emotions through color, form, shape, and image releases their hold on the body, mind, and spirit, clearing the way for healing to begin.

To start creating your own healing art, you must first learn how to bypass your verbal thoughts so that you can become fully present to how your body is experiencing your feelings, rather than what your mind is telling you about your feelings. To do that, you need to know how and why your verbal thoughts interfere with your body's ability to feel your feelings as they are happening. In this chapter, Session One will explain this interference and then show you how to move past it. You will learn the difference between left-brain, verbal thinking and right-brain, imagistic perception. You will then be ready to start expressing your emotions with imagery, which is the first step in using art to heal your body, mind, and spirit. So if you are tempted to jump right into the exercises—don't give in to the urge. The information that follows will become the basis for the healing artwork you will begin doing in Session Two.

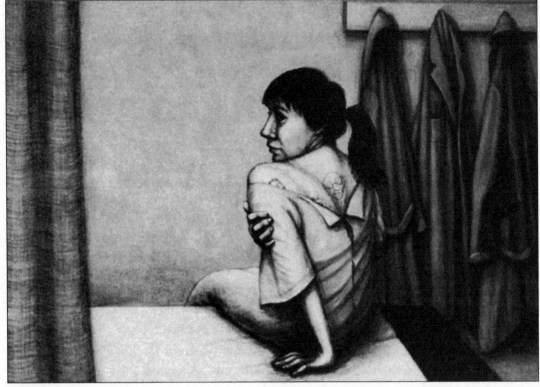

FIGURE 3-2.

Chorus

RIVA LEHRER

"My paintings help me come to terms with who I am and what that means."

Artist Riva Lehrer finds that her work serves as a metaphor for transcending her own personal life difficulties. She tells her stories pictorially, in images and symbols that are easy for the viewer to understand. *Chorus* is one of a series of paintings in which she reveals her struggle with spina bifida, a congenital disease of the spine. The woman in this painting displays for the viewer tattoos of her doctors' faces. The message here is that a patient's fate is often determined by the physicians he or she has been assigned or selected. Because she tries to convey a sense of hope amid pain, Riva believes that her images transcend this feeling of powerlessness that all people feel not only when they are faced with health problems but also with any life crisis.

How Words Betray Our Feelings

Although the key to healing lies in our ability to express and release our painful, stress-producing emotions, accessing these emotions isn't always easy when we continue to do it in the only way we know how—using words. We try to talk it out, yell it out, get it off our chest, but in the end, the feelings remain. That's because our left brain's verbal language is only capable of expressing what we *think* we feel, while the real feelings often go unnoticed and unexpressed. To access our real feelings, we must use the right brain's language of imagery.

As split-brain research has revealed, each side of the brain has separate and distinct functions. The body's senses take in all of our experiences and the emotions generated by those experiences and create imagistic impressions in the right side of the brain. As the right brain then processes these imagistic impressions, they are then transferred to the left side of the brain, where they are translated into verbal thoughts and memories. Unfortunately, however, something is often lost in the translation.

The left side of the brain is not an objective reporter of our feelings. It analyzes, categorizes, and judges every experience we have and the emotions we feel. The left brain uses our learned beliefs as a yardstick to evaluate our experiences, and as it does it weaves a different kind of story that frequently reinterprets, alters, or denies the truth of what has really happened. That's why several witnesses to an accident can have so many different versions of what they *think* took place. When we use words to talk about our feelings, what we often get is the left brain's judgmental interpretation. But when we use the right brain's language of imagery, we get the truth of our experiences and feelings, because judgment is not a right-brain function. (See color insert section, Plate 1, *Broken Promises* by Rochelle Newman.)

Judgment Is the Root of All Stress

Judgment causes conflict between the heart and the head. From a scientific point of view, we know that this reference is purely metaphorical, since the conflict is really between the right and left sides of the brain. Although the right side of the brain doesn't judge our experiences, it does perceive the feelings and emotions associated with those experiences as being either comfortable or uncomfortable. When the left brain receives the right brain's messages about a feeling that is being experienced by

the body, it then assigns a value of good or bad, along with an interpretation of what that good or bad feeling means. That interpretation and the action it provokes may be in conflict with the body and right brain's initial impression of the experience.

For instance, if someone cuts you off in traffic, the initial feeling may well be discomfort, signaling you to move away from the source. However, your left brain's judgment may interpret the act, based on your learned beliefs, as disrespectful and hostile. If you have been taught to believe that disrespect requires retaliation, that in turn may trigger a feeling of anger that can manifest into what is now being called road rage. This left-brain judgment and the emotion it has fueled can instigate a precipitous reaction that can place you and the other driver in grave danger. This is a prime example of inner conflict, because while the right brain simply said move away, the left brain said, "Get that guy!"

The body responds to these conflicted messages by releasing stress hormones, which shoot the blood pressure sky high, disrupt metabolic functioning, increase muscle tension, and send the immune system plummeting. People who live in a continual state of inner conflict are prime targets for heart disease, ulcers, cancer, and a variety of other stress-related diseases.

Our own inner criticism of ourselves and others is another major source of physiological stress. Our learned beliefs tell us what is acceptable and unacceptable about our own or someone else's behavior or choices. So when you catch yourself feeling like you want to goof off and see a movie, your left brain's critical voice may reprimand the feeling and tell you that you're a lazy, good-for-nothing bum. When one of your kids wants to take a year off from college and travel, that same inner critic may chastise your son or daughter and accuse them of being a slacker who will never amount to anything. In your heart you may understand and empathize with what your child is feeling, but your head won't allow you or anyone else to act on such feelings without suffering the wrath of your judgmental criticism. Judgment damages not only our personal relationship with ourselves and others, it also damages the body.

Even simple conflicts cause stress, like saying yes to your mother-in-law when she demands that you and your family come for dinner every Sunday, when your heart says you would prefer to be at home. Your learned beliefs convince you that saying no would be rude and inappropriate. The result is inner conflict. As you smile and say yes, and push your feelings out of the way, your heart cries out in

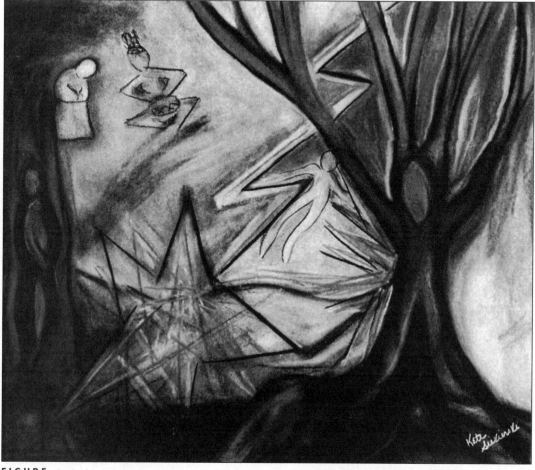

FIGURE 3-3.

Divine Intervention

KATE SIEKIERSKI

"In this watercolor, my mother, who represents my critical voice, and I are attached by an umbilical cord. A lightning bolt severs that attachment. Initially, I felt crucified on the tree. But as I continued to work on the picture, I felt more at one with the tree. Within it I could feel myself growing stronger, now that the attachment was severed, while my mother, my critical voice, decays inside the other tree. The two small figures at the top of my mother's tree represent my wise woman and my maiden woman, which are both parts of myself emerging."

anger because once again it is ignored. Eventually, your heart will shut down. In studies where first-time heart attack victims were interviewed in order to discover if there were any emotional correlations within the groups, the one consistent response the majority of them shared was feeling as if their heart had shut down, and they could no longer feel their feelings.

USING IMAGERY TO RECOGNIZE YOUR INNER CONFLICTS

To remain physically healthy, you need to resolve the conflicts between your thoughts and feelings. But you can't do that until you learn to recognize that these conflicts exist. If you're like most people, you may not even notice when you find yourself saying or doing one thing and feeling another. You are probably too busy trying to live up to someone else's expectations. So your body will send out stress

That Tied-Up-in-Knots Kind of Feeling

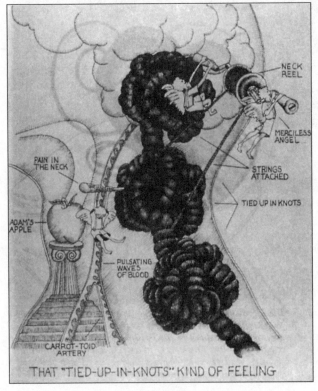

THAT "TIED-UP-IN-KNOTS" KIND OF FEELING

BARBARA GANIM

"When my thoughts are in conflict with my feelings, I get a pain in the neck. Expressing that pain was easy—it felt like my head was tied up in knots and some merciless little angels kept twisting the rope tighter and tighter. Just doing this drawing relieved the pain. Whenever it comes back, I just imagine those little angels unwinding that neck reel and releasing the rope, and before I know it, the pain is gone again."

FIGURE 3-4.

signals in the form of tension, agitation, restlessness, moodiness, and even apathy to let you know something is amiss. But again you probably won't connect the stress messages with the cause. To reveal an inner conflict, you must learn to go inside and tap into your right brain language of imagery. Accessing your imagistic impressions of an issue or emotion that you suspect may be causing conflict will expose the difference between your verbal, left-brain thought messages and your imagistic, right-brain feeling messages. By reconciling these conflicts, you will begin to alleviate the inner stress that has been silently taking its toll on your body and mind over the years. In addition, when these conflicts are recognized you can then begin to make the choices in your life that are truly right for you.

The next two exercises will teach you the all-important technique of bypassing your left brain's verbal thoughts by using guided visualization and body-centered awareness. As you do these exercises you will see just how easy it is to shift your consciousness into your body so that you can connect with your right brain's imagistic impressions of your feelings and emotions. The only difficult part will be learning to trust your imagistic impressions and the messages they will give you when you begin to express them through art.

Session One

THE DIFFERENCE BETWEEN EXPRESSING AN EMOTION WITH WORDS AND IMAGES

If you have gathered together the art materials suggested in chapter 2, and set up a comfortable and quiet place in which to work, you are now ready to begin your first session in expressive art. This session begins with two exercises that will demonstrate the difference between expressing an emotion verbally and expressing it imagistically. In the second exercise, once you have accessed your imagistic impression of a particular emotion, you will be directed to express it as a drawing. The third exercise will show you how to process your imagistic drawing to ascertain what your drawing has to tell you about your emotion. These three exercises, which will take about an hour to complete, will provide you with the basic procedures involved in using expressive art. You will then use this same process in the other exercises throughout the book.

EXPRESSING AN EMOTION VERBALLY

For this exercise you will need your healing journal, some pastel chalks, crayons or markers, and a pen. Place all your materials within easy reach, and open your journal to the first blank page. Sit back in a comfortable chair or on a pillow on the floor. You may want to put on some soft meditative music, light a candle or two, and even burn some incense if you wish. Since this first exercise isn't a guided visualization, it won't be necessary to pretape it. Just read through the instructions and follow the directions in each step.

- Think about a painful or stress-producing emotion that you have been experiencing lately—an emotion that you would like to release. Think of one word that best describes this emotion, for example, *sad, angry, helpless, depressed,* etc. Write this word in big, bold letters using markers, chalks, or crayons on the top of the first page of your healing journal.
- Look at this word—study it—then in one or two sentences write down how this emotion feels to you.
- When you have finished writing, read what you have written out loud to yourself. What do the words you've written tell you about how this emotion feels inside your body? Write the answer to that question.

ASSESSING YOUR EXPERIENCE: DID YOU USE WORD LABELS TO DESCRIBE THE FEELING OF YOUR EMOTION?

If you are like most of the people I work with, you may have had some difficulty identifying in writing how your emotion feels to you. When I give this same exercise to my clients or workshop participants, they often use words like *awful* or *terrible* to describe how a painful, stress-producing emotion feels. But words like *awful* and *terrible* or any of the other adjectives we may use to describe a feeling are nothing more than vague, nondescript word labels. They tell us absolutely nothing about how a particular emotion is being expressed or felt inside the body. So if you found yourself using word labels to identify and describe how your emotion feels, then you

have just experienced the ineffectiveness of left-brain, verbal thinking. Not only does the left side of the brain have difficulty separating and identifying our emotions, the words it uses to describe how these emotions feel are often laden with judgment.

Here's an example of how one of my clients responded to this first exercise. Jessica (not her real name) first came to see me when she was diagnosed with breast cancer. To help her get in touch with what she was feeling emotionally as she began her chemotherapy treatment, I asked her to write down one word to describe a painful emotion she wanted to release. She wrote the word *despair.* Then the two sentences she wrote to describe her feeling of despair were: "My despair feels just awful and I don't know how to stop it. Every time I think about it I get more and more confused."

As you read these two sentences, what do they tell you about how Jessica is experiencing her feeling of despair? Not much! All you know from what she wrote is that her despair feels awful and she is confused. Both the words *awful* and *confused* are nondescript word labels. No wonder she didn't know how to stop her despair, since she wasn't in touch with how this emotion really felt inside her body. She was only in touch with her *thoughts* about this emotion.

Only when you know how an emotion really feels inside your body can you release it. As long as Jessica's feeling of despair remains unclear to her, she will not be able to adequately express or release it. As a result, it will remain lodged inside her body, causing physical and emotional stress.

SOME PEOPLE ARE NATURALLY IMAGISTIC

There are some people who have retained their natural ability to think imagistically, even when they use words to describe how an emotion feels. For some reason, these people have been able to resist the early conditioning we all receive to ignore our right brain's perception of our feelings and accept instead our left brain's verbal reinterpretation, which gives us words like *awful* and *terrible* to describe an emotion. Such people, who can connect immediately with their body's physical sensations, are better able to tune in to their body's imagistic expression of a feeling. Thus when it comes to verbally describing an emotion, they tend to automatically use words that are more imagistic in nature. Poets are an example of people who use images expressed in words to evoke feelings.

For example, a naturally imagistic person might identify anger as feeling like a red, hot burning lump of coal deep inside his or her stomach. Although words are

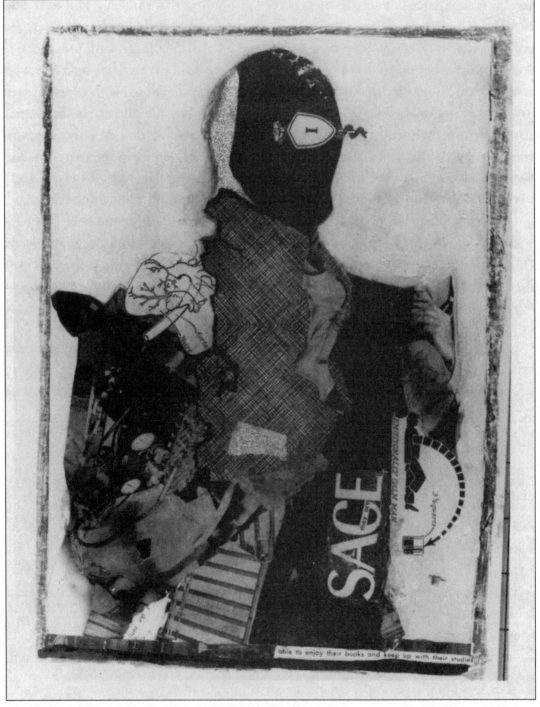

FIGURE 3-5.

used, this is an *imagistic* description of an emotional feeling. This description tells us far more about how that person is experiencing anger than if he or she had used nondescriptive words like *awful* or *terrible*.

If you found that the words you used in this first exercise did create an imagistic picture of your emotion, then you may be one of those naturally imagistic people. If so, then bypassing your left brain verbal thoughts in order to connect with your body's feeling sensations will probably be easier for you than it will be for others. If on the other hand you did use nondescriptive word labels, then shifting your awareness away from your thoughts and into your body may take some practice.

Even if you are one of those naturally imagistic people, you will still need to do the next exercise, which involves drawing an image of what your emotion looks like, because the nuances of your colors, the placement of your images on the paper, and the shapes and forms of your images will reveal far more than words could ever express. In this case, a picture truly is worth a thousand words.

S E E I N G W I T H Y O U R I N N E R E Y E S

In the next exercise you will learn how to access your body's impression of the painful, stress-producing emotion you began working with in the first exercise. Many people in my workshops often express concern that they won't be able to see anything when they close their eyes and try to do a guided visualization. Don't worry. Everyone experiences their inner imagery in different ways. While some people actually see an image in their mind's eye, others merely sense the idea of an image, that is, they just seem to know intuitively what their image is. Then there are others who see absolutely no images, nor do they intuitively sense them, but when they open their eyes and begin to allow their hand to draw, an image emerges on the

Deity

R I V A L E V I T E N

"I am turning seventy years old, and for decades my work has spoken to me, though the voices may change. This image Deity has forced me to look deeper inside. My soul-nature brings forth new experience that has transformed my total being. The message of the sage offers deeper and deeper insight into the cyclical process, opening a doorway to my heart."

paper. There is no right or wrong way to visualize. You just have to work with it and trust your own way of coming to an image. So don't get frustrated and give up if you don't actually see something when you close your eyes. Just allow yourself to begin drawing what you imagine your emotion feels like, and before you know it, an image will appear. The more you work with your ability to express your emotions imagistically, the stronger your connection to your inner imagery will become.

Shaman Journey

VALAIDA D'ALESSIO

"My paintings are intuitive, complex, a release of emotions. They are personal, my identity, an area of life controlled by no one but myself. They are each a personal journey within."

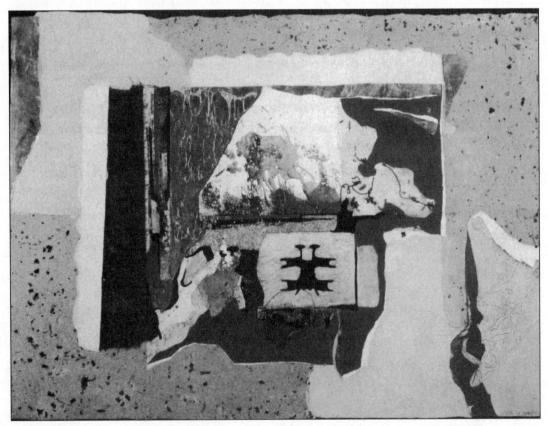

FIGURE 3-6.

Also be careful not to judge what you are seeing, sensing, or drawing because that will shift you back into the left side of your brain. If you sense that judgment is beginning to take over, close your eyes again, get back in touch with your body and your intuitive sense of knowing what your emotion feels like, then open your eyes and continue drawing. If you still sense yourself being critical or questioning the meaning of your colors or images, use your nondominant hand to draw. That will make it impossible for you to be concerned about what your drawing looks like, and that in itself will shift you back into the nonjudgmental right side of your brain.

Exercise 2
EXPRESSING AN EMOTION WITH IMAGERY

This second exercise introduces the techniques of guided visualization and body-centered awareness, which will enable you to bypass your verbal left-brain thoughts and shift your focus of attention to the place or places within your body where you are experiencing the stress-producing emotion you identified in the first exercise.

When you are ready to begin, place a large sheet of drawing paper in front of you. Unless you have a preference, I suggest you use pastels for this exercise. Position yourself comfortably in a chair or on the floor. This exercise will be much easier if you pretape the guided visualization. Remember to pause for several seconds wherever *(Pause)* is indicated in the visualization. If you prefer not to tape it, then simply read through each section of the visualization so that you understand the directions. Then close your eyes and guide yourself silently through it.

GUIDED VISUALIZATION

Close your eyes and take three deep, cleansing breaths (Pause), *and as you do, allow yourself to become present to your body. Become aware of your breathing. Feel your chest moving in and out as you inhale and exhale.* (Pause) *Become aware of your position in the chair. Feel the weight of your body being supported by the chair. Feel your clothing against your body. Now continue breathing normally for a few moments.* (Pause)

Imagine that your conscious awareness is a tiny bead of light nestled deep within the center of your cranial cavity between the right and left sides of

your brain. Imagine this light to be like an inner beacon that can illumi-nate whatever part of your body you move it into.

Now, focus your attention on the word you wrote down in the first exer-cise that identifies a painful or negative emotion you have been experi-encing lately. As you focus on this emotion, allow the light of your conscious awareness to move into the place or places within your body where you are experiencing the feeling this emotion is creating. (Pause) Allow yourself to become present to what this emotion feels like inside your body. (Pause)

Now imagine what the feeling of this emotion would look like if it were an image. (Pause) If you don't actually see or sense an image, what colors would best express what this feeling feels like? What shape would best express the feeling of this emotion? (Pause)

When you know what this emotion would look like, what colors and images would best express what this feeling feels like, open your eyes and draw what you visualized or sensed.

If no images, colors, or shapes came to you, then open your eyes and look at your box of pastels. As you focus on this emotion, what colors do you find yourself drawn to? Pick up the pastels of those colors, and just allow your hand to begin to spontaneously express what this emotion feels like, using those colors. As you draw, you will begin to see a form emerge. That form may begin to suggest or lead you to add more colors and fur-ther define the shape. As you draw, an imagze—which may be something recognizable or not—will begin to appear.

When you have completed your drawing, tape or pin it to a wall so that you can view it from a distance. This drawing is the imagistic expression of your emotion.

Now that you have expressed this emotion as a word and as an image,

can you see the difference between expressing your feelings verbally and imagistically? If so, write a few sentences in your healing journal about the differences.

(See Figure 3-7 for an example of how one person did this same exercise to express her feelings of frustration.)

You can use these first two exercises with any emotion that is bothering or confusing you. As you have just experienced in this second exercise, by using imagery rather than words, you are able to access exactly what is going on inside your body, where your feelings are untouched by the influence of your judgmental left brain. Imagery cuts through all the innuendos, the *maybe*s, *if*s, *and*s, or *but*s and allows you to literally see your emotions as they are happening inside your body.

In addition, the mere act of drawing a stress-producing emotion actually releases it from your body so that it can no longer cause physiological damage. This is the first step in the healing process. Then as you will discover in chapter 4, the final step in healing with expressive art is to transform the image of a negative thought or painful emotion into a positive, empowering image.

Frustration

NAME
WITHHELD

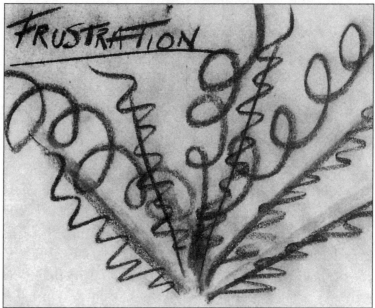

FIGURE 3-7.

To understand how your inner language of imagery works, think of it this way:

- Imagery is the body-mind's language.
- Art is the voice or expression of that language.
- The alphabet is color, shape, form, line, and texture.
- The key to translating this language is through metaphor and symbol.

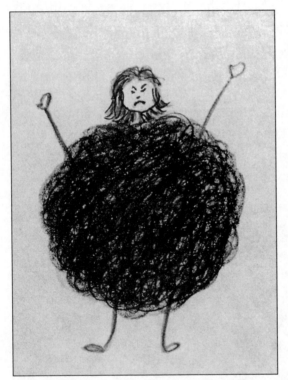

FIGURE 3-8.

Despair

This is Jessica's drawing of despair. While Jessica couldn't accurately describe what her despair felt like when she used words, her imagistic representation was very descriptive. Here, she depicted her despair as feeling like a giant lump of black tar inside her gut. When I asked her to tell me about the drawing, she said that she felt trapped inside that sticky mass, and that's why she drew an image of herself struggling to get out. As she continued to process her drawing—by answering questions similar to those you will find in the next exercise—she got in touch with how surprised she was that she drew such an angry expression on her face. "I don't feel angry," she said. "I just feel stuck, trapped. That's not anger, is it?"

For so many people, especially women, anger is such an unacceptable emotion that they are afraid to even allow themselves to know they are feeling it. This is a classic example of the left brain's ability to deny that a particular emotion exists. In response to her question, I suggested that she draw what that expression on her face represented or symbolized for her.

In this second drawing, which she later entitled *Anger*, Jessica was shocked when she drew what her facial expression represented. "I saw, in my mind's eye, flames everywhere, and I was in the middle of them," she said. "I knew then that it *was* anger. I could see images outside the flames of my husband and my two children—they had blocked ears. How typical! It is so clear to me now how I really feel, they just never listen to me. They never seem to care what I need or want. I feel unheard and unseen. And yes, I guess I am angry about that."

Anger

This drawing of anger and what it told Jessica about her feelings was a big breakthrough for her, because for the first time she realized that her despair was really a mask for her anger. She had unconsciously denied her anger for years, because it was not "ladylike," something her mother always reminded her she should be when she was a child. So instead of feeling anger, Jessica compensated by substituting a more acceptable emotion—despair. And despair was truly an appropriate substitute emotion, because it expressed her feelings of helplessness in a situation in which she was unable to show her real feelings. So while her family ignored her requests for help and emotional support, she ignored her own anger.

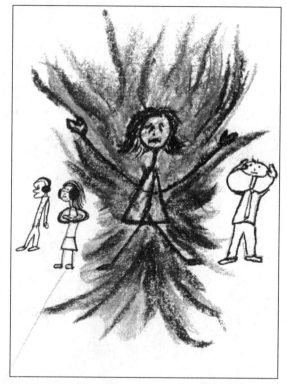

FIGURE 3·9.

She was taught as a little girl that family duties come first, and even now, as she battled a life-threatening disease, she didn't feel as though she had the right to expect her family to help her.

For years, Jessica had put her own life on hold while she spent every waking hour taking care of her family. But finally, by using expressive art, she was able to

get in touch with the feelings that had been hidden for a lifetime. "I can see now as I look at these drawings," she said, "that my anger has been there, unacknowledged, for many years. I also feel in my heart that it set the stage for so much internal stress that my system just couldn't protect me from this cancer." As she continued to talk about these two drawings and the feelings and insights they revealed, she said she also realized that her feeling of despair was her way of preventing herself from expecting help. Her despair kept her locked in a place of confusion and immobility. In essence, it was her excuse for not insisting that her needs be met by her family. As long as she was in a state of despair, she didn't have to confront her anger, her family, or her own needs.

Perhaps the biggest turning point for Jessica in this process of examining her inner imagery was the recognition that *she* was the one with whom she was really angry, because inside—within her right-brain consciousness, where she was not judging her feelings but simply accepting them as they were—she knew that she was abandoning and ignoring herself. She also admitted, for the first time, that her family treated her the way she expected them to treat her—the same way her mother had been treated by her family.

Following these two drawings, Jessica did a third drawing, a drawing of transformation, in which she imaged herself releasing her despair and anger. In this drawing, she portrayed herself as growing strong, powerful, and important within the ring formed by the members of her family. "This," she said proudly, "is how it has to be. I have to be as important to them as they are to me, or we are not really a family."

Letting Go of Anger and Despair

FIGURE 3-10.

These three drawings and the knowledge Jessica gained from doing them gave her the courage to go home and share her feelings with her husband and children. In our next session, she told me that talking with them and showing them her drawings was a remarkable experience. They had no idea how she had been feeling or that she even needed or wanted their help. A few months later, Jessica told me that this experience of getting in touch with her own feelings and then sharing them with her family had opened them all up to a totally new kind of family relationship. For the first time, they were talking about her cancer and the fear *they* felt about losing her. They also began talking about what they could do, as a family, to help her heal.

TRANSFORMATION—THE KEY TO HEALING

Transformation, as you will have an opportunity to experience in chapter 4, is the catalyst that induces the healing process. Transformation begins when we are able to see ourselves, our lives, and our experiences differently. When a negative, angry, or destructive image is replaced by a positive, peaceful, and loving image, the body responds. The spirit also responds. When we transform the body-mind, we also transform the spirit. That is why healing is a holistic process involving body, mind, and spirit.

PROCESSING YOUR ARTWORK

Just as Jessica gained a new insight into her own feelings and behaviors by talking about her imagery and what she felt it meant, you can do the same for yourself by answering the self-dialoguing questions in the next exercise. These questions will help you to understand the meaning of your inner imagery.

Avoiding Your Judgmental, Left-Brain Voice When Using Words to Process Your Artwork

One question that always comes up in my workshops is, "If I am using words to write about my artwork or talk about it, won't I be shifting back into my judgmental left brain?" That does happen, and it is something you will want to watch for in yourself when you begin the next exercise on self-dialoguing.

There are telltale signs that can tip you off when you do start to shift back into left-brain consciousness. If you find yourself writing or saying words like: "I *think* this color represents . . . or I *think* this image means . . . ," then you have most likely shifted back into verbal thinking, where judgment runs rampant. The verb *to think* is always a dead giveaway, because the left brain *thinks* it doesn't *feel*. Also be aware when you catch yourself using words like *should, could, if,* and *maybe.* Words like these carry judgment, conditions, and a sense of tentativeness. When we use them, it usually indicates that we are unsure of our thoughts and actions.

The left brain is never certain about its choices and opinions. It is always weighing every statement and decision against accumulated information to determine the right course of action or thought. But the right brain always knows what feels right. When you are in touch with your feelings, there will be no doubt that what you sense is right for you. It will never be conditional. To avoid this shift back into your judgment center, try to keep your responses framed in *I feel . . .* statements. Feeling is a right-brain response. Just using the word *feel* will automatically shift you back into imagistic thinking.

━━━━━

Exercise 3

SELF-DIALOGUING QUESTIONS TO HELP YOU PROCESS YOUR DRAWING

Write a response to each of the following self-dialoguing questions in your healing journal or if you wish, directly on your drawing. When you have completed this exercise, you should have a clear understanding of what the colors, forms, and images in your artwork mean.

1. In what part or parts of your body did you feel your painful, stress-producing emotion?
2. How do you feel now as you look at this drawing?
3. How do you sense that this drawing symbolizes your painful, stress-producing emotion?

4. What do the colors in your drawing tell you about this emotion?
5. Look at each of the shapes, forms, or images that you drew, and write a sentence or two describing what each one of them tells you about this emotion?
6. If this drawing could speak to you about how this emotion feels and the circumstances that evoke it, what would it say?
7. How did it feel to express this emotion in a drawing?
8. How does this emotion feel now inside your body?
9. What have you learned about this emotion from your drawing?
10. What have you learned from these first two exercises about the difference between expressing this emotion with words and expressing it with images?

UNDERSTANDING YOUR IMAGISTIC LANGUAGE

As you have probably discovered by doing the self-dialoguing questions in this last exercise, understanding the messages being conveyed through your inner language of imagery involves looking closely at the different components of each piece of artwork you create. First, you need to see what happens when you look at the completed piece. Try to be aware of any emotions or feelings that surface as you observe it. Then focus on the colors you used. Do they make you feel comfortable or uncomfortable? Do they arouse any particular emotions or memories? As you look at the work, always ask yourself this question: If these images or colors could speak, what would they tell me about the emotion or issue I was attempting to express through this piece? And lastly, always explore the possible meaning behind each artistic detail in your piece, no matter how small or insignificant it may seem.

As you are processing your artwork remember that, though some details may look too small to bother with, they may in fact be quite significant. For instance, if your drawing has five flowers in the grass, then ask yourself what the number five might signify to you. Do you have five children? Five members in your family? Or could it be that something happened when you were five that your body-mind wants you to remember?

I was once working with a client who did a drawing of a snake (shown in Figure 3-11) to express her feelings about the divorce she was going through. As she explained the drawing to me, she said that the snake had venom shooting from its mouth, representing the venomous feelings she had toward her soon-to-be ex-husband.

Like Jessica, this woman also had great difficulty expressing her anger. She had been holding it inside throughout the divorce so that she would appear, as she put it, to be a nice person. When I asked her what the five little dots at the end of each spray of venom were, she shook her head. I then asked if they were related in any way to the five dots that surrounded the snake's tail. Again she said that she had no idea. "I just put them there," she said. "They don't mean anything." My response to her was that every mark one makes when drawing an expressive art image on paper means something. Finding out what a seemingly irrelevant dot, line, smudge, squiggle, or slash means may require digging a bit beneath the surface of one's initial responses to the self-dialoguing questions, but the dig is almost always well worth the effort.

As I began to probe my client a bit further about what the number five could mean, we discussed every possibility, from the number of friends and family members she had, to the number of years she was married. Nothing fit. Then I asked her to tell me anything she remembered about being five years old. After a few minutes of blankly staring into space, her eyes began to well up. The tears started to flow as she described her fifth birthday party—a party her father was too busy to attend. "He always let me down," she said. "I was never important enough for him to . . ." Then she stopped abruptly, looked at me, and continued. "Just like my husband. He was never there for me, either. I never told my father how much he had disap-

Snake

NAME WITHHELD

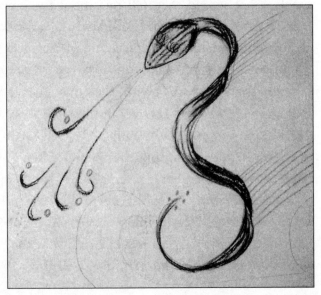

FIGURE 3-11.

pointed me, nor did I ever tell my husband how much he had let me down." I then asked her why she never told her father how she felt. "Nice girls don't complain," she said, now laughing.

This story demonstrates how important it is to pay attention to the details in your imagery. What you thought was a mere slip of the brush or a spilled bottle of ink obliterating a drawing could reveal an important piece of information about how your feelings, emotions, and memories are affecting you. Even accidents are not accidents when it comes to the messages the body-mind attempts to deliver.

YOU ARE THE ONLY ONE WHO KNOWS WHAT YOUR IMAGERY MEANS

If you are working with a therapist as you do your healing artwork, he or she may try to suggest what a particular image or color could mean in your artwork. But ultimately you are the only one who can truly know what your imagery means. While others may be able to offer an interesting and even insightful perspective on the possible meaning behind your imagery, it is still only their perspective. If what someone says about your imagery or artwork doesn't feel right to you, then trust that it isn't. Your own instincts will be your best guide when it comes to understanding the messages your imagery carries. Remember, your body-mind wants you to know what it has to say, and it will give you the answers, if you ask for them, in the form of intuitive hunches and flashes of insight. Just trust the notions that come to you as you ask your body-mind for the answers.

I always caution my students not to try and interpret another classmate's artwork, because an individual's inner imagery is completely subjective. No two people will experience an emotion in exactly the same way, so as a result, their imagistic expression of an emotion or feeling will never be the same either. For example, the color red may symbolize a feeling of anger for one person, and represent passion to another. While one person may express their feeling of being out of control by drawing an image of a turbulent river swallowing them up, another individual might express that same feeling by drawing a picture of themselves falling into the mouth of a giant monster. The colors and images people use to express their feelings and emotions are far too individualistic for anyone to ever presume that he or she can interpret another person's artwork.

Session Two

SETTING YOUR INTENTIONS TO ACTIVATE YOUR HEALING PROCESS

We would like to believe the old saying that time heals all wounds. But the fact is, without our own conscious intention to acknowledge our wounds and release the emotions that created them, we will never truly heal, no matter how much time passes. Thus healing begins with your intention to heal, which in turn triggers the body-mind to follow your inner directive.

THE DIFFERENCE BETWEEN HEALING AND CURING

There is a lot of confusion and misunderstanding around the concepts of healing and curing. Healing does not mean curing. Curing a disease or illness is what medical science attempts to do through external intervention, treatment, and medication. Healing is an internal process. No person or thing can heal you. Only you can heal yourself.

Healing restores balance and harmony to the body, mind, and spirit. Neither surgery, medicine, nor time can do that. Surgery merely removes cancer from the body, but if the emotional stress that brought the body into disharmony in the first place is not relieved, the cancer will surely return. The same is true for all disease and illness. Balance and harmony occur when there are no conflicts between what the body receives and the mind perceives. In other words, when our mind accepts what our body has experienced without reinterpreting it, a state of balance is created. Without the stress of mind-body conflict, the physical body can function harmoniously and the immune system can operate at peak efficiency. When the mind and body are free of inner conflict, the spirit is released to enact its divine purpose rather than being bound by the inner turmoil of a mind at odds with the body.

To begin the healing process, you must first set your intentions to create a balance between your mind and body. Since art is a healing agent that works from within, we will begin by creating a drawing or painting of intention.

Dr. Gerald Epstein talks about the importance of setting a healing intention in

his book *Healing Visualizations.* He says that "intention is the active expression of our desires channelled through our physiological systems. Intention depends on will, which is simply the life force impulse that enables us to make choices." With this in mind, we must remember that healing is always a choice. It requires our conscious participation. Setting your intention is just that—a conscious choice in which mind and body agree to a common goal. Once the mind sets an intention, the body will cooperate by responding to your desires.

The focus of this session is to help you create an artwork of intention to activate your own healing process. The guided visualization in the first exercise will help you connect with that part of yourself that is in need of healing. As you begin this visualization you might think that you have a certain idea as to what you would like to heal about yourself physically, emotionally, or spiritually, but as you tune in to your body's imagery, you may find that you get a totally different message about what needs healing. This happens frequently with the people in my art and healing groups. If this happens to you, allow yourself to trust this inner message. The mind or the left side of the brain, which is where we begin when we start to think about what we want to heal, knows only part of the story. Your imagery will reveal, if you remain open to its messages, the whole story, as witnessed by the body, mind, and spirit.

MATERIALS

Your artwork of intention can be executed in any medium that you desire. I suggest, however, that you think of this piece as a fully developed artistic statement rather than a quick sketch to express your inner images. When my students do this exercise, I try to encourage them to work very large. I like to buy rolls of paper from a local printer that come in three- or four-foot widths. I will then roll off a number of sheets that are six or seven feet in length and tape them to the wall so that each student can work with a piece that large. Some students who like to work in mixed media will collect branches, found objects from Dumpsters, and attic memorabilia including childhood photographs and toys, and construct a multidimensional collage on pieces of gessoed Masonite or plywood. Others who work in mixed media paint their visualized imagery in either tempera, acrylic, or oil and sometimes combine that with spray paint to get a different effect. They will then glue their found objects to their painted surface. Some students like to create heal-

ing boxes, which they construct out of wood or cardboard and place various personal or found objects inside to symbolize their healing intention. Sculptures can be approached in much the same way.

How to Begin

Your artwork of intention may take days or weeks to complete. If you anticipate spending that amount of time on it, be sure to find a place to work where you can leave your materials out and where your work will be left undisturbed. Again, as in the previous exercises, begin with the guided visualization below, which you can pretape, sit back in a comfortable chair, and close your eyes. Put on some soft, inspirational music that has a healing quality and dim the lights. Then allow your inner vision to take you on a healing journey within.

Exercise 1

Creating an Artwork of Intention

Focus your attention on what you would like to heal within yourself. Is it physical, emotional, or spiritual? Physical disease or illness may be life threatening or it may be a chronic condition that causes constant pain and discomfort. It may be a progressive, degenerative disease that displays few if any symptoms at the present time. Or you may want to heal a temporary illness like a cold, the flu, a broken bone, a pulled muscle, or a recurring backache.

If an emotional wound needs healing, it may involve an old emotion that has been with you for a long time, like a broken heart or a childhood anger or hurt that is still unresolved and unreleased. (If there is no old emotion, then perhaps there is something painful and disturbing going on now that you wish to heal.) Or it may be that you would like to heal a negative attitude, feelings of confusion, distrust, or a feeling of being pulled in many different directions—a sense of fragmentation.

If your desire is to heal yourself spiritually, it could involve a feeling of lack of purpose or a feeling of being separated from your soul or the very source of all creation. Or you may feel that what you need to heal is a combination of the physical, emotional, and spiritual parts of yourself. Whatever it is that you would like to heal, write it down in your healing journal. Be as specific as possible in your description or explanation.

GUIDED VISUALIZATION

When you are ready, close your eyes and take three deep, cleansing breaths, and as you do, allow yourself to become present to your body. (Pause) Become aware of your breathing. Feel your chest moving in and out as you inhale and exhale. (Pause) Become aware of your position in the chair. (Pause) Feel the weight of your body being supported by the chair. Feel your clothing against your body. (Pause) Continue breathing normally for a while until your breathing becomes easy and relaxed. (Pause) If any distracting thoughts enter your mind, imagine they are encased in tiny balloons that you allow to float away. Visualize releasing all distracting thoughts until your mind feels clear and calm. (Pause)

Now imagine that your conscious awareness is a tiny bead of light nestled deep within the center of your cranial cavity between the right and left sides of your brain. (Pause) Imagine that this inner light can illuminate any part of your body that you move it into.

Bring forward into your awareness what you wrote down in your healing journal as the aspect of yourself that you would like to heal. As you focus on this, allow the inner light of your conscious awareness to move into the place or places within your body where you sense the symptoms of disharmony and imbalance manifesting. (Pause) These symptoms are created by the physical, emotional, or spiritual wound you would like to heal. (Pause) Become present to the nature of these symptoms as the light of your conscious awareness illuminates this area or these areas within you. (Pause) As you witness the symptoms, imagine or sense what colors, symbols, or images would best express your inner intention or directive to bring this wounded area or areas within you into balance and harmony with your total being. (Pause)

Be patient as you allow the images and colors to emerge before your inner vision. (Pause) When you know what is needed to express your intention to create balance and harmony and thus initiate the healing process, open your eyes and create an artwork that best expresses your intention to begin healing.

When you have completed your artwork of intention, you will have initiated your inner directive to begin healing. This piece can and should be used as a focus for daily meditation. If you can, make the time to sit quietly for as little as three minutes each day and simply look at your artwork of intention and allow its forms and colors to be taken in by your physical eyes. When you do this, your body-mind will respond to its imagistic messages. These messages will act as a trigger to continually reinforce the ongoing process of healing by activating your central nervous system to release hormones and endorphins that will lower your blood pressure, relax muscle tension, enhance cellular functioning, and boost your immune system.

I created an artwork of intention several years ago when I was attempting to cleanse my psyche of old and often toxic patterns of thoughts, beliefs, and attitudes. The result of my visualization was a painting I entitled *Healing Waters* (see color insert section, Plate 2). As I painted the image, I could actually feel a deep internal sensation taking place in the center of my chest, as if the waterfall was flowing within my heart. After I completed the painting, the idea of this waterfall became so powerful to me, that each time I sensed one of my old, negative beliefs starting to emerge, the image of my healing waters would pop into my consciousness as a reminder to release that belief. I would then imagine that this toxic belief or thought was a black bubble being washed away by the flowing waters in my painting.

Exercise 2

SELF-DIALOGUING QUESTIONS TO PROCESS YOUR ARTWORK

The following self-dialoguing questions will help you process what your artwork of intention means. Write your responses in your healing journal.

1. How does this artwork symbolize that part of you that is in need of healing?
2. What do the images and colors tell you about your affliction?
3. What does this piece of artwork tell you about what is needed to restore balance and harmony to this wounded area within you?
4. How do you feel now about your ability to heal?
5. If each image, shape, or color within your artwork could speak, what would each one say to you about your affliction and the healing of it?
6. What have you learned about this part of yourself that is in need of healing?

This is the beginning. You have opened the door, cleared the path, and taken the first step forward in your healing journey. It is an exciting journey because it offers you far more than just an opportunity to heal the wounds that life creates. It is a journey that will take you into the unknown parts of yourself where you will discover the extraordinary power you have to renew yourself physically, re-create yourself emotionally, and transform yourself spiritually. (See color insert section, Plate 3, *Reaching* by Mary F. Hughes.)

FIGURE 4-1.

Pulse and the Symphony

MARIA COPPOLA

"The ritualistic shapes and repeated, extreme scrapings evident in my paintings represent a struggle with infertility: sadness, isolation, jealousy, guilt. Gold, silver, emerald, and ruby pigments offer a glimmer of hope, acceptance, and ultimately resolution and healing."

Healing the Mind

Emotions are not merely a state of mind—a way of thinking or reacting to your circumstances. Emotions have a direct impact on your body. Negative thoughts and painful or uncomfortable emotions, like sadness, depression, fear, loneliness, hate, guilt, and resentment, to name just a few, cause the body-mind to release into the bloodstream stress-producing hormones that create an immediate drop in the immune system's ability to function properly for a period of twenty-four hours after the emotion is first experienced. This is called the stress response. Positive thoughts and pleasurable or comfortable emotions, like joy, happiness, love, trust, hope, and contentment, release endorphins into the bloodstream, which boost the functioning of the immune system for a period of forty-eight hours after the emotion is experienced. Based on this information alone, it is easy to see how important our emotional outlook is to our health—both mentally and physically.

Unfortunately, a negative thought or a stress-producing emotion is not always over and done with in twenty-four hours. We don't automatically pass our thoughts and emotions out of our body the way we do our food or breath. Instead, we often tend to hold our thoughts and emotions in our mind for days, months, and even years. Holding positive thoughts and pleasurable or comfortable emotions in the body-mind cannot hurt us the way negative thinking and painful emotions can, so

FIGURE 4-2.

the real work in healing must begin by moving those stress-producing thoughts and emotions out of the body.

But you can't move or release these thoughts and emotions if you are not aware that they exist. All too often, we are oblivious to what we are feeling because we either ignore our emotions or we get caught in the trap of justifying our emotional reactions.

A painful emotion is like a thorn or sliver trapped deep in your finger. If you don't extract it immediately, the skin grows over it, but it never heals. For a while it may feel as if it has healed, but soon it will fester and become infected until the wound it creates finally gets bad enough to grab your attention and force you to extract it. Only then can it heal. Emotions, if unreleased, fester inside us in exactly the same way. They may appear to heal, but they don't. Someday the festering will create a wound serious enough to get our attention.

First let's look at our inclination to ignore our emotions. Most of us have been taught to think that a painful emotion is a bad emotion—something we are better off avoiding or ignoring. Many people will even deny feeling certain emotions like sadness, anger, or depression, to mention just a few. Every emotion we are capable of feeling is essential to our survival. Emotions warn us when something is uncomfortable or dangerous and signal us when something is pleasant and nurturing. Without these inner warnings and signals, we would never know when to move away from a threatening experience or when to move toward an enjoyable or fulfilling situation. I always tell my clients this: allowing yourself to feel a painful emotion cannot kill you, but denying that a painful emotion exists can.

Justifying our emotional reactions is another way of disregarding the warning signal a painful emotion is sending us. Instead of accepting and dealing with a painful emotion, we redirect it outwardly toward a person, place, or thing. In doing

Dreaming

HAROLD E. LARSEN

"To free myself from the distortion that my wounds, both spiritual and emotional, were too much, I hid them. Finally, I was reduced to honesty. Then my paintings brought about a birth for a voyage into a passion for living for myself and others. While expecting little, I received so much."

so, we are refusing to accept responsibility for the role we played in the situation that spawned the painful emotion. In turn we place the blame elsewhere, and in doing so we justify reacting in an inappropriate or even destructive way toward whoever or whatever sparked the emotion. This causes us to feel even more stress than the original emotion. At its extreme, justification can ignite brawls, rape, gang violence, domestic violence, drug use, and even terrorism and war.

When I conduct my healing-with-art workshops, I have found that many of the participants are shocked to discover that emotional stress can cause physical illness or disease. I often get a panic-stricken reaction from them in the beginning of the program, when I explain the connection between physical and emotional health. They are not only in a state of disbelief but they are also frantic, because most of them are convinced that they have absolutely no control over their emotions. The good news, I tell them, is that we all have absolutely 100 percent control over how we *choose* to experience and handle our emotions. While we may not be able to avoid painful emotions any more than we can avoid the experiences that provoke those emotions, we can choose to react differently to our stressful situations and the emotions they produce.

CHOOSING TO TAKE RESPONSIBILITY FOR YOUR EMOTIONAL HEALTH

A word of warning goes along with the knowledge that there is a direct connection between emotions and disease. It seems that people are much more comfortable with the idea that illness is random and think that if you're one of the lucky ones, you'll stay healthy and live to be ninety; if you're one of the unlucky ones, you'll get cancer or some other disease and die young. Even physicians will often present a prognosis when a life-threatening illness is diagnosed as a statistic indicating the patient's chances of survival, or the odds for or against their ability to beat this disease. But staying healthy is not about chances, odds, or statistics. It's about taking responsibility—not for just how you treat your body or what you put into it, but also for how you choose to think about, experience, react to, and process your emotions. Contrary to what most people believe, we are not victims of our emotions and feelings. It is always within your power to decide whether to act like a victim and believe that your emotions are beyond your control, or to take responsibility and learn how to be the one in charge.

FIGURE 4-3.

Releasing My Eagles

JEANNE NORSWORTHY

"As I underwent wrenching changes in my life, I wanted some way to say how hard it is to let go, how necessary it is for growth, yet how painful. I had to paint this picture to help myself cope with all the horror I was experiencing. Keeping the attachment to delusions and illusions that are unhealthy is like moving through a rock outcrop. If you do it long enough, you'll make your own trail through the things that make you stumble. As I release those illusions, in emotional turmoil, the storm is moving across my awareness, but not over me, no longer hindering me. The act of letting go, of profoundly saying good-bye from the depths of one's soul and releasing one's grasp totally, is not possible without strong spiritual help."

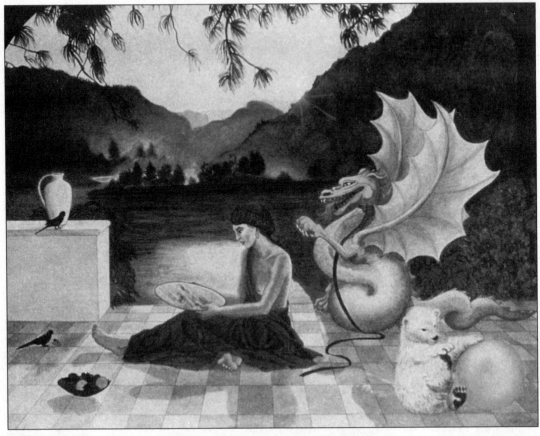

FIGURE 4-4.

Dragon of Choice

ISHMIRA KATHLEEN THOMA

"Self-dislike can completely distort my perception of the world around me. I can be surrounded by countless blessings and beauty yet still remain unhappy and indulge in self-pity. I have shown myself as a woman who sits in reflection as she sees a monster-self in the mirror. She felt it but could not confront it until she saw it completely. This is her shadow-self. She is so upset by this that she is oblivious to the beauty around her. She also does not yet perceive that she has a choice in this matter, that she can choose to accept her shadow and forgive herself. If she does, her shadow self can be transformed and integrated. The dragon is trying to get her to notice the choices she has, but she ignores him. The little bear gently plays with a pearl, reminding her of her need to play and enjoy life."

AVOIDING THE SELF-BLAME TRAP

Other people fall into the trap of blaming themselves for getting cancer or heart disease or some other life-threatening or life-altering condition. This is dangerous thinking that can keep people feeling powerless and victimized by themselves and their disease. Until research studies finally confirmed the mind-body connection, no one really knew that it was important to acknowledge and process our emotions.

The flip side of self-blame is self-responsibility. Just as cigarette smokers of thirty or forty years ago can't blame themselves for getting lung cancer because they didn't know the connection, we can't blame ourselves because we didn't know that recognizing and releasing stress-producing emotions was important. But now we do know. So just as a present-day smoker has to be willing to accept responsibility and the consequences for their actions if cancer develops, so too do we have to accept responsibility for our emotional health if we want to remain physically healthy. (See Figure 4-4, *Dragon of Choice* by Ishmira Kathleen Thoma.)

YOU DID NOT CREATE YOUR DISEASE

Please remember, no one consciously chooses their disease, nor does anyone consciously create it. It takes time for emotional stress to result in immune system dysfunction. So you needn't worry every time you get angry or upset that you may be causing yourself to get cancer or an ulcer. But in the long run, you must be aware that if you continue to allow anger or any other stress-producing emotion to tear you apart, then you are increasing your chances of developing a physiological environment in which illness or disease can more easily develop. As Deepak Chopra, M.D., says in his book *Quantum Healing,* "Doctors can cut out the cancer, treat it with chemotherapy, but it will return if the emotions and conditions that caused the cancer are not dealt with by the patient."

The exercises in Session Three will help you recognize and release your stress-producing emotions. You will also learn how to transform your judgmental, negative images representing your painful, uncomfortable emotions into positive, constructive images that can activate the healing response from within. The final exercise in this session will show you how to transform a learned emotional reaction into a new and less-stressful reaction of your own choosing.

Session Three

EXPLORING YOUR EMOTIONAL NATURE

To heal your body, you must heal your mind first. To help you do that, the exercises in this session will concentrate on exploring your emotional nature, using the three steps of healing with art. These steps are easy to remember because they just happen to—with a little help from me—spell the word *ART.* They are as follows:

Step 1. *Access* the images of your stress-producing feelings and emotions by visualizing them as inner images.

Step 2. *Release* these emotions and feelings by expressing the images that represent them through art.

Step 3. *Transform* the images of your negative thoughts and painful emotions into positive and empowering images.

If you did the exercises in chapter 3, you have already learned how to use steps 1 and 2. In the next exercise, you will again use these first two steps to access and release any stress-producing emotions you may be holding inside. Then in the second exercise, you will learn how to execute the third step of transformation by using a technique called reenvisioning, which will help you to transform the images of your painful emotions into positive, healing images. In the third exercise, you will take a look at how you tend to react to stress-producing emotions when they do occur. If you feel that your reactions are in need of change, you will again be directed to use reenvisioning to transform those reactions so that they no longer cause you physical or emotional harm.

Exercise 1

ACCESSING AND RELEASING YOUR STRESS-PRODUCING EMOTIONS

To clear out any unexpressed emotions you may be holding inside your body, you must transfer the imagistic expression of them onto paper, canvas, or into a piece of sculpture. In this exercise, you will start this clearing-out process by beginning

where your artwork of intention left off from the exercise in chapter 3. This time, you will once again be guided to allow your awareness to become present to the areas of discomfort you were drawn to during the artwork of intention exercise in Session Two. But in this exercise, instead of visualizing images and symbols that represent your inner directive to bring these areas into balance and harmony, you will focus on only one area of your body at a time as you visualize the imagistic impressions of the stress-producing emotions affecting each area.

MATERIALS

You will need your healing journal for this exercise, as well as any art medium you would like to use to express your painful, stress-producing emotions. You may want to put a variety of art materials out in front of you before you begin, and once you have done the visualization, you can then allow your emotions to guide you in selecting an appropriate medium. For example, if the emotions you encounter feel watery or without clearly defined boundaries, then watercolors may suit you best. If you find yourself and your visualized imagery feeling soft or expansive, then pastels might do. Or if you are feeling more like squeezing, pounding, or pushing your emotions out of your body, try some clay. As in the previous exercises, you can pre-tape the visualization or read it to guide yourself through each segment.

GUIDED VISUALIZATION

When you are ready, get comfortable in your healing space. Open your journal to the page on which you wrote down what it was about yourself that you wished to heal when you did the exercise in Session Two on creating an artwork of intention. Reread the description of your healing intention. Allow your consciousness to take it in and become one with this intention.

Now close your eyes and take three deep, cleansing breaths, and as you do, allow yourself to become present to your body. (Pause) Become aware of your breathing. Feel your chest moving in and out as you inhale and exhale. (Pause) Become aware of your position in the chair. Feel the weight of your body being supported by the chair. (Pause) Feel your clothing against your body. Continue breathing normally for a while until your

breathing becomes easy and relaxed. (Pause) If any distracting thoughts enter your mind, imagine they are encased in tiny balloons that you allow to float away. Visualize releasing all distracting thoughts until your mind feels clear and calm. (Pause)

Now imagine that your conscious awareness is a tiny bead of light nestled deep within the center of your cranial cavity between the right and left sides of your brain. Image this inner light illuminating whatever part of your body you move it into. (Pause)

Focus your attention again on the healing intention you wrote in your journal. Allow your consciousness to recall the place or places within your body that your awareness was drawn to during the artwork of intention visualization. (Pause) Then allow the tiny bead of light of your conscious awareness to drift ever so slowly toward this part of your body. (Pause) If there is more than one area calling your attention, direct your awareness to the strongest area and focus on only that area for now. (Pause) Imagine your inner light radiating into this area where you had previously sensed the symptoms of disharmony and imbalance manifesting. (Pause)

As you become present to this area and the symptoms that are being created by the physical, emotional, or spiritual wound you would like to heal, imagine that the light of your conscious awareness is now illuminating this area from deep within. (Pause)

Now ask your body and spirit to present to you images, colors, shapes, and forms that best express the painful or uncomfortable emotions connected to these symptoms. Allow your inner vision to become a witness to these imagistic messages from your body and spirit. (Pause)

Be patient as you allow the images, colors, shapes, and forms to emerge within your inner vision or present themselves as ideas to your sense of inner knowing. (Pause) When you feel that you know how to express

these painful, uncomfortable emotions, open your eyes and create a draw-
ing, painting, collage, or sculpture that best expresses these thoughts and
emotions.

If there are still other areas of your body in which you are feeling a sense of
emotional distress, you can do this exercise over again as many times as necessary
until you feel as though you have released these stress-producing emotions from all
parts of your body.

When completed, your artwork will allow you not only to detach from these
stress-producing emotions, but it will also enable you to look at them from a new
perspective so that you may begin to understand their imagistic messages. These
messages will serve as a guide to help you resolve your inner emotional conflicts,
and as you do, you will simultaneously initiate the healing process within yourself.

When you have some time available to contemplate the artwork you created to
express and release your stress-producing emotions, place it somewhere at a bit of
a distance from yourself. This will allow you to see it from a perspective that is dif-
ferent from the one you used to create it. Do try to spend at least several minutes
just looking at your work. Then, when you feel ready, open your healing journal
and begin the next exercise.

Using an Abbreviated Version of the Previous Exercise to Access and Explore Emotions as They Occur

You can do an abbreviated version of the previous exercise whenever you are expe-
riencing an unpleasant emotion that you would like to explore so that you may bet-
ter understand what the emotion is about. Even doing this quick version—it only
takes a few minutes—will enable you to release the stress effects of the emotion.
Some people find it helpful to carry a small three-inch-by-four-inch sketchbook
with them when they are out of the house, so that if something unpleasant occurs,
they can deal with it on the spot. The abbreviated version is as follows:

GUIDED VISUALIZATION

Sit quietly for a few moments with your eyes closed. (Pause) *Focus on the*
emotion you are experiencing—even if you don't know what the emotion

*is—and allow your awareness to be drawn to a place within your body
where you are feeling this emotion. (Pause) As you connect with the phys-
ical sensation of this emotion within your body, try to imagine what color,
shape, or image would best express what this emotion feels like within
your body. (Pause) When you know, take a piece of paper and quickly
sketch what you imagined, visualized, or sensed this emotion to look like.*

As you acquire more experience in expressing your feelings and emotions
through imagery, you will begin to understand what you are feeling almost as soon
as you do a drawing of it. Use the self-dialoguing questions that follow each visu-
alization exercise to help you get the most from your expressive art experience.
Whether you did the shortened version of exercise one or the full version, the ques-
tions in the next exercise will help you process your artwork.

E x e r c i s e 2

PROCESSING YOUR ARTWORK

The following self-dialoguing questions will help you process what the images you
have expressed in your drawing mean. Write your responses to these questions in
your healing journal.

1. As you look at the work you have just created that expresses the stress-
 producing emotions that you have been holding within a particular part of
 your body, what does this piece tell you about these emotions?
2. How do you feel when you look at this piece of artwork?
3. If your artwork could speak, what would it tell you about the emotions you
 are expressing in this piece?
4. What do your choice of colors in this piece tell you about the emotion or emo-
 tions being expressed in your artwork?
5. How did it feel expressing your feelings through this piece?
6. What part of your body was your attention drawn to as you experienced the
 stress-producing emotions you expressed in this work?
7. Have the feelings you expressed in this piece been present in your body for
 some time or are they recent? If they have been present for some time, then

write down how long, and indicate what circumstances you can recall that may have originally triggered these feelings.

8. Look at each image, shape, or symbol that you used in your artwork—how do you sense each one relates to the feeling your stress-producing emotions were creating within your body?

9. As you look at your artwork now, do you feel that it holds any special message or meaning for you around the emotions you have expressed? If so, what is it?

10. How does your body feel, now that you have expressed your stress-producing emotions in your artwork?

When you have completed the first two exercises in this session, the next section, on transformation, will introduce you to the third step in the healing-with-art process. Following an introduction, you will be given a third exercise in which you will reenvision the painful image you created in the first exercise and transform it into a positive, healing image. The next exercise will deal with helping you to transform your reactions to your painful emotion. It will do this by guiding you to reflect back on the emotions you expressed in the first exercise, and then examine the way you react when you experience these emotions. You will then learn how you can transform or change your emotional reactions, so that you are the one in charge of how your emotions affect you. Learning to take charge of your own emotional reactions will enable you to control and minimize the stress in your life and your body.

TRANSFORMING THE WAY YOU EXPERIENCE AND REACT TO YOUR STRESS-PRODUCING EMOTIONS

Transformation is the third step in healing with art. To transform means to change. In this case, when you are dealing with an emotion that you find unpleasant, uncomfortable, or painful, transformation means two things:

1. Changing the image association you have of this painful or uncomfortable emotion.

2. Changing the way you react to this painful emotion.

A painful emotion doesn't go away just because you tell it to. You can say to yourself over and over, "I'm going to let this anger go," but we all know that in spite of our most sincere efforts, it simply doesn't work. The reason it doesn't work

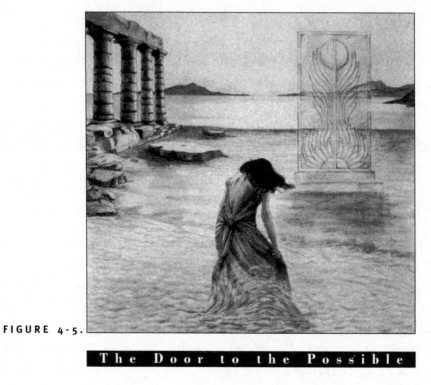

FIGURE 4-5.

The Door to the Possible

ISHMIRA KATHLEEN THOMA

"The ocean always seems to comfort me, to heal me, when I feel sad. Pain always seems cleaned away or at least soothed by water. I have used an image of a woman (myself) who appears tired, having struggled through pain for a long time, yet being near the end of my trial. This is an image of spiritual rebirth, or a threshold, a doorway, to a different self. People throughout times past have had this same pull toward transforming themselves through the spirit as I had. We leave our old selves behind when we rebirth ourselves. The waters of our emotions surround us, as did the waters of our physical birth. The ruins are a symbol of all the old failed dreams from the past, both mine and those of others.

As I painted this image, I learned that creating art can become a dialogue with the higher self. This was an act of capturing a moment in my life that was timeless, a pivot point in the life of my spirit. For the first time I saw that there was a door out of my pain, and that it was lying right in front of me. So why hadn't I seen it before? I was too tired from all my struggles, trying to ignore the truth."

is because—as brain research has proven—the body-mind does not respond to words, it responds to images. Words are, in essence, a foreign language to the body-mind. That's why, in spite of all our good intentions, verbal affirmations can really only work when we alter the image association our body-mind has of the change we want to invoke.

For instance, you might be affirming to yourself every day, "I'm getting thinner and healthier." But to activate this change deep inside, where change really takes place, you must begin to see or visualize an image of yourself as thin and healthy. Imagery, as I have explained in previous chapters, *is* the language of the body-mind. To change your internal emotional reaction, you must use the language your body-mind understands. Thus the third step in healing with art involves replacing the painful, uncomfortable image that you portrayed in your drawing, painting, collage, or sculpture with a new positive, healing image. To do this you can actually rework the original piece of artwork to transform its imagery or you can create a new piece. Most people like to let their visualized transformed image guide them as to which way is best.

As for changing our emotional reactions, most of us never realize that we can choose how we would like to experience or react to an emotion. Instead, we put all our energy into trying to change the people or the circumstances that contributed to the creation of that emotion in the first place. Sooner or later we all discover the impossibility of that task. We can rarely if ever change anyone or anything outside ourselves, but we can always change how we react to our own emotions.

Changing the way we react to a stressful emotion isn't as difficult as many people assume. When my clients protest that changing their emotional nature is simply beyond their control, I have to reassure them that they can. I take great pleasure in delivering the good news that emotional reactions are learned behaviors. Most people never realize this. We are so accustomed to hearing others say things like, "He can't help it if he has a violent temper, it's just his nature." Or "Poor dear, she has always been such a sad sack, crying her life away. She was just born that way." Nonsense! No one is born reacting a certain way. For instance, those who react to anger with disturbing verbal or physical outbursts have learned how to react in this way from someone else in their lives—usually a parent.

I once had a client who was afraid of her reactions when she became angry. When I asked her why, she said she reacted to her anger with what her family called

"Daddy rage." Growing up, she had witnessed her father explode in violent fits of rage whenever he was angry. And she said, "It always worked. When he would go into a state of rage, we would all do whatever he wanted, including my mother. We were terrified."

What my client recognized was that as a little girl she had learned that to get her own way all she had to do was to behave like Daddy. For her, too, it never failed to get the response she desired from others. What she also realized was that it was hurting the people she cared about most. The payoff was no longer worth the result. In addition, the guilt left her feeling anxious and tense, to the point, she believed, that she was now suffering from chronic high blood pressure, overeating, and sleep disturbances.

Seeing people continually repeat learned reactions in response to their emotions is what has led me to believe that most diseases—especially those directly linked to stress—are not genetically triggered but emotionally triggered by environmentally learned behavior patterns that induce physiological stress. This is why transformation involves altering both the image association we have for an emotion and the reaction pattern we tend to resort to, in most cases, on a subconscious basis.

REENVISIONING THE IMAGE

It is not enough to simply express and thereby release a painful or negative emotion from your body; you must also release its psychological hold on you. A technique I use with my clients I call reenvisioning. It means to look at the image you have expressed in a drawing or painting of a stress-producing emotion, and then imagine how that image would need to change so that it would feel better—less stressful and more positive. For example, if in a drawing you expressed your feelings of rage as a huge fireball, then you might reenvision it as a glowing star in the sky lighting your way. Keep in mind that your imagery not only expresses what you are feeling, it can also tell you what to do about these feelings. So that the message being conveyed by this new reenvisioned image may be trying to tell you how to use your feelings of rage as an opportunity to shed some light on a situation you may not have been seeing clearly. In this way your transformed image can serve as a guide to help you see new directions or choices. As always, however, the interpretation of your imagery is entirely up to you. Once a new image of the painful emotion is visualized, then that reenvisioned image would be

drawn, painted, etc., either directly over the old image or as a totally new piece or artwork.

Transformation doesn't mean denying the emotion or pretending that it doesn't exist. It means looking at it from a different perspective. Essentially, it is the old notion of seeing a glass half empty or seeing it half full. Transformation also does not mean resolving or solving a problem, it simply means being willing to let go of your old way of seeing things to embrace a new more empowering vision—a vision filled with possibility rather than impossibility.

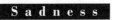

Sadness

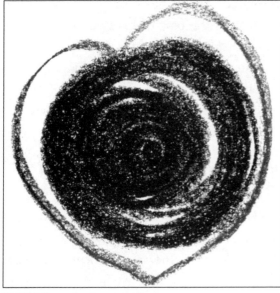

FIGURE 4-6.

This drawing, entitled *Sadness,* was produced by one of my clients, whom I will refer to as Dan. It is an excellent example of how someone can transform a negative image into a positive one by reenvisioning it. Dan lost his wife of twenty-three years in a car accident. For over a year and a half he was unable to shake his feeling of sadness, and it was beginning to have a detrimental effect on his work. His boss and coworkers could no longer excuse his inability to concentrate and complete his projects on time. Everyone around him felt that he should be over his grief by now. But he wasn't. He just couldn't seem to find a way to let go of this grief. So we began to work with his grief, which he described as "an unbearable sadness." In our first session, I asked him to go to the place in his body where he felt this sadness and get in touch with what this feeling looked like. As a result, he drew this drawing of an empty black hole deep in his heart.

To help him transform his feeling of sadness, I asked him to close his eyes once again and allow his awareness to go back into his heart and visualize that black, empty hole. I then asked him, "Although you can't change that your wife is gone and that you feel sad about this, how can you change your reaction to this sadness

so that you are not feeling so empty and immobilized?" After thinking about my question for a few moments, he said, "I guess I could think about the good times." Then suddenly, his whole demeanor brightened as he said, "Her love and our marriage was such a gift. I have two wonderful children—who I have been ignoring—and so many wonderful memories."

But just saying this and coming to this realization was not enough to anchor him in this more uplifting and positive mind-set. He also needed to change his image association of the sadness. So I asked him to imagine how he could change the image of that black, empty hole in his heart to reflect this awareness and his memory of the gifts the relationship represented. Again, he closed his eyes, moved his awareness back into his heart to connect with the part of his body in which he was feeling the sadness, and then he reenvisioned a new image. In this image, he imagined himself filling the empty hole in his heart with symbols that represent those gifts. Once he had the new image in his mind's eye, he opened his eyes and drew a second drawing in which he depicted a big pink heart filled with precious memories. He then entitled his drawing *A Heart Full of Happy Memories*.

HOW TO VISUALIZE REPLACING YOUR NEGATIVE IMAGE WITH A POSITIVE IMAGE

After completing this last drawing, I asked Dan to close his eyes one more time and imagine this new positive image of a heart full of happy memories replacing the old, painful image of a black, empty hole. This final step in the art and healing process

A Heart Full of Happy Memories

FIGURE 4-7.

of reenvisioning did not change that he *was* and *still is* sad about his loss. It merely allowed him to experience the feeling of sadness in a way that didn't cause stress to his physiological system. This final visualization exercise enabled him to release the grip his sadness had on his body, mind, and spirit by actually encoding this new, positive image in both his conscious mind, which the reenvisioning and drawing exercise did, and also in his subconscious mind and the cellular structure of his body. For permanent change to truly take place, it must occur on all three levels: the conscious, subconscious, and cellular.

In the weeks that followed this exercise, Dan said that he was finally able to put his wife's death behind him while still keeping the love he had for her in his heart. "Something finally clicked," he said. Once he started to focus on his heart being full of happy memories instead of the emptiness of his loss, life felt worthwhile once again.

THE IMPORTANCE OF REPETITION IN THE IMAGE-REPLACEMENT VISUALIZATION EXERCISE

You, too, will find that when you transform your painful images, the wound they created will begin to heal. What I do remind my clients, however, is that transforming their emotions by reenvisioning them is only the beginning. They will need to repeat the final visualization in which they replaced the painful image with their positive, healing image on a regular basis of at least once a day for a few weeks, so that they can activate healing on all three levels.

To easily accommodate this need for repetitive visualization, I advise my clients to make it a habit to take a few minutes each night before drifting off to sleep to visualize replacing their painful emotional image with their reenvisioned positive, healing image. If nighttime visualization doesn't work for you, then any time of the day will do. But be advised that you will be more successful in maintaining consistency if you choose the same time each day for your visualizations. If you wish to transform a recently experienced emotion, a solid week of daily visualization replacement will usually activate the desired change. If you are dealing with a painful emotion that has been with you for months or years, you may need to repeat this daily ritual for at least three to four weeks.

The best gauge for determining how long to keep up the replacement visualization exercise is to use your own inner sense of when your emotional wound feels

healed. You will know—it will just feel better. When in doubt, take a break from the visualization for a day or two and see if the emotion resurfaces. If it doesn't, then you can suspend your routine. If it comes back in a month or so, then begin the daily visualizations again. Or you can try reenvisioning and drawing another image, and then visualize replacing the painful image with the new one.

Exercise 3

TRANSFORMATION THROUGH REENVISIONING

This next exercise will take you through a guided visualization that will help you reenvision the painful emotion you drew in the last exercise into a positive, healing image. You can do this next exercise with any emotion you would like to transform.

GUIDED VISUALIZATION

Close your eyes, and allow the colors and images of the drawing you did in the last exercise to reappear within your mind's inner vision. (Pause) Focus on these images and colors, and as you do, imagine once again the light of your conscious awareness as a tiny bead of light, and allow it to drift to the place or places within your body where the emotion you were feeling and the images that evoked this first drawing were being experienced. (Pause)

As you become an observer to the imagistic expression of this emotion within your body, ask this part of yourself, the part that is in pain or discomfort because of this emotion, to present new images or colors that will transform the negative or painful image that you drew. (Pause)

As you sit quietly, you will begin to see or sense new colors and images replace the old colors and images of the affected area. (Pause) When you know what your reenvisioned imagery is, open your eyes and draw it.

If you are not getting any colors or images within your inner vision, then just open your eyes and allow the wisdom of your body-mind to guide your hand as you instinctively draw colors and images that feel more comforting and more empowering than the images and colors of your first drawing.

When you have completed this transformational drawing, put it up on the wall alongside the drawing of your painful, stress-producing emotion from Exercise 1. Spend a few minutes quietly looking at both drawings. Allow them to communicate to you on an intuitive, imagistic level. Trust your first impressions. When you are ready, begin the next exercise to process your images.

Exercise 4

SELF-DIALOGUING QUESTIONS

Ask yourself the following self-dialoguing questions, and write your responses in your healing journal:

1. As you look at both of your drawings—the painful image and the transformed image—what can you sense is the difference between these two drawings?
2. How do you feel about your second drawing as a representation of a transformed vision of your painful, stress-producing emotion?
3. How does this transformed image represent a new way of seeing the manner in which you *now* choose to experience this emotion?
4. Look at the colors, images, shapes, and forms you drew and try to see each one as a symbolic message or metaphor from your body-mind, then write a sentence or two about the metaphoric and symbolic significance of each one.
5. If this new drawing could speak, what would it say to you about the life lesson this emotion may have been trying to teach you?

Exercise 5

REPLACING THE PAINFUL IMAGE WITH YOUR NEW POSITIVE IMAGE

This second, reenvisioned drawing will now become the symbolic replacement of the painful, stress-producing image you originally experienced when you first encountered this emotion. To reinforce the transformation that has occurred, remember that it is important to take a few moments in meditation to imagine replacing the old image that evoked pain and discomfort with this new transformed, positive image. You can use the following visualization to guide you through this internal image-replacement exercise:

Close your eyes and move your awareness back into that place within your body where you were experiencing the stress-producing painful image of this emotion. Then imagine or sense the old image of this emotion, as expressed in your first drawing, fading away while this new, transformed image of your second drawing begins to appear in its place. Allow yourself a few minutes to focus on this new image—feel its power and presence within your body.

Take a deep, cleansing breath and imagine exhaling and releasing, into the universe, the old, painful image. Then relax.

Upon completing this exercise, you will begin to notice an immediate change in your body. You will sense a feeling of well-being and renewal. Savor the feeling as you allow your body-mind to accept and welcome the transformation as the healing begins on a conscious, subconscious, and cellular level.

Keep this last drawing in a place where you can see it frequently. Looking at it—even a quick glance as you pass by—will reinforce its imagistic message. If you can do this image-replacement visualization exercise every day for a few weeks, it won't be long before the old pattern of expressing and reacting to your emotion is completely broken. But like any habit or pattern, it does take time and persistence to break the old ways.

Exercise 6

TRANSFORMING YOUR REACTION TO A PAINFUL OR NEGATIVE EMOTION

It isn't always easy to recognize our own emotional reaction patterns, because they often become automatic responses during a stressful situation. But if you are serious about healing, it is essential to take the time to examine them. The next exercise can help you to identify your emotional reaction patterns, and then help you change those reactions that you feel may be causing you harm.

To begin this exercise, take out each piece of artwork representing an expression of a stressful emotion that you did for Exercise 1. Tape or pin them to a wall or lay them out side by side on the floor and take some time to reflect on each piece. Then

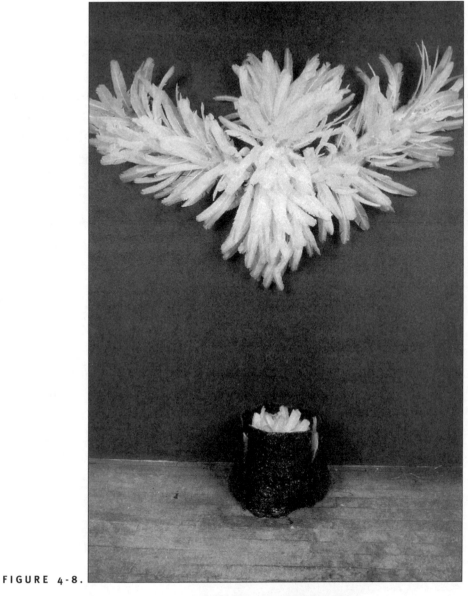

FIGURE 4-8.

Winged / Hope

PAM GOLDEN

"This piece is part of a series of nine sculptural pieces that deal with the rape and murder of my cousin, and my feelings of grief, anger, and sorrow, and the struggle to move beyond them. It is about healing and recovery."

in your healing journal, write down one word that best describes the emotion you expressed in each drawing. If you have four drawings, you should have a list of four words, one for each emotion, for example, anger, sadness, grief, rage. Once you have completed this list, open your sketch pad and tear out one blank sheet of drawing paper for each of the emotions you have listed. Using pastels or crayons, write one emotion on top of each blank sheet of paper. Beginning with one sheet of drawing paper and the emotion you wrote on top of it, do the following visualization and drawing exercise. Then repeat this same exercise for each of the remaining emotions.

GUIDED VISUALIZATION

Look at the emotion you wrote down on your piece of paper. Then close your eyes and allow your awareness to recall the last time you experienced this emotion. (Pause) Try to relive in your mind the exact situation or issue that provoked this emotion and the people involved. Now try to remember how you responded when you first felt this emotion. (Pause)

Allow yourself to become present to what this response felt like inside your body. (Pause) Let your attention be drawn to the place in your body where you can feel this response reaction expressing itself. For example, if you are recalling the last time you felt angry, and your response was to verbally lash out at someone, focus on the exact place in your body where you feel the physical expression of this lashing-out response. (Pause) You may be surprised to discover that it isn't always the same place where you originally experienced the feeling of the emotion itself.

As you reconnect with the physical sensation this reaction is creating within your body, imagine which images, colors, shapes, or forms would best express this reaction. (Pause)

When you are ready to express the imagistic representation of your reaction to this emotion, open your eyes and draw it.

After you repeat this exercise for each emotion you listed in your healing journal, tape all of these new drawings to a wall, side by side or one above the other,

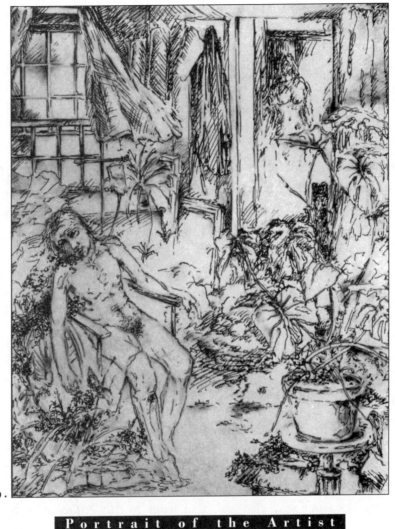

FIGURE 4-9.

Portrait of the Artist

JOSEPH G. PERRELLA

"My work with this particular idea, Portrait of the Artist, *began in 1985. I had been to visit a close friend and mentor, for what we both knew would be the last time. He was shortly to die of brain cancer.*

It is the work of art that I find indispensable. The process of image making enables me not only to preserve memories, but also to arrive at understandings and derive meaning from my life's experiences."

or lay them out on the floor and spend some time looking at them. Then when you are ready, do the following self-dialoguing exercise with each of your drawings.

SELF-DIALOGUING QUESTIONS

Begin with one drawing that represents your reaction to a stress-producing emotion. It doesn't matter which drawing you begin working with, if you have more than one. You can use your healing journal to write your responses to these self-dialoguing questions, or write them directly on the drawing if you prefer. If you write your responses in your journal, be sure to identify the emotion you are referring to in your responses.

1. Identify the place within your body where you were feeling this reaction to your stressful emotion.
2. As you look at this drawing, what does it tell you about your response to this emotion?
3. Do you sense from looking at this drawing that your response to this emotion is inward or outward?
4. As you look at this drawing, does it suggest that your reaction to this painful or negative emotion is in itself stress-producing? If so, in what way? For instance, how do the colors you used to express your reaction convey stress? In what way do the images convey a sense of stress?
5. Would you like to change the way you react to this emotion so that it is less stressful, more positive, and constructive? If so, how would you prefer to react to this emotion?
6. Do you feel that this new reaction will be less stressful? If so, in what way?

REPLACING THE OLD, PAINFUL IMAGE WITH YOUR TRANSFORMED IMAGE

When you have finished answering these questions, and if you stated that you

would prefer to react to your stress-producing emotion differently, then, using a new piece of drawing paper, do the following transformational image-replacement drawing exercise:

If you have decided that you would like to change your reaction to a stressful emotion, close your eyes and imagine a symbol that would represent your preferred emotional reaction. When you sense that you know what that symbol would be, open your eyes and draw that symbol.

GUIDED VISUALIZATION

When you have completed this new drawing, close your eyes and visualize the place within your body where you felt the emotional reaction that you were displeased with, and imagine replacing the image of this stress-producing reaction with your new image association that represents a more positive and constructive way of reacting to this emotion. (Pause)

Take a deep breath, and imagine sucking the image of your stressful reaction out of your body as you inhale, and then visualize blowing this image out into the universe as you exhale. (Pause) Do this several times, until you sense that the stressful image is completely released from your body.

This completes the transformational segment of this session on emotional healing. You can repeat these exercises whenever you find yourself experiencing painful emotions that need to be expressed, released, and transformed. If you do this healing process on a regular basis, you will be able to keep your body cleared of the harmful, stress-producing hormonal toxins and physiological reactions that can deplete your immune system.

FIGURE 5-1.

Deep Blue

S. A. JONES

"In 1994, I had both ovarian and breast cancer. I continued to paint between surgeries and chemotherapy. During this time, my paintings grew to be as large or larger than myself, and there was a new subject that reflected the challenge of these illnesses. The new subject was that of formation. In each painting, images arose from simple lines and shadings on the canvas surface to become entities as complex as living things. Making these paintings about formation provided me with visible evidence that I was remaking myself into something of substance again."

— ROCHELLE NEWMAN

"There are many levels of healing and many things to be healed. I am interested in making whole the split between left-brain and right-brain thinking and feeling, logic, and whim, as seen in the separation of art and mathematics, primarily geometry, which is the language of space.

"The nonrepresentational art that I do involves the use of geometry as both the subject matter and the structure of the work—the thinking rational aspect. Color, as the skin, evokes the feeling intuitive component. But I also have an emotional connection to the geometry and a rationale for the color."

(PLATE 1)

— B ARBARA G ANIM

"In this painting, my intention was to create a healing symbol that would help me cleanse my psyche of old and often toxic patterns of thoughts, beliefs, and attitudes."

(PLATE 2)

— M ARY F. H UGHES

"Layered and marbled patterns form a miniature cosmic landscape, a record of cosmic order from thought to matter. Metaphorically it mirrors psychological thoughts, feelings, and symbols that form the structure of human development."

(PLATE 3)

Be Still and Know That I Am God

— BEATRICE WAXLER

"My breast cancer diagnosis made me aware of the need for me to relive on paper the pleasantries I have enjoyed these sixty-plus years. A visit to my grandmother's farm was always a delight. I would attend church services with my grandmother, who would remind me, with a swift pinch, to be still when I wanted to wiggle around in my seat. In reliving the past through my artwork, I realized it was here that my faith was established. Cancer gave me an opportunity to use this faith through constant prayer and constant praise."

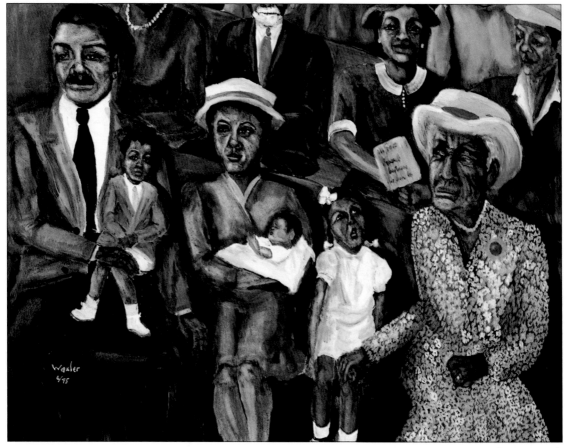

(PLATE 4)

— BARBARA GANIM

"After working though emotional wounds that kept me blocked and stuck in a rut dredged by my old ways of thinking, I felt light and free, ready to fly. I created this painting without thought or visualization. I simply wanted to express the elation I was feeling, and the energetic connection I could sense between my spirit and the spirit that moves through all things—that which I call God."

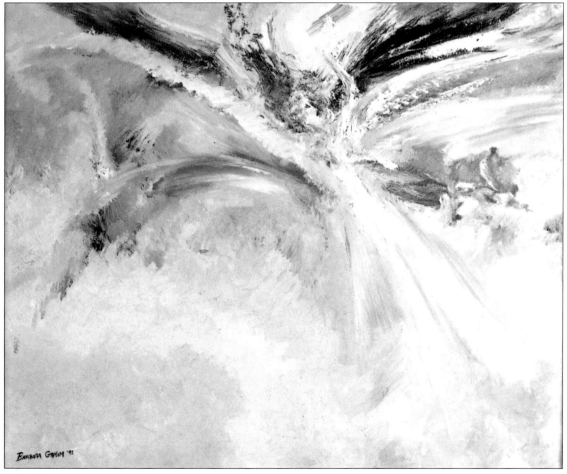

(PLATE 5)

Galactic Sea #2

— DIANA WONG

"To create is to synchronize my energy with the universe in order to put my whole being into a grand perspective—my attempt to see the whole and go beyond."

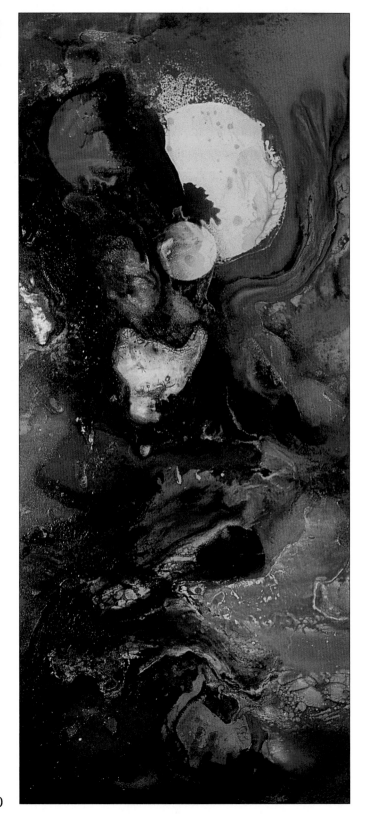

(PLATE 6)

— ANTOINETTE C. LEDZIAN

"This piece captures on paper my belief in God's unconditional love, which flows from his eye through light rays of the rainbow-colored umbilical cord, nurturing the warm yellow yolk surrounding the ovum (a symbol of rebirth), is beyond my human understanding. . . .

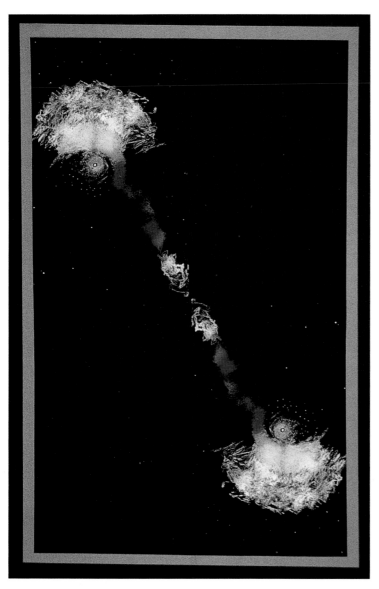

"A MIRACLE . . . the balance, the energy exchange, the yin/yang, the individual yet universal nature of the moment . . . God's phenomenal gifts of love, conception, and life spinning in the galaxy, emitting sparks of his being and hope for all mankind and peace on earth."

(PLATE 7)

— LOIS GRABOYS

"For many years, because of some chronic physical conditions, I have been severely limited in my ability to enjoy physical exercise and expression. But I have come to realize that the same supersensitivity, which manifests itself as pain and discomfort, also can be identified and transformed into creative energy. When I put color on paper or canvas, I feel the energy of the universe flowing through me and vibrating within every part of my being. I feel directly and intimately connected to the wholeness of the cosmos and so, during the act of creating, feel whole myself. The act of creating, no matter how simple, reminds me that I am more than this frail and finite body . . . that there is a greater energy within me that is part of the endless creative energy of the universe itself."

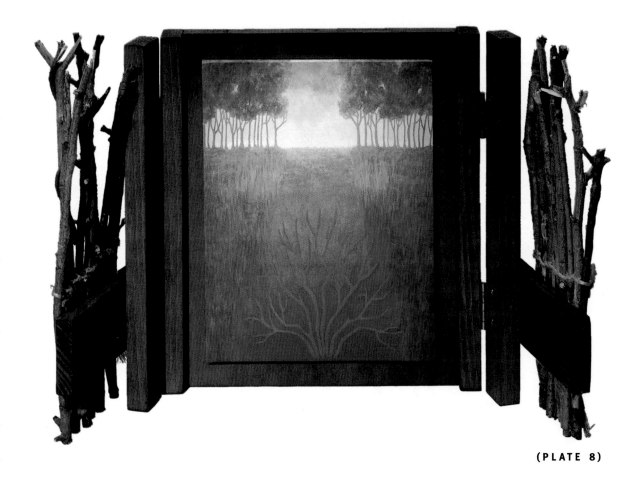

(PLATE 8)

— JUDY ASBURY

"My art expresses my feelings of connection to the cosmos. I believe art-making is a wonderful atavistic experience which envelops the artist in the universal connectedness that is the ground of all our being. I believe it is possible for the viewer of art to partake in this healing experience. Art-making for me is a flowing without interruption or obstruction, limitless and free. It is joyful and peaceful, and the experience is a realization of the interconnectedness in life between self and space."

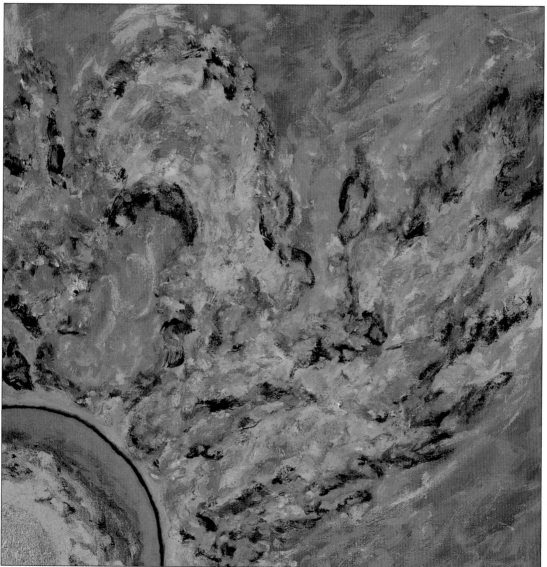

(PLATE 9)

—ANN JONES

"Painting connects me with my spirit and the deep loving space within my heart. When I create from my heart, I feel connected to the source of all creation. In this way, painting provides me with spiritual practice and images that tell the stories of my journey. These images celebrate the beauty present in nature and in my imagination. Creating art heals by giving me a vehicle for expressing my inner life and sharing it with others."

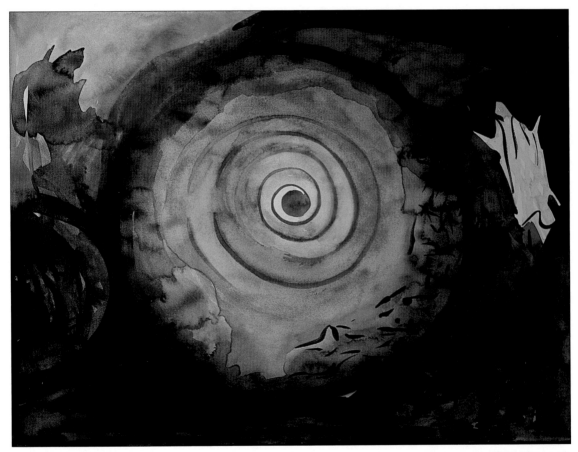

(PLATE 10)

—KIM CRAGIN

"This drawing represents the truth my soul wants me to know about the death of a close friend. The image is a circle with no beginning and no end. I feel that it represents my soul's connectedness to (him) and all life. His death has given me a deep feeling of inner strength, because I know (he) is on the other side protecting and guiding me. The pink circles represent each individual soul occupying its own unique space, form or body, telling me that we may all be different, but we are part of the same energy force—small circles inside a big circle, atoms that make up the molecule. This image has shown me that my soul can feel (my friend's) presence more since his death because now there are no physical barriers to separate us."

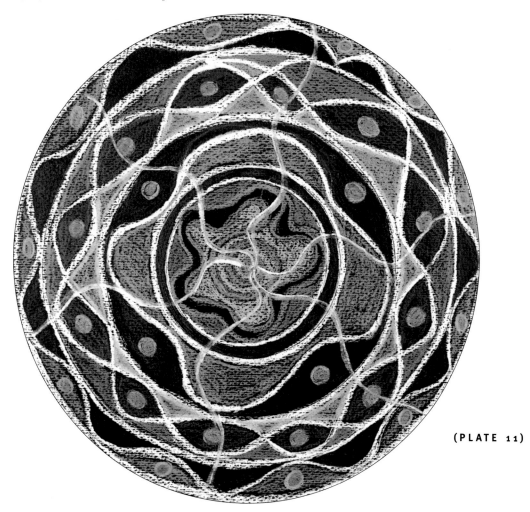

(PLATE 11)

Ribbons of Light

—LINDA LIGHT

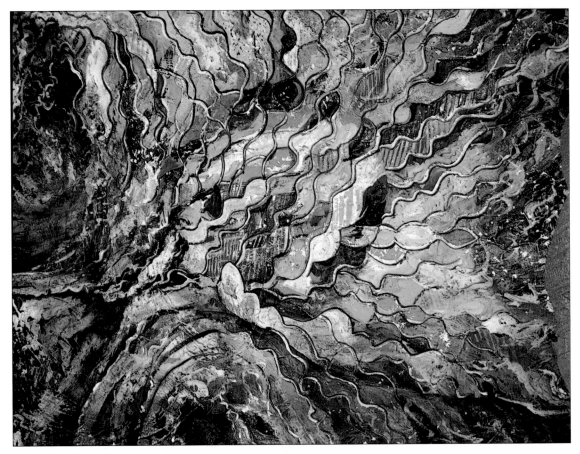

(PLATE 12)

— KATHLEEN HARUM

"When my sister Ellen's daughter, Alison, became ill, my entire family prayed for a miracle.

"I have been blessed with a pure gift of inspiration a few times in my life. This inspiration is characterized by a peaceful urgency to carry my thoughts through to a completed piece of art. When I am obedient to this calling, I always receive a gift of joy far greater than my time and efforts deserve. Alison's portrait began as a personal artistic venture mainly to be close in spirit to Alison, which resulted in a gift to Alison's parents."

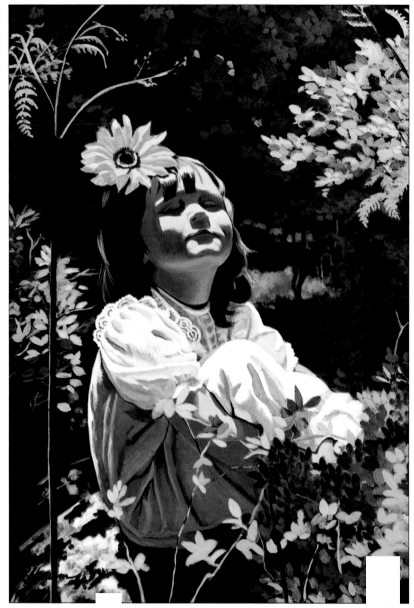

(PLATE 13)

Angel of Faith and Hope

—JO ANN DURHAM

"I feel this work was divinely inspired and is a message to all parents grieving over the loss of a child. Death is not the end. It is the doorway to heaven where we will be reunited."

(PLATE 14)

Winter*

— BARBARA E. CUNHA, RN

"*The element of Water is associated with the season of winter, whose essence is to rest. In winter, all of nature lies dormant. The still energy of water allows us to be receptive, to gather our resources for the next cycle, and to rejuvenate for the new growth to come. It is a time of being, a time of not doing. Out of this series of eight windows, many people choose this as their favorite. I think that is because on an unconscious level they recognize a need for this deep rest.*"

from a series of eight four-foot-by-eight-foot stained glass windows titled "Seasons of Salvation," St. John Neumann's Catholic Church

(PLATE 15)

— BARBARA E. CUNHA, RN

"The element of Wood is expressed perfectly by the season of spring, whose essence is to 'burst forth.' In spring, all nature comes to life. The upward moving energy of wood gets us into action. The capacity for clarity, organization, and focus are granted through wood. It is a time for new vision, new beginnings, and hope. In the same way that plants burst forth from seeds, actions burst forth from ideas. The subconscious draw of this window to the viewer may be the confident expectation that springtime brings. The crossing lines in this piece stimulate endorphin release, resulting in a sense of increased well-being."

**from a series of eight four-foot-by-eight-foot stained glass windows titled "Seasons of Salvation," St. John Neumann's Catholic Church*

(PLATE 16)

Healing the Body

LET YOUR BODY BE YOUR GUIDE

Every thought, feeling, emotion, and experience that you have ever had in your life is indelibly etched in your body as well as your mind. But the body never lies. While your mind may justify, reinvent, or deny the truth, your body can do nothing less than express it. Although your mind may say *all is well* when responsibility weighs too heavily upon you, your shoulders will betray that lie as they sag beneath the unbearable weight. When an opportunity comes your way, your mind may parade before you an arsenal of reasons why you shouldn't pursue it at the same time that your body feels surprisingly buoyant, joyous, and ready to forge ahead. When you are faced with a dilemma about which path to follow in your life, or when you are presented with choices that confuse you, you need only ask your body for guidance. Through its internal signals of feelings and emotions, your body will always reveal the truth of what is right for you. If you let your body be your guide, you will not only know how to resolve your indecisions, you will also know how to heal when illness comes to call.

The body has an inner wisdom that knows when something is wrong, and it also knows exactly what it needs to heal itself. When we learn to trust the messages we receive from the body, we can often turn the tide of an illness or disease before all hope is washed away.

The Beast Inside Me

CARROL CUTLER

Carrol Cutler was a member of one of my cancer support groups. When she first joined the group, she told us how she discovered that her cancer had, as she put it, "traveled" to another part of her body. "I told my oncologist," she said, "that I felt like I had a beast living inside me that was not in harmony with my body." Fortunately, Carrol's doctor took her body's message seriously. The next day she was brought into the hospital for tests, and a metastasis was found in her right lung.

FIGURE 5-2.

Session Four

USING YOUR BODY'S WISDOM TO HEAL AN ILLNESS

In this chapter, Session Four will be divided into three segments that will show you how to use your body's inner wisdom and guidance to activate your healing response if you are struggling with an illness or a physical condition.

In the first segment, you will find out how your body may be using a physical dysfunction, which can range from the common cold to a life-threatening illness, to express an emotional need you may have been repressing. The greater the need, the stronger the message must often be in order to get your attention. Once you have learned how to express your emotional needs and integrate them into your life, your body will no longer have to resort to creating a physical disturbance.

With this accomplished, the second segment will show you how to begin working directly within the area of your body that is in need of physical healing. Using visualization and body-centered awareness, you will first create an image

that represents what you imagine your body's dysfunction looks like. This drawing will not only reveal information about the nature of your illness or dysfunction, but it will also convey any negative attitudes about your condition that you may be harboring. In the next exercise, you will ask your body to show you, through its imagery, what this dysfunction needs to heal. As you create a drawing, painting, sculpture, or collage that expresses your body's image of this healing process, your imagery will begin to activate biochemical and metabolic changes on a cellular level.

In segment three, you will learn how to use visualization and expressive art to prompt your body to work harmoniously with any traditional form of medical treatment you may be receiving so that you can boost its effectiveness. You also will address the importance of exploring and transforming any negative feelings you may have about your treatment, so that you can reduce your stress and enhance the positive effects your treatment is meant to provide.

Segment One: Illness as an Emotional Metaphor

There was a time when psychotherapists and medical practitioners would have dismissed the phrase "what the mind represses, the body expresses" as having no more significance than an old wives' tale. What numerous studies in mind-body medicine have revealed is that the type of illness or disease a person develops is often a metaphorical reflection of what is going on emotionally in that person's life. (See *Women's Bodies, Women's Wisdom* by Christiane Northrup.) For instance, heart disease is frequently thought of as a metaphor for an individual's fear of opening his or her heart to love. Blocked arteries are often seen as a metaphor for the inability to allow the joy of life to flow freely through one's life.

When researchers looked at groups of people who had been diagnosed with similar illnesses and diseases, they found that the majority of these people also shared similar patterns of emotional expression or repression, along with similar attitudes and beliefs.

Consider, for example, a series of in-depth psychological/emotional profile studies of cancer patients, both men and women of all ages, conducted by various researchers over a period of more than sixty years, beginning in 1926 (see

Getting Well Again by O. Carl Simonton). These studies revealed overwhelming evidence that cancer patients, regardless of the kind of cancer they had developed, shared similar psychological and emotional characteristics. The most significant commonality among the participants in these studies was that nearly every one had suffered a deep emotional loss twelve to sixteen months prior to their diagnosis. The reasons varied from loss of a loved one to loss of a job, but the interesting unifying factor was that the loss in some way affected each person's sense of self-worth. In other words, they didn't just feel like they had lost someone they loved or an important job, they felt like they had lost a part of themselves. If we look at cancer as a metaphor for the emotions someone is unable to express, a disease that destroys healthy cells is indeed an apt metaphor for the loss of a part of one's self.

A Room with a Vase

S U S A N F O X

"I had been plagued by painful menstrual cycles, weight gain, and yeast infections for years. I sensed that something was going on emotionally that I was not in touch with. When I did this drawing of a vase with legs walking toward a new location of its own choosing, I knew it was a metaphor revealing my intense desire to make my own choices and follow my dreams without ridicule or condemnation. I had lost touch with this need until now."

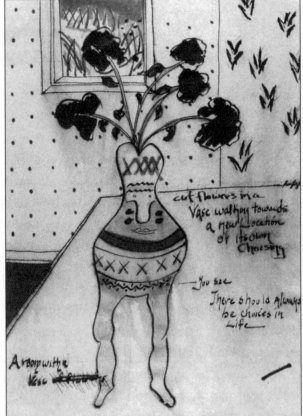

FIGURE 5-3.

In my own work with women who have breast cancer, I have observed that the majority of these women do not fall into the standard physical risk factor categories outlined for breast cancer or any other kind of cancer for that matter, such as being over fifty years of age, postmenopausal, with a history of high-fat diets, and excessive coffee intake, drinking, or smoking. In addition, very few of the women in my groups have had a family history of breast cancer. But what I *have* found is that all of these women do have the one emotional risk factor most often associated with breast cancer, and that is the inability to nurture themselves.

The breasts are a metaphor for nurturing, and when our own breasts develop cysts and tumors, our body is trying to tell us that we are repressing our need to nurture ourselves and also to allow ourselves to be nurtured by others. Reversing this repressed need for nurturing isn't always easy, because most women learn, as part of their cultural belief system, that it is a woman's duty to nurture others. Over the last ten years, I have seen numerous women come and go through my breast cancer support groups, and I can't recall even one who didn't suffer from Caretaker's Syndrome—an overpowering need to take care of others, usually at the expense of one's self. In addition, these women readily admit to feeling a lot of anger that they have been unable to express, because their own needs often go unnoticed by their family members and even themselves. This is a perfect example of a cultural belief that influences our behaviors and attitudes, yet is in direct conflict with the body-mind's wants and needs.

Many women fear that the solution to this dilemma is to ignore their families and become self-centered, but this extreme is not at all what is required to readjust this body-mind imbalance. What I teach the women in my groups is to first get in touch with what they need, and then acknowledge it to themselves and their families. By working together with her family, a woman can set boundaries and limitations on what she will and can do, and most importantly, she can set up a new pattern of being honest with her family about what she needs to feel peaceful and happy. This usually requires persistence and effort on her part to get her family to follow through on agreed-to compromises, but the effort is well worth it, and it can mean the difference between life and death.

Examples of the kind of compromises some of the women in my groups have asked their families to make include: having their husband and older children take turns preparing meals a few nights a week; giving Mom an entire evening to her-

self; or when there are small children in the home, the husband or a relative takes the kids one or two nights a week or all day on Saturdays to give Mom a break. Women without children who have a spouse or a live-in partner also have needs that must be addressed in the relationship and compromises that can be made to get those needs met. One woman in my cancer group asked her partner for a pamper night. That consisted of her partner either taking her out or cooking, followed by a movie or some other activity like a massage or reading together that felt nurturing or enjoyable.

UNDERSTANDING WHAT YOUR BODY IS TRYING TO TELL YOU

When you find yourself experiencing the symptoms of physical illness it rarely comes out of the blue. All illness is preceded by a period of time—usually months or even years—in which we have been given signals. Stress includes having feelings of anxiety, being quick-tempered and unable to concentrate, or feeling a sense of depression or being stuck in a situation that you believe you have no control over. When any or all of these feelings come over you, these emotional alarms are going off to alert you that something is going on that must be heeded. When we ignore our inner stressors, we completely miss what our body-mind is trying to tell us. As Christiane Northrup, M.D., says in her book *Women's Bodies, Women's Wisdom,* "Military metaphors run rampant through the language of Western medical care. The disease or tumor is 'the enemy' to be eliminated at all costs. It is rarely, if ever, seen as a messenger trying to get our attention."

Exercise 1

DISCOVERING THE METAPHOR BEHIND YOUR PHYSICAL SYMPTOMS

If you are presently suffering from an illness or disease, to heal physically, you must allow your body to express what your mind has repressed. This first exercise will help you do that by enabling you to discover the metaphorical meaning behind your physical symptoms. Using your body as your guide, you will ask it to present you with an image that represents what your body has been trying to tell you though your physical condition.

MATERIALS

You may want to place a variety of different art materials in front of you before you begin the guided visualization. When you are ready to create your metaphorical image, you can then select whatever medium feels most appropriate to the expression of this image. It may be interesting to see which medium you do find yourself drawn to use, as it may serve as a metaphorical message in itself.

GUIDED VISUALIZATION

When you are ready, get into a comfortable position and begin by thinking about the specific illness or physical condition you would like to heal.

Now close your eyes and take three deep breaths. Then begin to breathe normally, allowing your body to relax with each breath. (Pause) Become aware, as you breathe, of your physical body and the place within your body that is experiencing the symptoms of an illness, a disease, or a condition that is in need of healing. (Pause)

Allow your conscious awareness to be drawn into that place within your body. Focus your inner vision on this part of your body, connect with it, become present to it. (Pause)

Knowing that your body has infinite wisdom and the ability to communicate to you through your inner language of imagery, ask this part of your body that is experiencing illness or dysfunction to present you with an image that represents the metaphorical message your body has been expressing through your physical illness or condition. (Pause)

When you know what you need to draw or paint to imagistically express this metaphor, open your eyes and begin.

Having finished the artwork for this exercise, as always, take some time to be with it, reflect on it, and allow its imagery to touch you. When you feel ready to process the imagery, move on to the self-dialoguing questions in the next exercise.

Exercise 2

PROCESSING YOUR ARTWORK

The following self-dialoguing questions will help you understand the imagistic message behind the physical symptoms of the illness or condition you focused on in the previous exercise. Write your responses to these questions in your healing journal.

1. As you look at the image that you created in this drawing or painting, how does it make you feel?
2. If this image could speak, what would it say to you?
3. What emotions and feelings does this image seem to express to you?
4. What is the metaphorical message of this image?
5. What is the relationship between this metaphorical message and your physical illness or condition? For example, angina could metaphorically represent one's fear of expressing love; cancer could represent suppressed resentment; diabetes could indicate the fear of revealing one's own inner sweetness. Try to see the relationship between the metaphor you sense in this image and the physical condition your body is experiencing, and that your body's condition is a means of expressing this metaphor to represent needs and feelings that are going unrecognized.
6. Based on what you sense about the metaphorical meaning of this image, what is your body trying to tell you through your illness or physical condition?

This drawing, entitled *What Gall!*, is a piece I did several years ago to discover the metaphor behind the gall bladder attacks I had been suffering from for nearly a year. I had no idea what was going on emotionally for me when I did this drawing. As I connected with the symptoms of my physical condition in a visualization—the constant pain beneath my right rib—the imagery shocked me. As I began to draw, I knew immediately that it was anger. As I answered my own self-dialoguing questions, I began to understand that this gall bladder condition was a metaphor for the anger I had felt unable to express around a particular situation in my life. Feeling powerless to broach the issue with the person involved, I stuffed it down for over two years before the symptoms of this condition began to surface.

While I was doing this drawing, the words "What gall she had!" kept flashing in my mind. How perfect the body is in its expression of an emotional metaphor

What Gall!

B A R B A R A G A N I M

FIGURE 5-4.

through a physical condition! After all, what is the function of the gall bladder? It stores the bile, also called "gall," which is produced by the liver to aid in digestion. Bile is also the one body fluid that has come to be associated with bitterness of temper. Was I bitter? Absolutely. What couldn't I allow myself to digest? My anger. I had repressed it so much that my body had to express it in a way that would finally get my attention as well as convey a metaphorical message that could help me understand and release the underlying cause.

Exercise 3

CREATING A SYMBOL THAT REPRESENTS HOW TO EXPRESS YOUR NEEDS

Recognizing that you have been repressing a need is only half the battle. Changing how you have been reacting to your needs is the only way to ensure that a need will be expressed in a healthy and positive way. This exercise will direct you to again call upon the inherent wisdom of your body to present you with a symbol that represents what you need to do to begin making the changes that will allow you to express the needs and emotions you had been ignoring.

Occasionally, clients or workshop participants will question why they must go to the trouble of asking their body for a symbol representing change, when they know

in their mind what they should do to get their needs met. The answer often surprises them: your mind will tell you what you *think* you want, but only your body can tell you want you *really* need. Remember, the body doesn't lie. For example, in your mind you may think you want to end a relationship, when what you may really need is to learn how to communicate honestly and openly with your partner.

Trust the wisdom in the symbol you receive in this exercise to tell you what is best for you. At first, its message may surprise you, but as you come to understand its meaning, you will see just how perfect your body's guidance can be. Your spirit or soul communicates through your body, unhampered by your mind's interpretation. When you trust your body's messages, you are really trusting your soul to guide you.

MATERIALS

I suggest you use a piece of large drawing paper or your healing journal and pastels, crayons, or markers to do the art part of this exercise rather than using paint, clay, or collage materials. This exercise works best if it is just a quick drawing or sketch of the symbol you see or sense when you do the guided visualization.

GUIDED VISUALIZATION

Close your eyes and take several deep, slow breaths. (Pause) *Concentrate your attention on the rise and fall of your chest as you breathe in and breathe out. Continue breathing until you begin to feel calm and relaxed.* (Pause)

Once again, allow your awareness to move into that place within your body where you focused your attention in the first exercise in this session—the place where you are experiencing symptoms of an illness or physical condition. (Pause)

Allow your awareness to become present to this area again, and when you sense or feel that your full attention is focused here, ask your body in all its infinite wisdom to present you with a symbol—that you can either see or sense—that represents what your body wants you to do to express, in a positive and healthy way, the needs and emotions you have been previously suppressing. (Pause)

Take as long as you need to allow the symbol to come into your aware-ness. (Pause) You may actually visualize the symbol or you may only be given an idea of what it is. Or you may sense that you have to begin draw-ing in order to allow the symbol to emerge. Whatever way feels right for you, when you are ready to proceed, open your eyes and draw the sym-bol that represents what you need to do to express the needs, feelings, and emotions that have caused your body to act out.

Exercise 4

SELF-DIALOGUING QUESTIONS TO UNDERSTAND THE MEANING OF YOUR SYMBOL

The following self-dialoguing questions will help you understand what your sym-bol means. Write the answers to these questions in your healing journal.

1. Look at the image of the symbol that you drew. What is your intuitive sense of how it relates to the needs, emotions, or feelings you have been repressing?
2. What changes does this symbol suggest you need to make that will enable you to openly, truthfully, and positively express what you have been suppressing in your life?
3. What actions or steps can you begin to take, starting today, to make these changes?
4. What can this symbol teach you about expressing your needs?
5. What have you learned about your illness or physical condition from the exer-cises in this session so far?

Next you will learn how to use your inner imagery to work directly within the area of your body's dysfunction to activate physical healing and to encourage your body and mind to work cooperatively with any medical treatment you may be receiving.

Segment Two: Working Within the Body

Just as my cancer support group member, Carrol, sensed a beast growing inside her body before diagnostic tests revealed metastatic cancer, your body, too, will know when something is amiss long before your mind will.

Two years ago, my father was suffering from acute kidney disease. While on dialysis, he began experiencing stomach and chest pain, and his breathing became severely labored. Several days before he went into the hospital, I asked him how he was feeling. "Not good," he responded. I then asked if he could be more specific about his symptoms. Was there pain? If so, where did he feel it? His answer was a frustrated, "I just don't feel good. That's all I can tell you."

These kinds of responses are not uncommon when people are trying to explain to family members or their physicians what they are feeling. Since my father had always been a believer in the work I was doing, I asked him if he would be willing to do some visualization and artwork with me to see if we could get a better idea about what was going on inside his body. I explained that the more he knew about his condition and the symptoms he was experiencing, the more his doctor would have to work with when he went into the hospital for tests. He agreed.

This next drawing is the image he visualized of his body's illness. Unlike Carrol's, his image wasn't a symbolic beast; it was a literal depiction of what he sensed was going on inside his stomach, lungs, kidneys, and heart.

When I asked my father what his drawing was trying to tell him about his body, he said, "The two circles at the top are my lungs, and they are filled with fluid. They feel soggy—waterlogged. It's hard to breathe. The little red oval in the center of the drawing, with the three red lines running through it, is my heart, it feels like it's

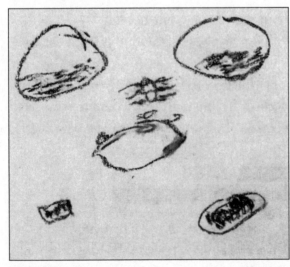

My Body's Illness

LAWRENCE GANIM

FIGURE 5-5.

being stretched, pulled tight. The big, pointed oval beneath my heart is my stomach." Inside the oval that represented his stomach, he had drawn three red slashes, so I asked him what he felt those were. "Those are sores inside my stomach, and I don't know why, but I feel like they are bleeding. I feel so weak, like I'm bleeding inside." I then asked him what were the other two red ovals with the red squiggle lines inside at the bottom of the drawing. He laughed and said, "Those are my kidneys, they don't work at all. They are just all raw inside." This man, my dad, who minutes before could tell me absolutely nothing about his body or what he was feeling, had now not only drawn an extremely representational view of his internal organs, but he was also describing in detail what was going on inside those organs.

Three days later, Dad was admitted to the hospital for tests, which revealed exactly what his drawing had depicted. He was suffering from congestive heart failure, which explained the fluid buildup in his lungs and his breathing difficulties. His kidney damage, of course, we knew about. And his heart was enlarged. But the most surprising discovery, which even his doctor found amazing, was that his X ray clearly showed three bleeding ulcers in his stomach in the exact locations Dad had indicated in his drawing.

When I conduct my two-week training programs in healing with expressive art for health care professionals, I always encourage the participants to have their patients draw their illness, disease, dysfunction, or injury rather than asking them to explain how they are feeling. Whether it's cancer, heart disease, the flu, or a broken arm, these drawings will tell them more about their patient's condition than their words ever could.

Exercise 5

EXPRESSING AN IMAGE OF YOUR BODY'S DYSFUNCTION

In this exercise, your conscious awareness will become a witness to your body's dysfunction, enabling you to sense or visualize what the inner arena of that dysfunction looks like. Remember, when you connect with the area of your body in which you are experiencing physical pain or discomfort, or simply allow yourself to connect with the area in which you know disease, illness, or damage has occurred, you may actually see an image or you may have only an idea of an

image. Whichever it is, allow yourself to trust the image and draw it as you sense or imagine it to be.

If after allowing your awareness to be present to your dysfunction for several minutes you still have no sense of an image, open your eyes and pick up the first color in your box of crayons or pastels that you find yourself drawn to. Then begin to draw. Let your intuition guide you as you just make marks—lines, forms, and shapes on the paper—without thinking about them. To your surprise, when you do the follow-up self-dialoguing exercise, whatever you have drawn will tell you all you need to know about your dysfunction. When you learn to totally trust this process and keep your left-brain thoughts and interpretations out of it, it will never let you down.

MATERIALS

Because your imagery needs to be as clear and straightforward as possible in this exercise, I again suggest limiting your materials to drawing paper and pastels or crayons. Place your materials out in front of you on a table or the floor, get into a comfortable sitting position, and begin the following visualization.

GUIDED VISUALIZATION

Close your eyes and take three slow deep breaths. (Pause) *Then allow yourself to feel the rise and fall of your chest as you continue to breathe in and out at a steady, slow, and regular pace until you feel your body begin to relax.* (Pause)

As you continue to breathe slowly and steadily, imagine your conscious awareness to be a tiny bead of light nestled deep within your cranial cavity, and imagine that you can move that awareness anywhere within your body that you direct it to go. (Pause)

Focus your attention on the place within your body that is in need of physical healing, and allow that tiny bead of light to move into that place. (Pause) *Imagine that this light of your conscious awareness is now illuminating this area, enabling you to observe your body's physical dysfunction with your inner eyes.* (Pause)

As you become present to this area of dysfunction, what image, colors, shapes, or forms best express what you see or sense this dysfunction to look like? (Pause) When you know, open your eyes and draw the image of your dysfunction.

When you have finished this drawing, as you have done in previous exercises, tape it or pin it to a wall, sit back at a bit of a distance, and observe it for several minutes. Don't think about it, just look at it. Feel yourself responding to it, as if it were having a conversation with you. Then when you are ready, move on to the next self-dialoguing exercise.

E x e r c i s e 6

SELF-DIALOGUING QUESTIONS

Write your answers to the following self-dialoguing questions in your healing journal or on the drawing you completed in the previous exercise. As you answer these questions, try to remain in a feeling mode rather than a thinking mode. If you catch yourself responding to these questions with *I think this means,* or *I think I feel* statements, you will know that you are using your left brain's consciousness to interpret your drawing rather than using your feelings to sense what your drawing is saying to you.

1. What is your drawing trying to tell you about your body's illness, dysfunction, condition, or injury?
2. How did it feel to draw this image?
3. How do you feel now, as you look at this image?
4. As you look at this image of your dysfunction, how is it expressing what is actually going on inside your body?
5. Does your imagery remind you of any past feelings, emotions, or experiences? In other words, does this drawing trigger any memories? Write down whatever comes forward for you, no matter how unrelated it may seem.
6. Look at each shape or form and each of the colors you used in your drawing. How do you sense or feel each one relates to your physical dysfunction, illness, or injury?
7. As you look at this drawing, do you feel that it holds any particular message

or meaning for you regarding this ailment or condition you wish to heal? If so, what is that message?

8. As you look at the drawing representing your body's illness or dysfunction, does the image strike you as being either weak or strong? Explain how or why it appears to you to be either weak or strong.

HOW IMAGERY CAN REVEAL YOUR SUBCONSCIOUS ATTITUDES TOWARD YOUR ILLNESS

As you may have discovered from these first two exercises, the image you drew of your illness or ailment can tell you and your doctor a great deal about the physical characteristics of your condition as well as your subconscious attitudes about it. Carl Simonton, M.D., who pioneered one of the earliest treatment programs to use imagery and drawing with cancer patients, points out in his book *Getting Well Again* that he uses specific criteria to determine whether the imagery an individual draws will help or hinder their recovery. He cites the following examples to illustrate what he means. "Representing cancer cells as ants, for instance," he states, ". . . is generally a negative symbol. Have you ever been able to get rid of the ants at a picnic? Crabs, the traditional symbol for cancer, and other crustaceans are also negative symbols. These beasts are tenacious, they hang on. They also have hard shells, making them relatively impregnable, and most people are afraid of them— the crab symbolizes the potency and fear of the disease."

Although you may imagistically represent your condition as more powerful than your own ability to heal it, that does not mean you are doomed to submit to its power. You need only imagine that your cancer is a house of cards that can be easily toppled, or you may visualize the plaque in your clogged arteries as layers of butter that will melt away when you imagine flooding your veins and arteries with a warm, glowing light. If you find you have difficulty changing or altering an over-powering image of your disease or illness, then another alternative is to imagine an even more powerful image as your healing symbol.

One of my clients saw an image of her breast cancer as a dragon spitting fire in all directions. This was a dangerously powerful image. When she tried to transform it into something less threatening, she couldn't do it. So she worked instead to envision a healing symbol that could overcome the dragon. Initially she imagined a

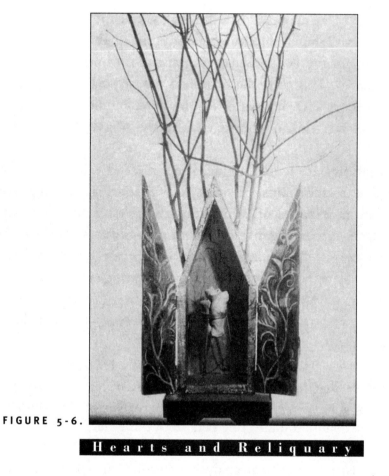

FIGURE 5-6.

H e a r t s a n d R e l i q u a r y

ANA FLORES

"A few years ago I was going through a period of great stress, my only sense of calm and well-being during this period was my walk in the woods behind our home. I had always been very regular about this walk, but its necessity in my life took on a new spiritual meaning. As I walked, my mind would clear, and the landscape absorbed me. In late February, I noticed that the high-bush blueberry bushes, which thrive in our peaty soil, put out new growth. Their limbs were blood red with fine branching like veins. That detail became transformed so that all the trees were blood vessels circulating out from the heart of the earth, and during my walk the heart of my being became one with the great heart of nature. That image became a part of me and has changed me as a person and an artist. The piece Hearts and Reliquary *is a visualization of those feelings."*

large, heavy black net being dropped over the dragon to capture him and carry him off. But each time she did the visualization, she said she knew he could just spit fire and burn his way out of the net. I suggested that she try once more to reenvision another healing symbol. This time she imagined the net being dropped by a fire brigade with large hoses spraying water on the dragon's fiery breath so that he couldn't burn the netting. This, of course, enabled the brigade to successfully take the dragon away.

While these examples are worth noting, keep in mind that your imagery will rarely be as literal as dragons, ants, or crabs. Most images are nothing more than unrecognizable lines and shapes of color. You are the only one who can decide whether your imagery carries negative or fearful connotations. And you can only know this by doing the self-dialoguing questions that help you see beneath the surface appearance of your images. After doing the dialoguing exercise, if you do perceive some fear or negativity emerging from your imagery, remember you always have the power either to transform it through reenvisioning or to visualize a more powerful healing symbol.

I want to reemphasize that if you are working with a therapist as you do these exercises or if you are sharing your work with others, never let someone else tell you what your imagery means. Only you can know for sure what it means. While someone else may give you an interesting perspective and may even spark a recognition or an awareness within you that your imagery may be suggesting a particular meaning or message, in the final analysis, rely only on what you sense your imagery means.

Seeing Beneath the Surface Appearance of Your Imagery

In general, your imagery *will* reveal whether or not you believe that your disease or physical dysfunction is more powerful than your body's ability to heal it. And I do believe that this is important information for you to know, but I also believe that the imagery we visualize represents many levels of our conscious and subconscious attitudes and feelings.

A visualized ant may, in fact, be nothing more than a visualized ant. As Freud pointed out when warning therapists about the dangers of using imagery in analysis, "Sometimes a cigar is just a cigar." So the person in the example who visualized

the ants may indeed be dealing only with an imagistic correlation between a tenacious picnic bug and cancer. If that be the case, then that is certainly simple enough to deal with. The solution involves merely reenvisioning or transforming the overpowering image of the ant into a new, weaker image, say a mound of ice cream that can be easily melted and flushed away. But imagery goes far deeper than a first-glance appraisal might reveal, which is why the self-dialoguing questions are so important when using art to heal.

Suppose an individual we'll call John has associated his cancer cells with an ant colony. Upon further exploration through self-dialoguing, John discovers that the ant imagery represents a subconscious association between ants and ambitious persistence. Ants are, in his mind, tireless creatures who accomplish great feats. As John continues probing into the deeper meaning of his imagery, particularly the question that asks, "Does your imagery remind you of any past feelings, emotions, or experiences?" he discovers that the ants do bring something to mind: they remind him of his nagging guilt and shame, which he has tried for years to ignore, about not being as ambitious and industrious as he was raised to be. This guilt, he now recognizes, has brought him incredible stress throughout his adult life each time he turned down opportunities for promotions, shirked (in his view) responsibilities, and pursued pleasure rather than achievement. His guilt is literally eating him up inside. This unexpressed painful emotion fostered an environment within his body in which cancer could breed. The real work he must do now is to reconcile and express his guilt about his lack of ambition and make peace with it by accepting it. If he can revise his belief that ambition is an admirable quality that he must possess, he will then begin to heal emotionally and reverse the stressful environment within his body.

In this fictitious example, our character, John, demonstrated how his ant imagery was extremely valuable, because it revealed something far more important than whether this image was overpowering his immune system. It was, in fact, overpowering, but for a different reason. If he had simply reenvisioned a weaker image, and left it at that, John would never have discovered the underlying emotional cause of his disease, and that was the most important aspect he needed to recognize about his imagery. What if he had decided not to go deeper in trying to understand his imagery, and opted instead to visualize a different, weaker, visual image? While that may have helped initially to reverse his cancer growth, ultimately, the underly-

ing cause would rear its ugly little head again, and the cancer would most likely resume its devastating path of destruction.

The important message here is to be certain that you have pushed yourself to explore every aspect of your imagery and every association it suggests, no matter how remote or insignificant it may seem. In the next chapter, you will be introduced to many methods to more fully understand the meaning and nuances of your imagistic language.

Mindscape V

C L Y T I E W. T A Y L O R

"In the spring of 1993, I found a lump in my breast and went to my internist. After receiving a mammogram, a biopsy, and several consultive medical opinions, I had a modified radical mastectomy followed by CAF-series chemotherapy. During chemotherapy, because I was too weak to create handmade paper or use an etching press, I experimented with manipulated Polaroid photomontages, which I could make while in bed. The Mindscape *images are my interpretation of chemicals actively moving through me to kill normal and cancerous cells. I drew the chaotic marks on the emulsion surfaces of shots of black space."*

FIGURE 5-7.

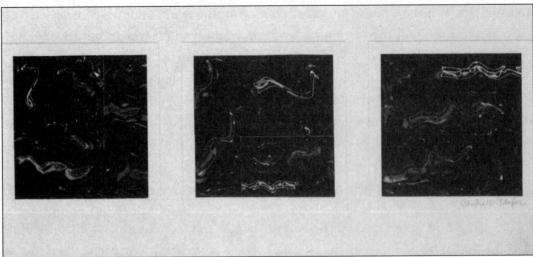

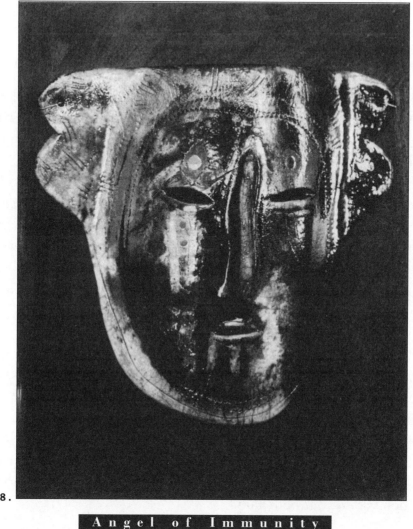

FIGURE 5-8.

Angel of Immunity

ELAINE GIFFORD

"I have spent most of my life making art in one form or another, and for the past sixteen years I have worked as a psychotherapist. I believe I am living and practicing the inextricable weave of art and healing. These faces, as I call them, are the depiction of our soul's companions as we face, endure, recover from, or succumb to illness—whether it be physical, emotional, or spiritual. The lines of demarcation have all but vanished. Whether we know it or not, we all have them—guides, angels, familiars."

Exercise 7

VISUALIZING WHAT YOUR BODY NEEDS TO HEAL

Your body will tell you through its imagery what it needs to heal—whether your healing imagery is literal and recognizable or simply color and form. Trust whatever image comes to you, because its power lies in your own interpretation of what it represents.

In this exercise, you will reconnect with the part of your body that is in need of healing and imagine seeing, once again, the image you drew in the first exercise that represented your body's image of your disease or physical affliction. As you focus on this image in your mind's eye, you will ask your body to present you with a symbol that represents what it needs to heal the affliction expressed in this first image. So, in fact, you are not working with the physical condition itself but with your body's image of it.

MATERIALS

You can use any art medium that seems most expressive of the symbol you visualize in this exercise. Because this symbol is powerful—it has the ability to activate your healing response on a physical level—it is best to approach creating your healing symbol as a fully developed piece of artwork. The more involved you become in creating it, and the more substantial the finished piece, the more impact it will have on the three levels—conscious, subconscious, and cellular—necessary to initiate a reaction within your body/mind.

Take several moments to reflect on the drawing you completed in Exercise 4 of the image of your body's illness or dysfunction. As you look at it, allow the image to reenter your consciousness.

GUIDED VISUALIZATION

Then when you are ready, take several deep, cleansing breaths, imagining that the air you are breathing is sweeping clean all your negative thoughts and toxic emotions as it enters your body. (Pause) *As you exhale each cleansing breath, imagine releasing these unwanted thoughts and emo-*

tions into the universe. Continue doing this until you begin to feel calm and relaxed. (Pause)

Now allow your conscious awareness—that tiny bead of light you've visualized in previous exercises—to move into the area of your body where you are experiencing the physical illness or dysfunction you wish to heal. (Pause) *As your awareness becomes present to this area, imagine seeing the image you drew of this illness or dysfunction manifesting within this area of the body.* (Pause) *As you observe the image that represents your body's impression of this dysfunction, ask your body to present a new image in the form of a symbol that represents what your body needs to destroy, repair, or alter this image of your dysfunction so that physical healing and recovery can begin.* (Pause)

Take time to allow the healing symbol to appear or for you to sense an idea or a symbol. (Pause) *When you know what your healing symbol is, open your eyes and begin to create a work of art that expresses your body's symbol of healing and recovery.*

As always, if you do not get an image or impression of a healing symbol, just open your eyes and allow your intuition to guide you as you begin to spontaneously create a symbol.

Exercise 8

SELF-DIALOGUING QUESTIONS TO EXPLORE THE MEANING OF YOUR HEALING SYMBOL

Use your healing journal to record your answers to the following self-dialoguing questions.

1. How did it feel to create this healing symbol?
2. How do you feel as you look at the completed artwork expressing this symbol?
3. How do you sense this symbol relates to your healing process?

4. If this symbol could speak, what would it say to you about healing your illness or physical dysfunction?

5. Did this symbol surprise you when you first visualized it? If so, how?

6. What do you sense your body is trying to tell you through this symbol?

7. Does this symbol suggest any changes you need to make in your life, habits, thoughts, or beliefs in order to heal?

8. Has this symbol caused you to think or feel differently about your illness, disease, or physical affliction?

9. What have you learned from this symbol?

Once you have completed this exercise, you will need to spend a few minutes once a day for the time period recommended below doing a visualization to replace the old image of your illness or ailment with this new healing symbol.

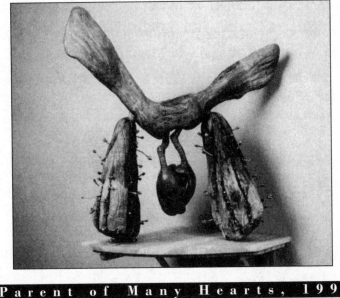

FIGURE 5-9.

Parent of Many Hearts, 1992

JULIA SHEPLEY

"Through carved and constructed works of mixed media, I explore the aspects of balance, survival, and growth using the repetition of forms and patterns that themselves are often repeated in nature. In this piece, a seedlike heart is being lifted by a winged breastbone and anchored by expanding lung supports. What is present by suggestion is, this balancing act pulses with life."

RECOMMENDED TIME PERIOD FOR REENVISIONING VISUALIZATION EXERCISE

If you are trying to heal a temporary condition like a cold, flu, a broken bone, pulled muscle, torn tendon or ligament, or a mild infection, do this replacement exercise at least once per week or until your condition has healed.

If you are dealing with a chronic condition like backaches, headaches, migraines, etc., do this replacement exercise for a week, then repeat as often as necessary when symptoms return.

For more serious problems like cancer or heart disease, do this exercise for at least one month, and then cut back to every other day until you have medical evidence that physical improvement has taken place. As your condition begins to reverse itself, continue to do this visualization exercise at least twice a week for as long as necessary.

For serious but chronic conditions like high blood pressure, diabetes, arthritis, rheumatism, etc., do this exercise every day for two weeks, then you can cut back to every other day. You will need to maintain this visualization routine for the rest of your life, unless your condition totally reverses itself and no symptoms are present. If this should occur, I would still recommend booster sessions once a week.

HOW IMAGERY AFFECTS THE PHYSICAL BODY

Thirty years ago, when medical practitioners and researchers first began using visualization and art to facilitate physical healing, little was know about how imagery actually affected the body. There were many theories but practically no scientific data to support them. Since then, many studies have been done that now substantiate the way imagery interacts with the mind and body.

We know, for example, that the body cannot tell the difference between a real and an imagined experience in terms of its biochemical responses. For instance, if

you close your eyes and imagine that you are being chased by a mugger with a knife, your body will react by releasing stress hormones that will initiate the fight-or-flight syndrome. Your heartbeat will increase, your breathing will become rapid and shallow, your blood pressure will rise, etc., as your body prepares to respond to an attack. The same is also true if you imagine yourself in a close encounter with someone for whom you feel a strong sexual attraction—your body will respond. But knowing that an imagined experience can affect the body and understanding how the effect occurs are two entirely different things.

It was biofeedback research that finally provided the measurable evidence needed to prove that imagery directly affects the autonomic nervous system, which controls body functions like breathing, blood pressure, metabolic and biochemical activity, along with the most significant physical function relating to our ability to heal—the immune system. What this means is that the functions controlled by the autonomic nervous system will respond to a visualized image of an idea.

Norman Shealy, M.D., neurosurgeon and founder of the American Holistic Medicine Association, clearly illustrates the impact imagery has on the physical body in his book *Miracles Do Happen*. In a chapter on biofeedback, he discusses in detail one of the many studies conducted by Dr. Elmer Green and his wife, Alyce, in the late 1960s in which patients suffering from migraine headaches were taught to use visualized imagery to relieve their pain.

Migraine headaches, as Dr. Shealy points out, are the result of stress, which causes the autonomic nervous system to constrict the flow of blood to the hands—producing cold hands. This decrease in blood to the hands in turn causes the blood vessels at the base of the brain to dilate, flooding the brain with too much blood,

Woman with Box on Head

L. LANHAM BUNDY

"This painting is a metaphor for the fear that heart disease patients experience as they cope with the possibility of another cardiac episode. It depicts a woman who cannot see ahead as she carries a precious box on her head without the help of her arms. But I have turned fear into hope by facing the woman toward the light. As she walks, the viewer is left with the feeling that she will reach the shore, the water cleansing her as she passes."

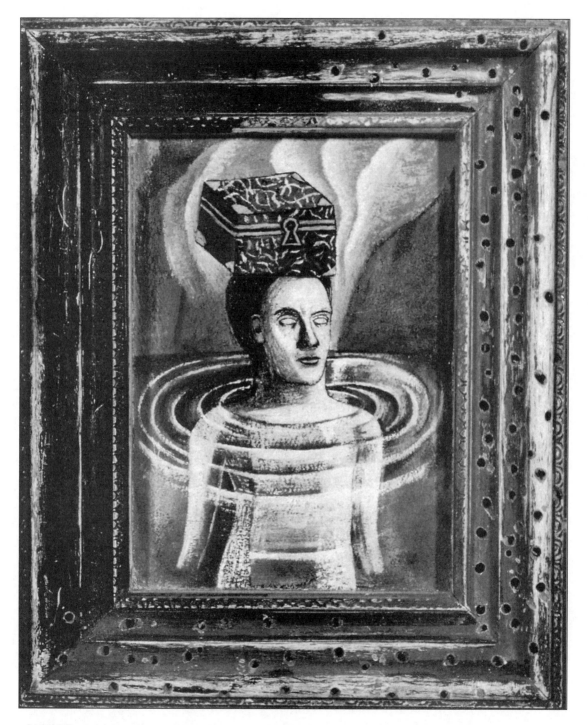

FIGURE 5-10.

resulting in the pain of a migraine. When patients in this study were taught to warm their hands by visualizing the sun's rays pouring down upon their upturned palms, the migraines subsided. The reason was that when the blood vessels to the hands expanded, allowing the blood to flow freely once again, the blood vessels at the base of the brain were able to return to normal, thus reducing the excess blood flow into the brain.

So can migraines be cured by just warming the hands through any means? No. When the patients in this study tried to warm their hands by placing them in warm water, nothing happened. That's because, as Dr. Shealy explains, the neural reflex that controls vessel dilation can only be activated by the sympathetic nervous system, which is a part of the autonomic nervous system. Since then, numerous studies, including those done by Dr. Shealy, have continued to demonstrate the effect of visualization on the autonomic nervous system in reducing or eliminating pain from chronic conditions, as well as reversing the progress of illness and disease by increasing the functioning of the immune system.

When visualization is combined with expressive art, the results are even more astounding. In this next segment, you will begin using your visualized imagery and art to help your body work cooperatively with any medical treatment you may be receiving so that you can optimize your body's ability to heal from within.

Segment Three:
Using Visualization and Expressive Art
to Enhance Your Medical Treatment

If you are receiving or scheduled to receive some form of medical treatment, whether it is chemotherapy, radiation, surgery, medication, physical therapy, or any other type of treatment, you can consciously direct your body to work in harmony with your treatments so that you can maximize the results and minimize the side effects.

Many people go through their treatment procedures with fear, apprehension, and even anger. What they often don't realize is that seeing their treatment as something to grit their teeth and get through is a negative image the body will respond to by triggering the stress response. This produces the exact opposite effect they need in order to heal. Seeing your treatment as an ally can alter the way in which your body responds to the treatment. This change in attitude

begins by first exploring how your body-mind is actually perceiving the treat-ment you are either presently experiencing or preparing to begin. This next exer-cise will help you ascertain what kind of feeling images you are holding in regard to your treatment.

Exercise 9

EXPLORING YOUR TREATMENT IMAGES

Harnessing your own powerful inner resources to heal an illness, ailment, or con-dition is one part of the physical healing process, and guiding your body-mind to accept and work in cooperation with a prescribed medical treatment is the other. More often than not, in an effort to be a good patient, your mind may tell you all the reasons why you should engage in this treatment, while your body may indicate its feelings of rejection by sending you warning signals in the form of a headache, stomachache, muscle tightness, or even just feelings of free-floating anxiety. All too often, however, these warning signals go unnoticed.

By connecting with your inner imagery while focusing on your thoughts about your treatment, you will discover what you are really feeling about your treatment. Feeling fear and negativity can reduce the treatment's capability to produce the desired effect. Feeling overly dependent on this treatment to save you can prevent you from relying on an equal partnership between your body and the treatment to work harmoniously together. And equally important, if this treatment is entirely wrong for you, your body's wisdom will inform you through its imagistic messages and guide you to a more appropriate form of treatment. And feeling very positive and empowered by your treatment will magnify the healing results the treatment and your body can achieve together.

This next exercise will consist of creating a series of four separate but related visualization and image drawings. The first three drawings and the self-dialoguing questions that accompany them will help you get in touch with your feelings about the treatment you are receiving or you are about to receive, the way you see this treatment interacting with your body and immune system, and whether or not this particular treatment is in your highest good. The final drawing in this series will help you create an image that directs your body-mind to work harmoniously and cooperatively with your treatment.

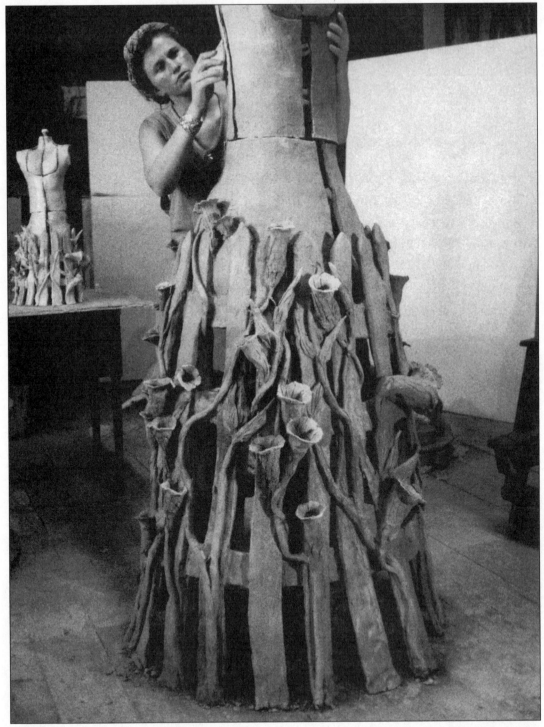

FIGURE 5-11.

Picket Fence Skirt

ALLISON NEWSOME

"For me, the action of making art is like having a conversation. As the conversation unfolds, a series of sculptures and paintings work their way out. One conversation leads to another, and the imagery takes on a new course. This process can be described as an internal dialogue. I am not always aware of the intention or direction of the work, sometimes a few years may pass before I realize how the work related to my environment and state of mind at the time. An ongoing theme has remained an undercurrent in my work, this being the change of our environment from the wilderness, to the agrarian, to the industrial. I realize now that I focused on 'The Agrarian' in 1996–1997 as I physically performed agriculture on my own body with the emotionally stressful in vitro fertilization procedure. I became preoccupied with the midsection of the figure, doing away with the head, arms, and hands. Thus emerged The Dress Maker Dummy *series, of which* Picket Fence Skirt *is a part. Now, four years later, with the birth of my twins two years ago, I realize the act of making this work helped me through that stressful time."*

MATERIALS

It is best to keep your imagery simple and to the point so that you do not run the risk of becoming so involved in the artistic execution of your images that you misinterpret the message your imagery is attempting to convey. To facilitate this, I suggest you limit your imagistic expressions to drawings using either pastels or crayons to express your visualized imagery.

Begin by taking four large sheets of drawing paper, and at the top of each one, indicate whether it is part one, two, three, or four, and then write the title of each individual visualization.

PART ONE:
HOW YOU FEEL ABOUT YOUR TREATMENT

When you are ready to begin, retreat to your healing space, place your drawing materials in front of you, and pretape this visualization or read it through, and then with your eyes closed, lead yourself through each step.

GUIDED VISUALIZATION

Close your eyes and take three deep, slow, cleansing breaths. (Pause) Now allow yourself to breathe normally in a slow, deliberate, and repetitive pattern, concentrating your attention on the rise and fall of your breath. (Pause) Feel yourself connecting with your body as you breathe. Become aware of your body's position, feel your clothes against your skin, sense your presence within the room. (Pause)

As you continue breathing, allow your awareness to focus on your treatment, imagining yourself receiving this treatment and your body's reaction to it. (Pause) Become aware of how you feel as you reflect on the idea of this treatment and its interaction with your body. (Pause) Notice where in your body you are feeling yourself react to the idea or notion of this treatment. (Pause) Allow your awareness to move into the most predominate place within your body where you are sensing a reaction to the idea of this treatment. (Pause)

Focus your awareness on how this physical sensation feels as you think about receiving this treatment. (Pause) What does the physical sensation of this feeling you have about your treatment feel like? (Pause) What images and colors would best express what you are feeling about your treatment? When you know, open your eyes and draw what this feeling associated with your treatment feels like.

SELF-DIALOGUING QUESTIONS

Use your healing journal to write the answers to the following self-dialoguing questions. Be sure to identify that these answers correspond to Part One of Exercise 8 so that you may refer back to them at a future time.

1. How did it feel to express your feelings about your treatment?
2. Describe what your imagery looks like to you.
3. What do you sense your imagery is trying to say to you regarding how you feel about your treatment?

4. Does your imagery seem to be conveying a negative, untrusting feeling about your treatment or a positive, empowering feeling? Or is it something else?

5. What have you learned from your body's image of your feeling about this treatment?

PART TWO:
HOW YOU SEE YOUR TREATMENT INTERACTING WITH YOUR BODY AND YOUR IMMUNE SYSTEM

GUIDED VISUALIZATION

Once again, close your eyes and take three deep, slow, cleansing breaths. (Pause) Now allow yourself to breathe normally in a slow, deliberate, and repetitive pattern, concentrating your attention on the rise and fall of your breath. (Pause) Feel yourself connecting with your body as you breathe. (Pause) Become aware of your body position, feel your clothes against your skin, sense your presence within the room. (Pause)

As you continue breathing, allow your awareness to focus on your treatment. (Pause) Imagine yourself receiving this treatment and allow yourself to see how your body is interacting with this treatment. (Pause) How do you see this treatment affecting your body? (Pause) How do you see your immune system interacting with this treatment? (Pause) What images do you see associated with your immune system? (Pause) What image or images, colors, shapes, and forms best express how you see your body and your immune system reacting to your treatment? (Pause) When you know, open your eyes and draw these images, colors, shapes, and forms.

SELF-DIALOGUING QUESTIONS

Use your healing journal to write the answers to the following self-dialoguing questions. Be sure to identify that these answers correspond to Part Two of Exercise 8 so that you may refer back to them at a future time.

1. How did it feel to express your feelings about your body's interaction with your treatment?

2. Describe how your treatment is interacting with your body and your immune system.

3. What do you sense your imagery is trying to say to you about how your treatment will affect your body?

4. Does your imagery seem to be conveying a negative feeling or a positive feeling about the effects your treatment will have on your body?

5. What have you learned about how this treatment will affect your body?

If you drew an image that depicts your treatment having a negative effect on your body, the final exercise in this series will enable you to transform that image by reenvisioning a more powerful and effective interaction between your body and your treatment.

WHAT YOUR IMAGERY CAN TELL YOU ABOUT YOUR TREATMENT

While using visualized imagery and drawing with his cancer patients Dr. Carl Simonton discovered that imagery could reveal whether they had positive or negative feelings about their treatment's ability to achieve the desired results. He noticed that some patients, although they were faithfully doing their visualization and drawing exercises daily, were not getting better. Up to this point, he admitted not paying much attention to the actual images his patients were drawing, but then when some of them were not progressing as expected, he started to look more closely. What he observed was that those patients who were not responding well to their treatment and experiencing more adverse side effects were drawing what he called "strongly negative expectancies in their imagery."

Based on Dr. Simonton's experiences, negative expectancies are revealed when an individual draws his or her disease, illness, or condition as being bigger and more powerful than the treatment he or she is receiving or about to receive. For example, if you have cancer and you drew your cancer as a large mountain and your chemo treatment as a rainfall washing over the mountain eroding only parts of it while leaving the majority of the mountain intact, then you are not seeing your treatment as being capable of eliminating the entire mountain or tumor.

Dr. Simonton additionally points out that drawing images of one's treatment as being damaging or dangerous to the body also demonstrates a negative expectancy. I once had a client who drew an image of her chemo treatment as the Terminator,

obliterating everything in sight. When I explained that her image revealed an underlying belief that her chemo would destroy not only her cancer cells but also her healthy cells, she reenvisioned a new image that was more selective in its destruction. The new image was of Tinker Bell sprinkling magic fairy dust on only the tumor cells.

How did you envision your immune system? Did you see it as powerful and able to overcome your illness? If the images of one's immune system are represented as being less powerful than the treatment, that could mean you are dependent on the treatment to do the work rather than believing in the power of your own body's immune system to effectively participate in the healing process.

When you look at the images you drew in Part Two, did you discover any negative expectations? If you did, you may want to be sure that you feel this treatment is the right one for you, which the next exercise will help you determine. If it is, then the last exercise will help you to reenvision your imagery so that your illness is depicted as weak and very susceptible to your treatment, and your immune system is envisioned as a powerful healing agent supporting your treatment.

PART THREE: IS YOUR TREATMENT IN YOUR HIGHEST GOOD?

More often than not, my clients, who are struggling with treatment decisions, will experience serious misgivings about the prescribed treatment their physician is recommending. It is a painful and confusing time for them. They fear not only making the wrong decision but also making any decision.

If you are in the uncomfortable position of questioning the treatment method or procedure that has been recommended for you, this exercise can help. My experience with clients has proven again and again that the body knows far better than the mind whether or not a particular treatment is in their highest good. Your body knows when you are thirsty, hungry, or tired, and it sends out signals calling your attention to its particular need. The same is true when you think about the treatment that has been suggested to you. Your body is sending signals that say either "Yes, this feels right" or "No, this isn't for you." But most of us have learned to overlook our feeling signals in lieu of our mind's directives, which intertwine judgmental fear messages with all the so-called common sense reasons why the doctors know best.

If you have been doing the exercises throughout this book, you know by now that the only way to access your true feelings in a clear and concrete way is by using your body-mind's language of imagery. This exercise will help you do just that as you connect with your body's imagistic impression of its true feelings about your prescribed treatment.

GUIDED VISUALIZATION

Once again, close your eyes and take three deep, slow, cleansing breaths. (Pause) Now allow yourself to breathe normally in a slow, deliberate, and repetitive pattern, concentrating your attention on the rise and fall of your breath. (Pause) Feel yourself connecting with your body as you breathe. (Pause) Become aware of your body's position, feel your clothes against your skin, sense your presence within the room. (Pause)

As you continue breathing, allow your awareness to focus on your treatment. (Pause) Imagine yourself receiving this treatment, and allow yourself to feel how your body is reacting to this treatment. (Pause) As you sense your body's reaction to this treatment, notice where in your body you are feeling this reaction. What does your reaction to your treatment feel like? Be present to the feeling. (Pause) Is it comfortable and welcoming or uncomfortable and rejecting? (Pause) Ask your body to present you with a symbol that represents its acceptance or rejection of this proposed treatment. (Pause)

Be still and wait for an impression of the symbol to appear or a sense of knowing what this symbol is. (Pause) When you know, open your eyes and draw your body's symbol of its acceptance or rejection of this treatment.

At first glance, this symbol may seem quite clear in its intention and directive, or it may strike you as vague and difficult to understand. As you answer the self-dialoguing questions that follow, you may begin to gain some clarity about the symbol's meaning. If after completing these questions, you are still unclear, you may want to discuss the image with a therapist or your doctor. The other option, if discussing the symbol with someone doesn't feel right to you, is to just be with it for a time—

perhaps several days or so—and see what thoughts and impressions come to you. Pay close attention to your dreams during this time, as your body-mind will send messages through dream images when a message isn't getting through the other channels. The answer will eventually present itself—usually when you least expect it. I always get my intuitive answers when I'm in the shower. That is because we move into right-brain awareness states when we are engaged in nonthinking activities like taking a shower, jogging, walking, singing, dancing, drawing, dreaming, or meditating. When the answer does come to you, trust your own feelings about its validity.

If some time has passed and you are still uncertain as to how to proceed with this treatment, you may want to try this exercise again and see what happens. If you are still getting what you perceive as an unclear message, then your mind may believe more strongly than your body that this treatment *is* necessary. In such a case, you may have to let your mind lead in order to feel as though you have done all that you could to treat this illness.

SELF-DIALOGUING QUESTIONS

Use your healing journal to write the answers to the following self-dialoguing questions. Be sure to identify the title of the exercise (Exercise 8, Part Three: Is Your Treatment in Your Highest Good?) that these answers correspond to so that you may refer back to them at a future time.

1. How did it feel to express your body's feelings about this treatment?
2. Describe how your drawing is expressing your body's feelings about this treatment.
3. What do you sense your imagery is trying to say to you about this treatment?
4. Does your imagery seem to be saying "Yes, this treatment is in my highest good" or "No, it is not in my highest good"?
5. What have you learned about your body's feelings in regard to this treatment?

PART FOUR:
CREATING AN IMAGE THAT DIRECTS YOUR BODY-MIND TO WORK COOPERATIVELY WITH YOUR TREATMENT

If you envisioned an uncooperative, negative image of your body and immune system interacting with your treatment, then you will have an opportunity to transform that negative impression into a positive one in this exercise. If your images in

both part one and part two were already positive and empowering, then you may not feel a need to do this exercise. Or you can do it and reinforce that positive image of your body and immune system overcoming your disease, ailment, or physical condition by seeing it as even more powerful.

GUIDED VISUALIZATION

Once again, close your eyes and take three deep, slow, cleansing breaths. (Pause) Now allow yourself to breathe normally in a slow, deliberate, and repetitive pattern, concentrating your attention on the rise and fall of your breath. (Pause) Feel yourself connecting with your body as you breathe. (Pause) Become aware of your body's position, feel your clothes against your skin, sense your presence within the room. (Pause)

As you continue breathing, imagine that your conscious awareness is a tiny bead of light nestled deep within your cranial cavity, directly behind the center of your forehead. (Pause) Imagine directing this bead of light into the area of your body that is in need of healing. (Pause) Imagine that this bead of light is now illuminating this area from within and that you can observe and become a witness to this area of affliction within you. What do you see? (Pause) Be present to this place of malfunction. (Pause) Ask your body to present an image of what it needs to do to work cooperatively and harmoniously with the treatment you are receiving or you are about to receive. Be patient and allow the images to present themselves to your awareness. (Pause)

When you sense that you know which images clearly depict how your body and your immune system can work in the most powerful and harmonious way with your treatment, open your eyes and draw these healing images.

As I have instructed you to do in previous reenvisioning exercises, it is important after you have completed this drawing to take a few minutes every day during the duration of your treatment to practice visualizing the images in this drawing. Imagine seeing your body and immune system responding and interacting with your treatment in exactly the way your drawing has portrayed it. You may even

want to continue doing this visualization for several weeks after your treatment has been completed to reinforce your body's inner directive.

CHANGING HOW YOU SEE YOUR ABILITY TO HEAL YOUR ILLNESS OR CONDITION

In documented cases where people have experienced what is called a "spontaneous cure" or the reversal of a life-threatening illness or a chronic condition, researchers have noted that the cure or reversal is often preceded by a marked shift or change in the patient's view of their illness. Deepak Chopra, M.D., talks about this change, describing it as a shift in consciousness, in his book *Quantum Healing.* He says that every case of spontaneous cure that he has ever seen has always been preceded by a shift in the patient's thinking. Dr. Chopra explains that shift in the following way: "Research on spontaneous cures of cancer, conducted in both the United States and Japan, has shown that just before the cure appears almost every patient experiences a dramatic shift in awareness. He knows that he will be healed, and he feels that the force responsible is inside himself . . . and at that moment, such patients apparently jump to a new level of consciousness that prohibits the existence of cancer. Then the cancer cells either disappear, literally overnight in some cases, or at the very least stabilize without damaging the body any further."

Exercise 10

SEEING YOURSELF AS HEALTHY AND WELL

In this final exercise, you will have an opportunity to create a piece of artwork that expresses your inner image of yourself as fully healthy and well in body, mind, and spirit. Unlike the quick drawings you had been doing in the previous four-part exercise, I suggest that you see this as a fully executed piece of art. Use any medium that seems most appropriate to expressing this symbolic image of your wellness. I would like you to think of this piece as your talisman, your totem, your symbol of complete recovery. It represents imagistically what your body-mind sees as the embodiment of your own shift in consciousness—a shift that proclaims that you *are,* not will be, already healed, already healthy. This exercise will direct you to call forth an image or symbol from your heart that represents your assertion that the healing force that can make you well is inside of you.

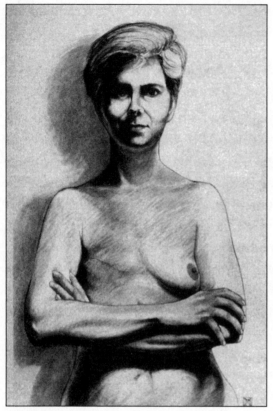

FIGURE 5-12.

MARCIA SMITH

"Through this work I found that when one heals, there is a shift of attitude: a subtle or larger change in the way one sees oneself in relation to the world. In my experience, that change comes to us when we can look clearly at the situation or disease, acknowledge it, get to know it intimately, not shy away from it. In getting closer to it, we become more powerful. Each step that I have taken in this process has brought me closer to this confrontation with the disease (breast cancer). The act of making these marks on paper—of my arm moving vigorously or tenderly to give clear expression of what I am perceiving internally as well as through my eyes—pulls energy up from deep inside. The act of doing this has helped bring a sense of resolution, gratitude, and healing to my life."

When you are ready to begin this exercise, place whatever materials in front of you that you feel will be needed. Pretape or read through this visualization, following each phase of the instructions as closely as possible.

GUIDED VISUALIZATION

Close your eyes and allow yourself to become totally relaxed and present to your physical body. (Pause) You can do this by taking in several deep breaths. As you breathe in, feel the air enter your lungs, expanding your chest cavity to its fullest potential. As you release the air, feel your chest release and relax as the air leaves your body. (Pause) After breathing

deeply three or four times, begin to breathe normally once again, but now focus your attention on the rise and fall of your chest as you take in the air and release it. (Pause)

With each breath, feel your body becoming heavier and more relaxed. (Pause) *Feel your body sitting in the chair or on the floor.* (Pause) *With each breath, become aware of the position of your head.* (Pause) *As you exhale, feel the muscles holding it release any tension they may be holding and relax, becoming heavier and heavier.* (Pause) *Next, as you inhale, become aware of the muscles in your shoulders and feel them relax as they release their tension through your exhaled breath.* (Pause) *Then move your awareness into your chest as you inhale, and feel those muscles relax as they release their tension through your exhaled breath.* (Pause) *Then focus your awareness on the muscles in your abdomen as you inhale, and feel those muscles relax as they release their tension through your exhaled breath.* (Pause) *Now become aware of your legs as you inhale, and feel those muscles relax as they release their tension through your exhaled breath.* (Pause) *And finally become aware of your feet as you inhale, and feel those muscles totally relax as they release their tension through your exhaled breath.* (Pause) *Now feel the complete sense of release and relaxation within your entire body.* (Pause)

Imagine now that your conscious awareness is once again a tiny bead of light nestled deep within your cranial cavity. Imagine that you have the ability to move this bead of light anywhere within your body that you direct it to. (Pause) *As you silently count down from ten to one, imagine that this tiny bead of light is drifting ever so gently downward into your heart center. Begin the countdown now: ten, nine, eight, seven, six, five, four, three, two, one.* (Pause)

Imagine seeing that tiny bead of light deep within your heart center, illuminating your heart from within. (Pause) *Now ask your heart to present you with a symbol that best expresses its optimal image of you as fully healed, completely well in body, mind, and spirit.* (Pause) *When you*

know what this symbol or image is, open your eyes and begin to create a piece of art that fully expresses this symbol.

When you have completed the artwork in this exercise, use this piece as a meditative source for a visualization that you do frequently—perhaps once or twice a week. I recommend that you alternate this visualization with the other two daily visualizations you are already doing in which you see your body and immune system interacting harmoniously with your treatment, and the image you drew of what you need to heal.

Healing the mind and body enables us to discard our old patterns of thought, our negative beliefs, and the attachment we had to the pain that kept us from releasing the past. This is a cleansing of our entire being that now frees the body-mind to open the channel of communication and cooperation with our spirit. Through this healing and release, mind, body, and spirit can reconnect and become unified in purpose and action once again, creating what is called transformation of the spirit.

Emergence

CARROL CUTLER

"This drawing represents my soul's image of healing. I call it Emergence *because it signifies my true purpose, meaning, and direction. Following this direction is what I need to heal. Following it will allow me to go beyond my limitations. At first, when I drew this, I was concerned that this sense of purpose and direction would spew out— meaning that I would lose control. But it didn't. Instead it came out in a forceful and controlled way."*

FIGURE 5-13.

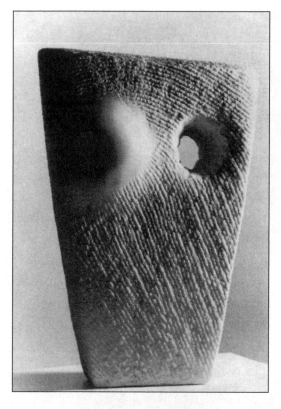

Modified

R O B I N M A C D O N A L D - F O L E Y

"As a teenager, I lost my mother to breast cancer. Years later, my awareness led to the examination and diagnosis that saved my life. The healing process began during a return to stone carving. Modified, a self-portrait, became a celebration of life and a tribute to my survival."

FIGURE 5-14.

In the next chapter, you will discover, if you have been doing the healing exercises throughout this book, the transformation that has taken place within your spirit. By tuning into your body's energetic system, you will learn how to open the connection between your soul and universal spirit energy. This connection will allow you to communicate directly with your soul. Using art to express its messages, you can discover your divine purpose on this planet, and how all that has happened in your life, both good and bad, was in harmony with this purpose. Through this understanding, you will learn the ultimate and most valuable of all spiritual lessons—unconditional love and forgiveness—which brings the process of healing and transformation of body, mind, and spirit full circle.

FIGURE 6-1.

Sacred Circuit

MARY BEAM

"My work is an effort to affirm and celebrate the spiritual in art. From expressing and releasing pain, the soul is healed. In creativity, health and the spiritual are joined."

Transformation of the Spirit

The process of healing the mind and body brings about a transformation of the spirit. When the spirit is transformed, the full cycle of healing the body, mind, and spirit is complete. A transformation of the spirit occurs when the soul is released from the limiting and destructive patterns of the past to embrace the unlimited potential of the future.

The spirit is the beacon of light within us, the light of divine connection that guides the mind and body through its journey in life. All too often we become separated from our spirit, unable to hear its call through our inner voice, a call that directs us, as Bernie Siegel, author of *Peace, Love & Healing*, says, to our path in life, our purpose or "job on earth." But the spirit is persistent. It will command our attention in one way or another. I believe that when the inner voice of the spirit is stifled or ignored, the universe—its source of power and direction—gives us a boot in the pants by creating a life disturbance of one sort or another. After several boots and shoves, if we still don't get the message to wake up and listen, the universe will give us what I call a knock on the head with a cosmic two-by-four in the form of a physical or emotional crisis.

Unfortunately, it seems that many of us have to experience some kind of life-altering crisis before we finally acknowledge the voice of our spirit, but once we do, it changes everything. It changes the way we see ourselves, our lives, our choices,

our relationship to others, and most importantly it changes the understanding we have of our existence. These changes are so significant that they often become the catalyst that enables an individual to reverse a life-threatening illness or a chronic condition for which little hope was previously held.

HOW ILLNESS CAN BE A GIFT TO THE SPIRIT

In the years that I have been working with cancer patients, I have rarely met one who hasn't said that cancer was their greatest gift. Cancer, they say, was their wake-up call—the ultimate crisis that forced them to realize that there was a purpose to their lives they had yet to fulfill. And that one realization, they believe, changed their lives and their ability to survive this disease.

Before their cancer diagnosis, my clients tell me, they were so caught up in petty concerns, pursuing dreams that were not their own and living with the constant fear of making a mistake, that their lives had no real meaning. "When you are fighting so hard to survive," one of my ovarian cancer patients once said, "it makes you decide that your life had better be worth the effort. If my life is going to be nothing more than more of doing things the same old way—the same meaningless thoughts, pursuits, and fears—then why bother? That's when I finally got it," she said, "the old way was *their* way—what others had taught me to believe was not important. If I am going to find out what's important to me, I have to stop listening to them and listen instead to my heart." By listening to her heart, she heard her inner voice, and through that voice she discovered the purpose of her life—her soul's purpose. (See color insert section, Plate 4, *Be Still and Know That I Am God* by Beatrice Waxler.)

HEART AND SOUL

I have always felt that the spirit speaks through the voice of the heart, because I believe that the heart is the keeper of the soul. After all, the heart is the one organ in the body that is most responsive to our feelings and emotions, and since I believe that our soul's desires are expressed through our feelings and emotions, it seems to me that if the soul were to reside anywhere within the body, the heart would be the most appropriate dwelling.

I look to my heart for messages from my soul when I need guidance and direction. When I trust its messages, I have never been led astray. When I doubt its messages, and act in opposition, inevitably I live to regret it. But trusting that inner

voice—the soul—is not always easy. We are so conditioned to think things through—to do what is logical and sensible—that we often miss those inner tugs from the heart and soul that whisper, "Look here, go there." The soul does not think; it feels, and it sends its messages through our feelings. Our feelings are not logical or sensible. They lead us down the road less traveled, where others fear to tread. When we walk the road of the heart and soul, we walk in truth and harmony with the universe.

ART SPEAKS FROM THE HEART

In Session Five you will learn how to connect with the inner voice of your spirit by expressing through art the imagistic messages of your heart. By tuning into your body's energetic system, you will learn how to open the connection between your soul and universal spirit energy. This connection will allow you to communicate directly with your soul. Using art to express its messages, you can discover your divine purpose on this planet, and how all that has happened in your life, both good and bad, was in harmony with this purpose. Through this understanding, you will learn the ultimate and most valuable of all spiritual lessons—unconditional love and forgiveness—which brings the process of healing and transformation of body, mind, and spirit full circle.

Session Five

OPENING THE DIVINE CONNECTION TO EXPRESS THE IMAGES OF YOUR HEART

Opening the divine connection from the heart to the soul begins with the destruction of our old ways of thinking, seeing, and being in the world. Through destruction comes a rebirth of our awareness as we begin to see ourselves as individuals who are a part of a greater whole. That awareness fills our lives with purpose and meaning. From that awareness, another stage of transformation often follows in which we begin to feel our connection not only with our soul's spirit but also to the universal spirit of all existence. Through this second stage of transformation, our vision of life broadens as we move from the narrow perspective of seeing the events of our day-to-day lives as the only reality affecting us, to the all-

FIGURE 6-2.

encompassing realization that our lives are integrally entwined with and influenced by a divine intention.

As our consciousness evolves to a higher state of awareness, we begin to understand that although we have free will at all times to make our own choices and decisions, that will is always being influenced by a greater force presenting us with opportunities and possibilities that are tied in with this divine intention. The opposing force to this divine intention is our own limited thinking, which is an outgrowth of our preconceived ideas defining what we believe life should be like. The limitations inherent in this kind of thinking is a by-product of inbred fear and negativity. When we let go of our learned fear and negativity, we transform our personal and world vision.

When you have healed your own emotional wounds, you will experience the transformation of your spirit. When this occurs, you will actually feel the veil of darkness, confusion, and doubt lift as you open to a new view of your life that will feel light and clear. Your mind will feel less cluttered, and you will begin to experience a new sense of freedom and peace of mind. The difficult part of transformation is often in the waiting—having the patience and trust it takes to allow the process to conclude before the new dawn of enlightenment occurs.

This sometimes arduous process is best described by a woman who was a frequent

Strength Within the Myth

SUSAN MILLS

"As we recognize and repair the split between our inner and outer worlds, our bodies and souls, we heal ourselves and our planet. My art is the embodiment of my search for a new myth, a metaphor to pierce the illusion of separation and lead us back to wholeness. The objects I use are a way of recording my inner journey. They are my honoring and illuminating of both the visible and invisible realms. The impetus for my mixed media work is very personal. The symbols and glyphs are my own iconography, yet they seem saturated with meaning, as if they have been handed down for generations. We are all individuals, yet we are all connected. When one of us takes a journey, it affects us all. When people see my work, they are often moved to tell me their own stories—and we all become reconnected in the myth, in the oneness we all share."

participant in many of the healing-with-art workshops my colleague Susan Fox and I held at our Center for Holistic Development in Rhode Island. Her name is Antoinette Ledzian. She is an artist, a writer, and a creator of handmade journals. She calls herself the "Journal Lady.®" Antoinette invited me to share her story of transformation in this book and the artwork that brought it about, which she titled *Transcendence*.

T r a n s c e n d e n c e

ANTOINETTE C. LEDZIAN

Antoinette describes the difficult transition that occurred for her as she went from destruction to rebirth. "I started this piece during the workshop," she said.

I know it was a reaction from my unconscious to the severe stomach pains I had been experiencing for over a month. This pain fired my only

FIGURE 6-3.

feeling of energy. I was creatively drained and in a void. I felt totally empty except for the pain. As I created this piece, I gave no thought to the colors or the medium I would use—I just let it happen. It began with a form that looked like a white fog on black paper, and gradually I began using greens, blues, and purples, first in pastel using only my fingers, and then in acrylic paint with a brush.

I felt out of control, confused, and sick while I was painting this piece. When I got home, I tore up the entire piece. I was angry, and I felt like these pieces became my anger. These angry pieces stayed in a pile for six days silently, patiently, waiting. I could sense them talking to my sub-conscious the whole time, so finally I decided to face them and rebuild my torn soul. In trusting the process, and letting go, I began to rearrange the pieces, leaving some out and using the back side of oth-ers. The song lyric from "America the Beautiful," "God shed his grace on thee," was constantly flowing through my brain; I started envision-ing temples, and a swirling force of energy began to take over. I began creating in this piece my own temple of security, which had many roofs. The earthly structure was binding the torn pieces of myself with their ragged, imperfect edges, and I began to feel safe as the pieces were reconstructed to form a unified, meaningful escape from my ego to the sacred universe. The entire process I called Transcendence *because it was a rebirthing of myself. I felt very spiritual while having a human experience.*

Days after the second stage of reconstruction took place in the finished piece, I began to notice a multitude of images in Transcendence. *To date, I have counted thirteen, which appear mostly as faces in both positive and negative shapes. The most astonishing image is Shiva, who, it is believed, restores what has been destroyed so as to live again. In a four-thousand-year-old manuscript, Devi asks Shiva about his reality. In response Shiva replies, "Suppose you are gradually being deprived of strength or of knowl-edge. At the instant of deprivation,* transcend." *My piece,* Transcendence, *was definitely created from this state!*

THE REBIRTH OF YOUR DIVINE SELF

In this first exercise, you will be guided to visualize images that represent the destruction and transformation of your old patterns of negativity and fear. As these images appear before your inner vision, you will then begin to imagine their disintegration and rebirth into new images that symbolize the emergence of your divine self.

MATERIALS

It may be best to surround yourself with a variety of art materials before you begin this exercise. As Antoinette found in her experience with this transformative process, you can never prejudge or anticipate where your imagery will take you. Being receptive to the possibilities of artistic expression is symbolic of opening your own divine connection. If you allow yourself to learn and be guided by the experience, you will most likely be amazed by the results.

GUIDED VISUALIZATION

Close your eyes, and allow your awareness to become present to your body. (Pause) As you begin to focus in on your body, take a slow, deep breath, and as you do, gather up any tension you may be feeling in your body and imagine drawing that tension into your inhaling breath. (Pause) Then imagine releasing that tension as you exhale. (Pause) Again, breathe in deeply and slowly, gather up your tension, and then slowly release it. (Pause) Again, slowly breathe in, but this time consciously gather up any negative thoughts you may be holding inside and release them as you exhale slowly. (Pause) Then breathe in again and imagine gathering any worries or concerns you may be feeling, and release these as you exhale. Now you can allow yourself to breathe normally once again, and focus on the rise and fall of your chest as you do. (Pause)

When you feel relaxed and at ease, imagine your conscious awareness to be a tiny bead of light nestled in the center of your cranial cavity. And

imagine allowing that bead of light to drift down ever so gently toward your heart center as you count down from five to one. (Pause)

With your awareness now present within your heart, imagine that you can illuminate this area of your body from within with the light of your conscious awareness and imagine viewing the internal landscape of your heart, the keeper of your soul. (Pause) *What do you sense this place of your soul's dwelling to look like?* (Pause) *Allow the image of your soul's dwelling place to become firmly implanted within your mind's eye so that you may return to this place with ease whenever you are in need of a soul connection.* (Pause)

From within the temple of your soul, allow yourself to focus on the old ways of thinking and being that have dictated your life decisions, actions, and attitudes to this point in your life. (Pause) *What images, symbols, shapes, and colors do you most associate with these old patterns of belief?* (Pause) *Allow these forms to appear on the horizon of your soul's landscape. As they begin to take form, imagine their destruction.* (Pause) *What would that look like as you watched these images begin to deteriorate and disintegrate?* (Pause)

As you imagine viewing this destruction, imagine the feeling of letting these forms born of fear and negativity go out of your life, body, and soul. (Pause) *Sense the feeling of freedom and lightness as these forms are released.* (Pause) *As the old destructive forms pass away, imagine a transformation beginning to take place as new empowering and enlightening images begin to emerge from the destruction.* (Pause) *See or sense these images beginning to take shape.* (Pause) *When you sense that the old destructive images have completed their transformation and rebirth into new forms and images, open your eyes and begin to create a symbolic representation of this experience.* (Pause)

If you prefer to allow the destruction and rebirth to take place as you create the artwork, feel free to move directly into the artwork without going through the entire visualization process.

Exercise 2

PROCESSING YOUR ARTWORK

The following self-dialoguing questions will help you understand the symbolic meaning of the transformative imagery expressed in the artwork you created in response to the previous exercise. Write your responses to these questions in your healing journal.

1. How did it feel to visualize the experience of destruction and rebirth as you imagined releasing and transforming your old patterns of fear and negativity?
2. Describe your artwork as it relates to this process of rebirth and transformation.
3. What do you feel your imagery symbolizes?
4. How does this symbolism reflect your own sense of spiritual transformation?
5. If this piece of art could speak to you, what would it say?

A painting that depicted my own spiritual transformation can be seen in Plate 5 of the color insert section. This piece I called *Spirit Rising*. After working through emotional wounds that kept me blocked and stuck in a rut dredged by my old ways of thinking, I felt light and free, ready to fly. I created this painting without thought or visualization. I simply wanted to express the elation I was feeling, and the energetic connection I could sense between my spirit and the spirit that moves through all things—that which I call God. I have always had a personal relationship with God, but in the past, it was more like a child talking to a parent or a wise elder. Now, with my path cleared of the emotional debris I had gathered through the years, I felt that relationship shift. It now became a cocreative union.

In this painting, I allowed the eyes of my soul to open, and as I did I felt something magical happen. My mind and its judgment were shut out, and I felt my spirit illuminate an inner channel to my soul. I saw a montage of shapes, forms, and colors appearing before my inner vision. I had no idea what they were or what form they would take as I moved my brush across the canvas. Painting as fast as I could, I just let them emerge. Being extremely nearsighted, I took off my glasses so that I couldn't see the images that were forming. I was afraid that if I could see the images, I would begin to control them. I filled the entire canvas in a little over two

hours. Then I stepped back, put on my glasses, and to my delight, I was totally amazed to see the image of a woman rising into the heavens, leaving behind what looked like the weight of her earthly concerns.

The imagery in this painting symbolized my own spirit rising, and the feeling of that experience was translated into form without my conscious intercession. It felt pure and clean, unfettered by artistic manipulation. For years, my artistic works had been carefully controlled and contrived. I could never seem to get past my own obsession with realistically depicting my external world. Finally, with the creation

FIGURE 6-4.

ISHMIRA KATHLEEN THOMA

"This is an image of shedding an old ego-self, an imprisoning, limiting, self-identity that was no longer needed. To step off into nothingness, into the space of faith, requires a shedding process, a healing of faith. The seven steps represent the seven chakras through which we travel to the great leap."

of this painting, I felt as though I had escaped that obsession by looking inward and viewing my internal world, where reality isn't a thing but rather a feeling.

THE ENERGETIC EXPRESSION OF SPIRIT THROUGH ART

When I am working with clients and students who have evolved to the stage of healing in which a transformation of the spirit has taken place, almost invariably, I see a corresponding transformation begin to occur in their artwork as well. Quite often, that transformation involves a movement away from the depiction of their imagery as recognizable symbols to a more abstract form of expression. Many of them have explained to me that their imagery seems to be coming directly from a connection to what they sense to be energetic vibrations moving throughout their body. By transforming their negative thoughts and stressful emotions, they were able to release areas of blocked energy within their physical body. The release of emotional energy blockages, combined with a higher state of spiritual awareness, enhances one's ability to connect more directly and effectively with the body's energetic system, through which mental and spiritual consciousness move. When this heightened awareness occurs, an individual using visualization and body-centered awareness is able to tune in to the imagery of their energetic vibrations, which is more closely aligned with pure pulsating patterns of color and light as it moves through the body and beyond.

OUR ELECTROMAGNETIC ENERGY FIELD

Emotions and feelings are conveyed through the body on the waves of our electromagnetic energy field. Happiness, joy, peace of mind, and all such comfortable and pleasant emotions create a state of relaxation or more specifically an absence of tension within the body. This absence of tension enables our electromagnetic energy to flow smoothly throughout the body without interruption. Sadness, guilt, anger, and similar unpleasant emotions activate the stress response, which triggers body tension. Tension adversely affects the flow of energy through the muscles, skin, vascular system, and all the organs of the body. As a result of this internal tension, the energy flow gets blocked and is unable to move freely. Blocked energy causes physical pain like backache, arthritis, rheumatism, joint pain, and stiff neck. Eventually this results in nerve, muscle, tendon, and system deterioration along with immune system dysfunction, which ultimately paves the way for illness and disease to set in.

When we visualize an image of what is going on in those parts of the body that feel tense or when we are focusing on areas in which we know or sense the presence of physical deterioration or disease, what we are really feeling is the sensation of our blocked energy. As we release our limiting thoughts and beliefs along with

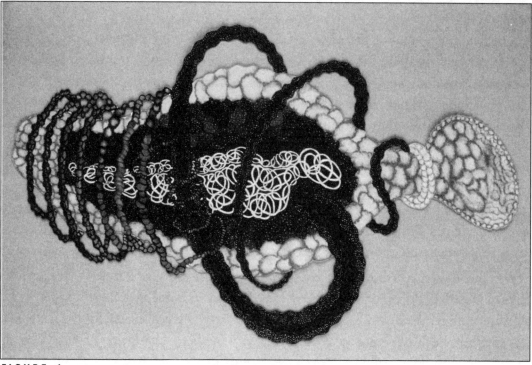

FIGURE 6-5.

Intestines

ANN LEDA SHAPIRO

"My art is about the body as landscape: interior and exterior, dark and light, male and female, what is aliveness and what is death. Intestines is one of a series of cutout paper paintings in which body parts are rearranged with the elements of nature to express emotional and spiritual states, exposing what is hidden—like X-ray vision. I was drawn to study traditional Chinese medicine to more deeply understand the nature of my paintings. As a practicing acupuncturist, I am working with the body's energies and how it all connects. The art inspires the medicine and the medicine inspires the art."

the painful, stress-producing emotions they create, we are releasing the energetic blockages and restoring the natural flow of our energy throughout the body.

The electromagnetic energy that flows through the body is, as quantum physics has shown, the substance of life, of matter, of all creation. Energy makes up the unified field believed to connect every atom and subatomic particle throughout the universe. By observing light photons, it has been discovered that energy carries intelligence, responds to intention, and is not local to our physical bodies nor to other living matter. This means that our individual energy system, which flows continuously throughout our body, is not confined by the limitations of our physical form—it flows through us and beyond us. Our energy is a part of the cosmic web that links all living things, forming a universal consciousness and intelligence. (See Figure 6-5, the painting *Intestines* by Ann Leda Shapiro, and color insert section, Plate 6, *Galactic Sea* #2 by Diana Wong.)

Through the movement and flow of our energetic system our thoughts, feelings, and emotions are expressed as pure vibration that can be sensed and felt by others. You have probably had the experience, as most of us have, of walking into a room and feeling that the person you were approaching was either receptive to you or not. You could *feel* their good or bad "vibrations." You may have noticed the same thing happening as you walked past someone on the street or stood next to someone in line at a grocery store, for example, and suddenly you found yourself becoming aware that this person gave off a feeling of hostility or agitation even though he or she may not have said a word to you or anyone else around you. What you are picking up on when this happens is another individual's energy field. Our energy field extends approximately three feet beyond our physical body. All living organisms—plant, animal, and mineral—have energy fields. Our energy field intersects with the energy of other life-forms when we are near them. Our energy is also connected through the unified energy field to all life-forms on this planet and throughout the physical and metaphysical universe.

My Energy Released

SABRA

"This is what my energy would look like if it were released. It would be explosive, uncontained, beautiful to behold and as pure in its emotion as it is in its color."

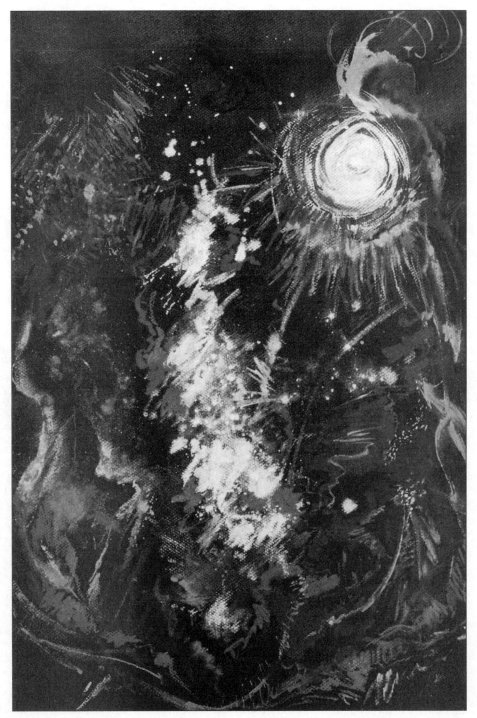

FIGURE 6-6.

Following Antoinette C. Ledzian's own experience with the release and destruction of old patterns of belief and emotional response, she created a painting she called *Epiphany of the Soul: One with God, Supernova, Rebirth* (see color insert section, Plate 7). In this piece, she was able to feel her soul's energetic connection as it moved outward from her body through a "rainbow-colored umbilical cord" to connect with God. To see a few more examples of how other artists have expressed their own sense of energy and what that means to them, see Figures 6-6 and 6-7, as well as Plates 8, 9, and 10 in the color insert section.

The Black Pearl

SABRA

"This is the essence of who I am. But it is kept safe within me, cradled by my soul's energy. I am not ready for it to emerge yet—I am just learning who I am. I am not yet prepared to share myself fully yet."

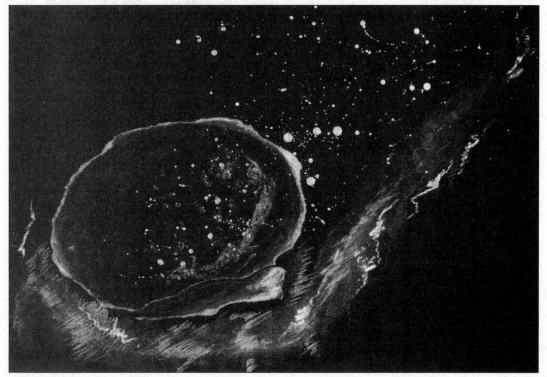

FIGURE 6-7.

EXPRESSING YOUR SPIRIT THROUGH YOUR ENERGY FLOW

The metaphysical universe is beyond the physical and enters into the realm of the spiritual. I believe that our soul's intentions and messages move, as do our emotions, through our energetic system. If our emotions are expressed and carried beyond our physical bodies and transmitted through the unified field of energy to others, then it seems quite reasonable to assume that our spirit's energy is also transmitted via that same system. Energy, as Einstein once said, can be neither created nor destroyed, it simply changes form. Thus I believe that the vibrations of our spirit or soul are pure energy that resides in union with the physical body's energetic system, and when the body dies, that energy and the individual consciousness that each of us possess does not die; it is released into the higher realm of universal spirit consciousness. This, of course, is my own personal view. How you sense or interpret your spirit's presence within your physical body and its connection beyond the boundaries of your body is up to you.

If you don't already have a clearly defined impression of how your soul or spirit is expressed through the vehicle of your physical body, then this exercise will help you tap into your body's energetic field so that you are able to sense and feel its wave vibrations and the pattern and movement of its flow throughout your body. You will be directed, through the guided visualization that follows, to bring your conscious awareness into your heart center, where you will be guided to tune in to your heartbeat, and then to experience the pulsating waves of energy flowing and moving throughout your body. You will then be guided to imagine what that would feel like as pure pattern and color. From there you will be instructed to sense your soul's vibration as it begins to emanate from your heart and flow into your body's energetic system. You will then express what you visualized or felt in a drawing or painting. I specifically mention drawing or painting and not sculpture or collage, because color and its movement or flow will most likely be prominent in both your visualization and the finished piece.

An example of this approach can be seen in this drawing by one of my holistic counseling graduate students, Stephanie Birnbaum. Stephanie had someone lightly

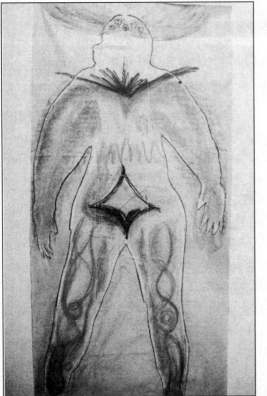

Full Body Energy Drawing

STEPHANIE BIRNBAUM

FIGURE 6-8.

draw an outline of her body on a seven-foot sheet of four-foot-wide newsprint. During the visualization, she imagined being able to see her entire body as if it were completely transparent and she was above it looking down and able to see her spirit's energy flowing through it. Then using the flat side of pastel chalks, she drew broad strokes of color to depict the movement of her energy throughout her entire body.

You can do this exercise either as a full-size body drawing, in which case you will need to prepare your drawing or painting surface by having someone trace your body's outline as you lie on the paper or canvas, or you may find that you want to be free to see how you perceive your energy's flow and its connection beyond your body during the visualization before you decide how to express it.

HOW TO BEGIN

I suggest that you pretape, in your own voice with some appropriate gentle music as background, the guided visualization that is about to follow. This visualization is lengthy because you will need to allow yourself to move into a deeper state of

awareness than has been necessary in previous exercises. In this exercise, as you move your awareness into your heart center, and then connect with the flow pattern of your body's energetic system, you will begin to sense the flow of your spirit's energy and will be able to feel the merging or comingling of these two forces. At first you will feel the vibrations, and then you will begin to see or sense the flow of waves of color and shape as these two energy patterns move throughout your body. You will then be guided to sense how they move or extend beyond the confines of your physical body to connect with the divine source of all energy.

NOTICING YOUR ENERGY BLOCKAGES

Be aware that you may discover energy blockages as you do this visualization or during the actual process of drawing or painting your energetic flow. If this occurs, don't be alarmed. Everyone has energy blockages most of the time. In Stephanie Birnbaum's drawing, you can see one such blockage or fixed energy in the pelvic area—the blue diamond shape. This is simply the immobilized emotions that need to be explored, which you can do imagistically, by working further into the colors and shapes that you find yourself expressing in this energy piece. You can do that directly on this drawing or painting, or you can do an entirely new piece—whichever feels best for you at the time. The act of doing this drawing or painting will actually help facilitate the movement of any blocked energy points you encounter.

GUIDED VISUALIZATION

Sit in a comfortable position with your eyes closed, and take several deep, slow breaths. (Pause) As you breathe deeply, feel the rise and fall of your chest as you inhale and exhale. (Pause) With each intake of breath, imagine that you are drawing into your lungs any tension you may be holding in your body and releasing that tension with each exhalation of your breath. (Pause) Feel your body becoming more and more relaxed as you consciously release this tension. (Pause) When you feel relaxed and at ease, allow yourself to breathe normally while still focusing on the rise and fall of your chest. (Pause) Continue to breathe for several minutes, allowing any conscious thoughts, worries, or concerns that you may notice passing through your mind at the moment to simply pass by without allowing yourself to attach to these thoughts or concerns or to dwell on them. (Pause)

*When you feel totally relaxed, imagine gathering your conscious aware-
ness into a tiny bead of light, and imagine that tiny bead of light nestled
deep within your cranial cavity. When you are ready, imagine moving that
light to the innermost part of the top of your head.* (Pause) *With this light
of your conscious awareness located now at the top of your cranium,
allow yourself to tune into or become aware of the flow or rhythm or
vibration of your inner energy as it moves through this part of your body.*
(Pause) *Sense the flow and movement patterns as your energy vibrates
within you.* (Pause)

*It may take a few minutes before you sense an energetic connection to this
inner flow or rhythm. When you feel yourself connecting with it, allow
yourself to feel it and see it if possible or imagine what it would look like.*
(Pause) *What colors do you sense your energy to be?* (Pause) *What pat-
terns of movement does it have?* (Pause) *Do you sense any images emerg-
ing into your awareness that seem to be emanating from your inner
energy?* (Pause) *Do you sense or feel any blockages or stuck areas of
energy?* (Pause)

*When you feel as though you have connected with the flow or movement
of energy within your cranium, allow your tiny bead of light—your con-
scious awareness—to float ever so gently downward into your throat,
and allow yourself to tune in to the energy flow and pattern of movement
and vibration within your throat area. What does this flow or movement
of energy look like?* (Pause) *What colors do you see or sense? Are there
any images coming into your awareness?* (Pause)

*Then allow the light of your conscious awareness to move down into your
shoulders, and sense or feel the flow of energy within that area.* (Pause)
*See the colors, patterns of movement, and any images that arise from that
area or any blockages that might be present.* (Pause) *From your throat,
allow your awareness to move into your heart center and tune in to the
energetic flow emanating from within and around your heart.* (Pause)
Again, try to imagine what this flow or movement of energy looks like.

(Pause) *What colors do you see or sense? Are there any images coming into your awareness?* (Pause)

From your heart, allow your awareness to move into your abdomen and tune in to the energetic flow as it moves within this part of your body. (Pause) *Imagine what this flow or movement of energy looks like. What colors do you see or sense? Are there any images coming into your awareness?* (Pause)

From your abdomen, allow your awareness to move into your pelvic region and tune in to the energetic flow as it moves through and around this part of your body. Imagine what this flow or movement of energy looks like. (Pause) *What colors do you see or sense?* (Pause) *Are there any images coming into your awareness?* (Pause)

From your pelvic region, allow your awareness to move into your legs and tune in to the energetic flow as it moves through both your upper legs, knees, and lower legs. (Pause) *Imagine what this flow or movement of energy looks like.* (Pause) *What colors do you see or sense?* (Pause) *Are there any images coming into your awareness?* (Pause)

And finally, from your legs, allow your awareness to move into your feet and tune in to the energetic flow as it moves through and around both feet. (Pause) *Imagine what this flow or movement of energy looks like.* (Pause) *What colors do you see or sense?* (Pause) *Are there any images coming into your awareness?* (Pause)

Now that you have scanned your entire body from head to foot, move the light of your conscious awareness back up into your heart center. (Pause) *Become present to the feeling of being within your heart center.* (Pause) *Be with that feeling for several moments.* (Pause) *With your awareness now present to your heart, imagine what it would feel like to tune in to your soul's energetic vibration emanating from deep within your heart center. Can you imagine that?* (Pause)

What does it feel like to be in tune with your soul's vibration? (Pause) Imagine now sensing the flow of that energetic vibration of your soul from deep within your heart. (Pause) What does that flow feel like? (Pause) Where is it flowing to or toward? (Pause) Is it moving outward from your heart center and connecting with the rest of your body? (Pause) What is the path and pattern of its movement? (Pause) What colors do you see or sense as part of your soul's energetic vibration? (Pause) What shapes or forms or images seem to be emerging, if any, from within your soul's vibration? (Pause) Are there any areas within your body in which you feel that your soul's energy is blocked or immobilized? (Pause) What does that blockage feel like? (Pause) What does it look like? (Pause)

Imagine that you can allow the light of your conscious awareness to move above your body so that you can look down and view your entire body. (Pause) Imagine that you can now see the flow and movement of your entire energy system as it courses throughout your body. (Pause) Imagine that you can also see your soul's energy or spirit emanating from deep within your heart center as it moves outward, pulsating in union with your body's energetic flow. (Pause)

Imagine now that you can also see the flow of both your physical and spiritual energy moving beyond the confines of your physical body and extending outward into the space around your body as an aura of light, pattern, and color and connecting with what you envision as the unified field of energy that surrounds the entire planet and extends throughout the entire universe. (Pause) What do you see or sense this energetic flow and connection to look like? What colors do you see or sense? (Pause) What are the lines or places of connection between your body and spirit's energy and the unified field? (Pause)

When you sense that you can express in a drawing or painting the movement, flow and pattern, and color of your body and spirit energy, as well as the flow and connection of your energy as it extends beyond your body

and intersects with the unified field of universal energy, open your eyes and begin to create a drawing or painting that expresses it. (Pause)

As you draw or paint, you will still be connecting with your energetic field, so allow yourself to follow the guidance of your intuition and draw or paint whatever images, shapes, forms, or colors seem to want to be expressed as you are engaged in the act of expressing your body and spirit's energy.

When you have completed this painting or drawing of the expression of your body and spirit's energy system, put it up on a wall where you can look at it for a few days, allowing yourself consciously and unconsciously to react to it. Notice how you feel as you look at it or pass by it. What part of your body do you sense yourself being drawn to or reacting to as you observe this piece of artwork? Then when you are ready, you can address the self-dialoguing questions in the next exercise.

Exercise 4

PROCESSING YOUR ARTWORK

The following self-dialoguing questions will help you understand the symbolic meaning of the transformative imagery expressed in the artwork you created in response to the previous exercise. Write your responses to these questions in your healing journal.

1. Describe what your experience was like during the visualization as you felt yourself tune in to your own energy field.
2. How have you been reacting to this piece of artwork now that it is complete?
3. What part or parts of your body seem to feel a reaction or response as you look at this drawing or painting of your spirit's energy?
4. As you look at this drawing or painting now, how do you feel about it?
5. What have you discovered about your body's energy system from doing this exercise?
6. Describe how this artwork depicts your soul's energy connecting to the divine source or universal energy field.
7. What have you learned about yourself and your soul's expression from doing this piece?

8. What do the colors you used in your drawing or painting suggest to you about your physical and spiritual energy?
9. Did you visualize or express in your artwork any areas of energy blockage? If so, what does your drawing or painting suggest to you about these areas?

DISCOVERING YOUR SOUL'S PURPOSE

Once you have opened the connection between your body and soul, your spirit and the universe, your soul is free to express its divine purpose. The soul's purpose is to fulfill the intention for which it incarnated into flesh in this lifetime. Each one of us

FIGURE 6-9.

Scar

DIANE K. DOERSCH

"I used my own body as a source of imagery for a series of paintings of scars. The scars hold meaning for me not only as personal blemishes or abnormalities, but also as a record of significant past events. Influenced by readings in forensic science and anthropology, in which scientists gather from bits of wood, bone, or artifacts astounding amounts of information which has been 'written' upon these objects as the organisms lived and even long after they died, I began to look at scars as places where the world is writing our histories upon our bodies. As such, they come to represent humanity's connection to the natural world, where instead of existing as autonomous and alien, a human being is penetrated by the forces of nature, and although vulnerable, is therefore also a part of something immense."

has a divine purpose, which I believe is but a mere seed of intention at the time of our birth. If that seed is noticed and nurtured, it will grow and flourish. But many of us never discover our purpose, so our precious seed of intention can never be cared for and tended, and then all too often it withers away. Our soul purpose gives meaning to our lives. As our seed of intention takes root and grows, it fills the emptiness so many of us feel inside when we mindlessly pursue the goals and dreams set out for us by others.

When people take the time to communicate with their soul, they often discover that their soul's purpose and the life goals they have set for themselves may be quite different. Yet when they finally become aware of their soul's intention, they say it's as if the idea of that purpose was always there inside them—they just didn't take it seriously. They ignored the pulls or opportunities that would have taken them in that direction.

A woman who took one of my workshops had been working for several years on her master's degree in psychology. She had thought she wanted to be a psychotherapist, but she was beginning to realize that her heart really wasn't in it. But even once she realized that counseling wasn't her soul's purpose in life, she didn't want to quit because she didn't have a clue about what else she would want to do instead. Nothing excited her. When we did the exercise in class to discover one's soul purpose, she was shocked by the results. The message she got from her soul clearly indicated to her that her purpose in life was to become a lawyer and work with underprivileged women. All of her life, she explained to the group, she had fought pressure from her family to study law. It seems that her entire family, for three generations, had been lawyers. Through her exposure to her family's preoccupation with money and power perpetuated by their involvement in a multigenerational, family-owned law firm, she had come to hate the idea of being a lawyer. It never occurred to her that the law could be used to serve the less fortunate, which is why she went into psychology in the first place. And it certainly never occurred to her that she could practice law outside the family business. The more she thought about it, the more she admitted that she had denied the tugs of her soul throughout her entire life. Since taking this workshop, she has since gone on to law school and is now working happily in an all-female private practice of attorneys who specialize in protecting women's rights.

This example is not to say that everyone who does this exercise will find their

soul's purpose to be a shocking surprise, but many of you may be astonished to discover that what you thought was your path, your purpose in life, may turn out to be a dead end. So keep an open mind and heart as you approach this exercise. And do remember that if your purpose appears to be something you would never have sought out for yourself, and you can't even imagine how you would begin to pursue it, your soul will know the way. If you trust its guidance, it will lead you in the right direction.

The soul's purpose is not always about following a particular career path. The soul works its intentions in many miraculous ways, and one way is never more important than another. While one person's soul purpose might be to serve others as a lawyer, an artist, a musician, a banker, a doctor, a nurse, or a teacher, another person's purpose might be as a parent to a child, as a mate to one's partner, or to touch the life of one particular person or group as a friend or relative. A woman in one of my cancer groups said she had always known that her soul purpose in life was to somehow serve as an instrument in helping people unravel their relationship entanglements. Whatever your soul purpose turns out to be, it is important not to judge it. No one can ever predetermine how important their soul's contribution in life is when they use human standards to evaluate it. Our soul's purpose is divinely inspired, and as such, we may never know the full impact and extent of its influence.

HOW TO BEGIN

I recommend that you pretape the visualization directions in this exercise, because you will need to devote your full attention to the meditative experience as your awareness is guided into your heart center, where you will meet an image or vision of your soul self. In this visualization, you will imagine your soul self presenting you with a symbol that will represent your life purpose. This symbol may feel familiar because it *is* familiar on a deep subconscious level. This symbol represents the seed of intention that you were born with. This exercise helps you bring forth an intention that already exists inside your heart and soul.

MATERIALS

Let your visualization experience guide you in selecting the materials or mediums that are best suited to expressing the symbol of your soul's purpose.

FIGURE 6-10.

Transformation

BETTY KEISEL

"My work is an integral part of my life in which I can express my feelings and concepts of existence. I need to continually renew my thinking to keep it fresh and current with new thoughts and awareness, making changes as needed in my life and work. Eventually, we do become the person we were meant to be and go on to help others to see the way of the soul."

GUIDED VISUALIZATION

Sit in a comfortable position with your eyes closed, and take several deep, slow breaths. (Pause) As you breathe deeply, feel the rise and fall of your chest as you inhale and exhale. (Pause) With each intake of breath, imagine that you are drawing into your lungs any tension you may be holding in your body and releasing that tension with each exhalation of your breath. (Pause) Feel your body becoming more and more relaxed as you consciously release this tension. (Pause) When you feel relaxed and at ease, allow yourself to breathe normally while still focusing on the rise and fall of your chest. (Pause) Continue to breathe for several minutes, allowing any conscious thoughts, worries, or concerns that you may notice passing through your mind at the moment to simply pass by without allowing yourself to attach to these thoughts or concerns or to dwell on them. (Pause)

When you feel totally relaxed, imagine gathering your conscious awareness into a tiny bead of light, and imagine that tiny bead of light to be nestled deep within your cranial cavity. Then ever so slowly and gently allow this tiny bead of light to drift downward toward your heart center. When you sense your awareness to be present within your heart center, imagine this light of your conscious awareness illuminating this part of your body from within, and imagine yourself walking down a quiet and safe moonlit path at night. (Pause) As you look around, you see the path stretching out before you. (Pause) On each side of the path you see trees and shrubs of beautiful flowers whose petals glow in the brilliant moonlight. There is a canopy of stars above your head, and although you are alone as you walk this path, you feel safe and protected. (Pause)

As you continue to walk on the path, you see ahead of you a glowing ball of white light moving slowly toward you. (Pause) As it comes closer and closer, you begin to see a form emerging from the light. This form, although translucent, is now clearly visible to you. It is an image of a person, someone with whom you feel intimately connected. (Pause) As you stare at the

image of this person, you begin to realize that this image is the representation of your soul self. As you move closer, you feel the wisdom and love that emanates from your soul self filling every part of your physical self. (Pause)

As you approach your soul self, you see that he or she is holding a golden box. As you now stand face-to-face with your soul self, he or she gently hands you the golden box. (Pause) You take the box, for you know that within it is a gift—your special gift. This gift is the symbol that you carry within you. It is the symbol of your life's purpose. This gift has always been there waiting for you to notice it. (Pause)

You open the box and look inside. What do you see? (Pause) What is the symbol of your life's gift? (Pause) When you know what it is, take it out of the box and hold it in your hands. (Pause) Press the symbol to your body, and allow it to merge and become a part of your physical and mental self. (Pause) Feel the joy deep inside, now that you know the purpose for which you were born. The comfort that comes in knowing this purpose will guide you on your path in life. (Pause)

Now when you are ready to outwardly express this symbol, open your eyes and create in a drawing or painting or sculpture or collage what will be an artistic representation of the symbol of your soul's purpose.

The artwork that you create to express this symbol of your soul's purpose will become a visible and tangible representation of your divine intention. The process of creating this symbol and then being able to live with this creation on a daily basis will continue to motivate and influence you on both a subconscious and cellular level, reinforcing your inner drive to move toward your soul's purpose.

Exercise 6

PROCESSING YOUR ARTWORK

The following self-dialoguing questions will help you understand the meaning of the symbol you visualized and expressed as a representation of your soul's purpose.

Write your responses to these questions in your healing journal.

1. Describe in your healing journal what the symbol of your soul purpose looks like.

2. What do you feel your soul's purpose is, based on what this symbol is telling you?

3. How do you feel this purpose can fit into your life right now?

4. How do you see this purpose unfolding in your future?

5. Does this soul purpose provoke any fear or apprehension in you right now? If so, what?

6. If you are feeling some fear or apprehension about following the direction indicated by the symbol of your soul purpose, what do you sense these fears and apprehensions may be trying to teach you?

7. How can the lessons you might learn from your fears help you in pursuing and fulfilling your soul purpose?

8. How can you begin today and in the coming days to integrate your awareness of your soul purpose more consciously into your life?

9. Was the symbol of your soul's purpose a surprise or did it feel familiar to you?

10. Have you seen any evidence of your soul's purpose manifesting in your life in the past? If so, how?

This drawing is an example of a symbol of soul purpose created by Nicki Toler,

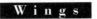

Wings

NICKI TOLER

FIGURE 6-11.

a member of one of my healing-with-art groups. At first when Nicki drew the image of the wings, she said, they were separated, disconnected. But as she continued to look at them, she felt that they definitely needed to be connected in some way or they wouldn't be able to fly. After staring at them for a while, it finally occurred to her that they needed a heart to connect them. So she drew a heart in between the wings, and that created the necessary connection.

As Nicki began to talk about her symbol with the group, she came to realize that the wings represented a new direction she would soon begin to take in her life as a writer. Although she had been working as a professional writer for the last few years, lately she had been feeling as though her heart wasn't in it. "The wings," she said, "symbolize a new beginning in my work, a new chapter in my life." I asked her what she knew or sensed about this new chapter and how it related to the wings. "I don't know," she replied, "but what's interesting about this symbol is that it reminds me of the kind of wings I have seen in so many Italian Renaissance paintings, and that's interesting because the one thing I've been thinking about lately is how much I would really like to write about my one love—Italy."

Nicki had lived in Italy for a time and had recently returned there for a visit. The more she talked about this symbol somehow being related to her desire to write about Italy, the more animated and excited she became. As she continued talking with the group about her symbol, it became crystal clear to Nicki that her gift for writing must be used to write about those things that have touched her deeply. (For another example of a symbol of soul purpose, as expressed by Susan Fox in her drawing *Woman Who Swims Through Life,* see Figure 6-12.)

FOLLOWING YOUR SOUL'S GUIDANCE

As you may have experienced after doing these last two exercises, knowing your soul's purpose can sometimes be both an exciting and a frightening revelation. While it may help you clarify the direction you need to take in order to pursue your soul's purpose, it can also be a bit scary if your purpose seems to contradict the life goals you have already set up for yourself. If this is the case for you, keep in mind that there are many ways to achieve the soul purpose you have just discovered. Trust is an important part of fulfilling that divine purpose. Up to this point in your life, you may have been moving in a direction that now seems in total opposition to where you would have gone had you been more aware of your soul's purpose. You must trust that a seemingly

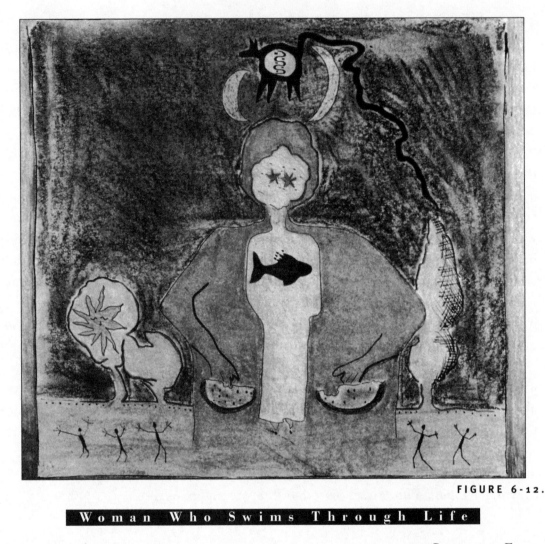

FIGURE 6-12.

Woman Who Swims Through Life

SUSAN FOX

"The fish in this drawing is a symbol of my soul's purpose. I saw it appear within an image of my inner or soul self, which I visualized inside an image of my outer self. I believe that the fish represents a spiritual trusting that is essential for me to embrace and live by if I am to move through life freely without fear and resistance. The watermelons represent my soul's desire to reexperience the kind of bliss and joy I remember from my childhood. This symbol appeared to remind me that my soul's purpose is to teach others how to live in joy and contentment without fear, but first I must learn to do it for myself."

extraneous direction may have been precisely the path you needed to be on. Often in hindsight, it is easier to see how the many divergent pathways we've taken in our lives may have provided us with crucial pieces of information and essential lessons that we needed to learn in order to one day bring us around to the right path. Trust that nothing is ever a waste of time. And trust that there is no choice you can make that is ever a mistake, as long as you are able to learn from the experience.

SEEING YOUR LIFE THROUGH THE EYES OF YOUR SOUL

The final and most significant stage of self-healing takes place when you begin to see your life through the eyes of your soul. Becoming aware of your soul's purpose often facilitates the ability to see your life from this new perspective. The eyes of your soul see a different vision from that of your physical eyes. The soul sees the lessons behind each and every experience you encounter. When there is pain and sorrow, your soul will implore you to ask yourself: why did this happen *for* me? This question is quite different from the one the mind often asks, from its limited perspective, when it demands to know: why did this happen *to* me? Although these are similar questions, their answers will yield radically different outcomes. The answer to the first question will tell you what you were meant to know and learn about yourself and others from a painful experience, and how the experience itself was meant to serve your soul's purpose in this lifetime. The answer to the second question will do little more than set you up to feel self-pity, blame, and anger.

TRUST, FORGIVENESS, AND UNCONDITIONAL LOVE

When you are able to make the shift from seeing your painful experiences through your human eyes and expectations into seeing these same life events through the eyes of your soul, you will have transitioned into a state of heart and mind in which you can no longer believe in mistakes or failure, nor can you harbor ill will toward others. This blessed state is called *Trust,* and the two most important emotions that emerge from a state of trust are forgiveness and unconditional love.

When you can trust that all things happen for a divine reason, you will be able to forgive those who hurt you. And it is through forgiveness that you can once and for all heal the wounds of your past by releasing your hatred, anger, and judgment. When you suspend judgment, you embrace the purest form of love—unconditional

love. Only through unconditional love and forgiveness toward all can you follow, without wavering or distraction, the soul path you are meant to walk.

SEEING AN EXPERIENCE THROUGH THE EYES OF YOUR SOUL

We all have experiences that leave us wondering why—why did this happen to me? In this next exercise, you will have an opportunity to focus on any experience in your life—past or present—that still has you asking that question. This time, you will be guided to examine this experience through the eyes of your soul as you ask a different question: why did this happen *for* me?

Wishbone Series: Counting Days

LIESE PFEIFER

FIGURE 6-13.

"In May of 1994, I lost to cancer my dear friend, artist, and collaborator, Lois Nowicki. It was three months from diagnosis to death for this sweet soul. This event coincided with the loss of my first pregnancy. In my struggle to reconcile these losses, I thought of the number of times we face elements of chance in our lives and how little we can control them. I quickly went to memories of wishbones: the anticipation of holding one side, not knowing if I'd break off the big part and 'win' or get the little part and 'lose.' Sometimes I'd keep the wishbone for months before breaking it. Wishbones are also a symbol of hope, at least before they're broken."

During the guided visualization that follows, you will be instructed to move your conscious awareness into your heart center, the keeper of your soul, where you will ask your soul to present you with images that represent why this experience happened for you. Once you know what your soul's images are, you can use them to create a piece of artwork that portrays this experience as it is seen through the eyes of your soul. The answers you will receive through your soul's imagery will help you see the blessings—the life lessons—behind the experience.

By acknowledging the blessings, you can begin to understand exactly what you have learned or what you were meant to learn from this experience. When we open ourselves to the lesson inherent in each experience that we encounter, we facilitate not only our own emotional healing, but we also expand our cognitive understanding of ourselves and others, an understanding that fosters our ability to feel compassion and empathy toward all living beings. Only through our willingness to learn the soul's lessons can we awaken to the inner joy and peace of mind that comes when we begin to know—not think, not hope, not speculate, but know in the depths of our soul—that nothing in life can hurt us. When we embrace and trust the divine purpose, the cosmic reason for every painful and seemingly senseless occurrence in our lives, we energize the inner drive within us that will keep us moving steadily toward the fulfillment of our soul's purpose.

HOW TO BEGIN

To begin this exercise, open your healing journal and write down a brief description of a particular experience in your life that you desire to see through the eyes of your soul. Following that description, write down the question you would like your soul to answer through its inner language of imagery: why did this experience happen *for* me? You may want to pretape this guided visualization so that you can concentrate fully on the visualization experience. When you are ready, position yourself comfortably, and begin.

GUIDED VISUALIZATION

Close your eyes and take several deep, slow breaths. (Pause) *Focus your attention on the rise and fall of your chest as you breathe in and breathe out.* (Pause) *Feel your lungs expand with each inhalation and contract with each exhalation, and feel your body relax and release any tension*

you may be holding with each outflow of your breath. (Pause) When you feel completely relaxed, allow yourself to focus on your body. (Pause) Become aware of your presence within your physical body, and then become aware of your body's presence within the room or space it is occupying at this moment. (Pause)

FIGURE 6-14.

The Gift

MARY WILBANKS

"For quite some time, my work has been a source of healing to me—both physical and emotional. There are certain healing images that I visualize, and they often appear in my work. From my experiences I have learned to live in the present moment and to regard each day of my life as a gift."

Now imagine your energy field emanating from within your body and flowing in waves outward beyond the confines of your body. (Pause) See or imagine that you are connected through a beam of white light entering through the top of your head and moving downward into your heart center—the keeper of your soul. (Pause)

Focus your attention on the experience you wrote down in your healing journal. (Pause) Imagine bringing the thought of that experience into the light of your conscious awareness, located deep within your cranial cavity. As the thought and memory of this experience joins with your conscious awareness, allow the light of your awareness to drift ever so gently downward into your heart center. (Pause)

With the light of your conscious awareness now resting comfortably within your heart center, ask your soul self to come forward. (Pause) Imagine seeing an image of your soul self standing within your heart center. (Pause) Imagine an image of your physical self facing your soul self. (Pause) Imagine your physical self asking your soul self to tell you, through its own language of imagery, why this experience happened for your highest good. (Pause) Ask what you were meant to learn from this experience. Be patient as you wait for the answer to your questions to appear. (Pause) Imagine your soul self stepping aside and inviting you to behold a vision as it begins to unfold before your inner eyes. There within your heart center, imagine that you can see or sense an image or a montage of images begin to emerge clearly within the sacred chamber of your heart center. (Pause)

When you feel that you know what image or images your soul has revealed that convey the divine reason why this experience was important to you in your life, open your eyes and use whatever art materials or mediums seem best suited to expressing your soul's message.

It doesn't matter whether you express your soul's vision of this experience as a quick sketch or a fully developed piece of artwork, the vision will come through in

either form. When the artwork is complete, you may know immediately what the imagery means, or you may find yourself entirely baffled by the piece. Don't worry if you experience the latter reaction. Place the artwork at a distance from yourself and spend some time now and again later just looking at it. Take the images in and feel yourself react to them. Then answer the self-dialoguing questions in the next and last exercise of this chapter.

To see an example of how one of my students interpreted a mandala that she created after doing this same exercise, see color insert section, Plate 11, *My Soul's Truth* by Kim Cragin.

Exercise 8

PROCESSING YOUR ARTWORK

The following self-dialoguing questions will help you understand the meaning of the symbol you visualized and expressed as a representation of your soul's purpose. Write your responses to these questions in your healing journal.

1. Describe the image or images you expressed in your artwork that represented your soul's view of the reason why the particular experience you focused on in this exercise happened for you.

2. What feeling or sensation do you get when you look at the art piece you created in response to this exercise?

3. How did you feel as you were working on this piece?

4. What message is your soul trying to give you through the imagery in this piece?

5. Based on the message in this imagery, what do you feel the lesson behind the experience was?

6. What personal strengths and qualities do you now have that would never have developed if this experience hadn't taken place in your life?

7. What blessing does your soul see in this experience and how is that expressed in your imagery?

These last two exercises can be used to explore your soul's vision of any experience in your life. In time, you will begin to communicate more directly and spontaneously with your body and soul as you become more fluent in your ability to use imagery rather than words for your own inner communication.

HONORING YOUR SOUL'S WISDOM

Being able to tune in to your soul's voice will be a major turning point in your life. When you live your life following your soul's guidance rather than your mind's directives, you will live without fear, without frustration, and without doubt. Imagine how living this way would bring a sense of freedom to every aspect of your life. Your thinking will be replaced by knowing. You will now know what is right for you as you face each choice and opportunity in your life. But none of this will happen if you don't consciously and faithfully practice honoring your soul's wisdom. And to honor it, you must care for it by listening to it, trusting it, nurturing it, and above all loving it. I am reminded, as I write this, of a quote by Thomas Moore in his book *Care of the Soul,* "By caring for the soul faithfully, every day, we step out of the way and let our full genius emerge."

FIGURE 7-1.

Benediction

MARY BEAM

"Through Nature we are healed. This painting was my attempt to thank God for all the blessings that have come my way and are so dear to me. I think that giving thanks is a universal healing tool that accesses and promotes the healing process. The viewer as well as the maker are both beneficiaries of this phenomenon."

Healing Others

Creating art that heals others is a practice whose roots go deep into the soil of human history. Through the centuries, these roots have branched out in all directions, deriving their sustenance and richness from the traditions of cultures that span the globe. More recently, and especially within the last ten years, there has been a resurgence of this age-old tradition, as artists and nonartists alike have discovered the power of art not only to heal themselves but also to heal others.

It is natural to want to share with others what one has learned. In this chapter, you will have an opportunity to take all that you have learned about using art to heal your own body, mind, and spirit, and apply that learning, if you desire, to help those around you.

In Session Six, you will be introduced to the various ways in which art can be used to facilitate the healing of others. You will also learn about some of the theories that support the efficacy of art as a healing vehicle that can affect an individual's emotional well-being, physiological functioning, and spiritual consciousness. In addition, you will become acquainted with several extraordinary artists who are using their art to help others heal, along with some commentary from a few of the people who were the recipients of this healing art. This session will conclude with an exercise that can help you create a piece of artwork intended to aid in the healing of another person or a group of people.

Following Session Six, the last section in this chapter, entitled "A Community of Artists," will bring this book to a close. Here you will meet several artists who were instrumental in inspiring me to begin writing this book four years ago.

Session Six

HOW ART CAN HEAL OTHERS

Through reading this book, you know by now that an image held in the mind can positively or adversely affect one's emotional state and physiological functioning. When that image is expressed in a tangible form, such as a drawing, painting, photograph, a film, a piece of sculpture or collage, the expression of the image affects not only the creator but also the viewer. I'm sure you have had the experience of seeing a film or a play that touched you deeply—moving you to tears or laughter. A painting or any other art form can do exactly the same thing. Art can produce a vicarious experience for the viewer that can elicit an emotional response. Any emotional response will alter an individual's body chemistry, which in turn affects metabolic functioning. When the emotional response is positive and uplifting or cathartic, it activates the release of healing endorphins into the bloodstream that boost the immune system, reduce or eliminate the stress response, and enhance metabolic functioning, all of which are crucial components in the healing process.

HEALING INTENTIONS

Since art has this power to activate emotional and physiological reactions, an artist has a responsibility to be cognizant of his or her intentions when creating healing artwork. Because art is, in essence, prayer made tangible and even palpable, the artist must take care to be sure that his or her intentions are directed toward the highest good of the person or persons for whom the artwork is being created.

We know from the numerous research studies conducted in the last few years on the impact of prayer in healing that the intention behind the prayer is crucial. (See *Prayer Is Good Medicine* by Larry Dossey.) What these studies have shown is that prayer *does* work to bring about an outcome, but that outcome depends largely on the nature of the prayer.

Our thoughts, if they are positive, loving, and peaceful, can induce the flow of stress-relieving endorphins within our body, while if our thoughts are negative and fear based, they can initiate a stress-producing state within our body. Our thoughts create energy, and we know that our energy and that of others is not restricted to the confines of our physical bodies. Our energy flows through us and out of us, connecting us and our positive or negative thoughts to others. So it may very well be that when we send out positive thoughts in the form of a prayer stating our intentions, those thoughts or intentions may be picked up by others through our connecting energy fields, causing stress-relieving endorphins to flow inside their bodies just as if they had created the thought themselves. If this is what does happen, then it is easy to see why our intentions must be clearly stated before we engage in prayer. When we embody an intention in a piece of artwork, we magnify its power, which makes it even more imperative that we clarify our intentions before we create the work of art.

Studies have also shown that prayer is most beneficial to the one being prayed for when the person praying states his or her intentions in either of the following ways: "Please bring to (the person's name) whatever is in his or her highest good," or "Thy will be done regarding whatever it is that (the person's name) needs in order to heal." Humans have free will, so if we ask for something, we may just get it because the power of our thoughts caused it to happen, not because a higher power granted our request. But if we leave the outcome to the universe or God and request that thy will be done, or whatever is in the highest good of that person be done, not ours, then I think we give divine providence the room to act in a way that *is* in the best interest of the person we are praying for. In other words, we get our will out of the way and allow God or the universe to do the work.

ACCEPTING THE WILL OF DIVINE INTENTION

We must always remember that in spite of our own desires or the desires of those we wish to help heal, recovery may not always be in the highest good of that person's soul. In our desire to help, we need to be willing to ultimately accept the will of divine intention, even if that means it is time for that soul to depart. If we don't, we set up ourselves and the person we are attempting to help to feel like failures. There are no failures in the process of healing, because healing is not about surviv-

ing, it is about letting go of our woundedness, embracing forgiveness, and opening ourselves to divine intention.

So the first and only rule of creating art to help others heal is to set an intention as you begin the artwork. That involves asking for divine guidance to help you visualize and create imagery that is in the highest and best good of the person or persons concerned. Then, as they say in AA, "Let go and let God" guide your creation.

ART THAT CAN HELP OTHERS TO HEAL

There are as many ways to create art that can help others to heal as the imagination can devise. However, to make this particular topic area more manageable, I have synthesized the various types of healing art into eight categories that will account for the majority of work that is being done today. This is not to imply that these eight categories represent the only artistic forms that can be used to help heal others. Anything and everything can be employed as healing art, if healing is the intention behind it. As I describe these various types of healing art, you will also see some examples of artwork that may fall into more than one of these categories. So think of the following categories as a basic framework from which any type of artistic expression may emerge. Then when you decide you are ready to begin creating your own healing artwork for others, you need only let your intentions and creativity be your guides.

SYMBOLIC HEALING IMAGERY

This particular type of healing art is the most common form produced to heal a specific person or a particular group of people. Symbolic healing imagery involves creating a specific image or combination of images that symbolize what the artist feels needs to happen for healing to take place.

The drawing in Figure 7-2, entitled *For Joel,* was created by Marcia Smith, an artist and illustrator. It is an excellent example of symbolic healing imagery.

Marcia describes the circumstances that precipitated the creation of this healing piece and her intentions while producing it in the following way:

> *"Two and a half years ago, I found out that a very dear friend and colleague was having a recurrence of soft cell alveolar sarcoma, a rare form of cancer that in his case had materialized in his lungs and heart. He was*

F o r J o e l

M A R C I A S M I T H

FIGURE 7-2.

thirty-two at the time, and had been dealing with the cancer since he was fifteen. Joel was a cantorial soloist in a synagogue, and it was emotionally and physically painful for him to have his lungs restricted by growths. I did this drawing as a visualization . . . to help him breathe freely, without hindrance, and to be able to continue to use his wonderfully expressive voice as a vehicle for his energy. I know that it helped me to do it: it was a way that I could focus my energy and mind for his benefit. He loved the drawing. It was returned to me following his death in March of 1996."

Just as Marcia experienced, an act of creating a piece of healing art for someone you care for not only helps the person in need of healing but it also helps the creator. It is a way of relieving that feeling of helplessness we all get when someone else is sick or in pain. It provides a way of focusing our energy and efforts that is not intrusive to the other person. This kind of healing artwork can be given as a gift to the person or persons for whom you are creating it, or it can be done anonymously. Like a prayer, a piece of healing art can be powerful regardless of whether the recipient knows about the piece or not. The power of the image can move through our collective energy field even though we have no conscious knowledge of the work. I do think, however, in the case of someone you are close to, presenting that person with the completed artwork can be especially comforting and encouraging, which in itself can activate both emotional and physiological healing at an even deeper level.

FIGURE 7-3.

Comfort Quilt

ALLEGRA KRAFT MCIVER

COMFORTING HEALING ART

This category includes any kind of artwork that is specifically designed to give comfort to another person. This could be a painting, drawing, photograph, or even a sculpture that depicts a particular scene or object that the person in need of healing finds comforting and nurturing. Or it could be a piece of artwork that is also useful in a comforting way.

This next piece, called *Comfort Quilt* (Figure 7-3), was created by artist Allegra Kraft McIver. It is a fifty-eight-inch-by-seventy-inch quilt made from cotton broadcloth. Allegra became interested in quilting when she was introduced to the technique of quilting by machine. Although her work has received national recognition for its unexpected combinations of pattern and color, her greatest joy has been creating special occasion quilts for close friends and family members. This particular quilt was made as a comfort healing quilt when a longtime friend from college got cancer.

The recipient of the quilt, Phoebe Rogosin Resnick, sent me the following statement and invited me to share with my readers how receiving this quilt made her feel. "The quilt was a complete surprise, arriving by mail while I was in the midst of chemotherapy. It was accompanied by a note from Allegra saying, 'This is to wrap yourself in comfort and healing.' I was overwhelmed and extremely grateful for the beauty and friendship that enveloped me, quite literally, through the patterns and pieces sewn together on my behalf. Such gifts of art can be powerful expressions of love and support for cancer patients. For me, there is a special kind of medicine in my comfort quilt."

Another artist whose work falls into the category of comforting healing art is Linda Light. Like most healing artists, Linda began doing her own healing art when she was faced with a life-threatening illness. Her immune system had broken down to the point that it was attacking nearly everything that entered her body. This illness became a life-altering experience as she went about eliminating all the toxins from her body. That's when she realized that her toxins also included her pent-up anger and rage. "I had to be totally honest with myself," she said as she explained her process of healing to me. "I had to ask myself why I needed this illness and what

benefit was it serving. Then I had to start creating the life that would satisfy my emotional needs, thus eliminating my need for the illness. I knew that I needed to start to view my life and my illness from a whole new perspective."

Using visualization and biofeedback, Linda began to turn her vision inward where she encountered a world of healing lights. "Each color," she said, "seemed to be used to heal a specific problem." When she regained enough strength, she began painting these light experiences, called the "Light Vibration and Ribbons of Light" series. After a while, she began doing these healing light paintings for other people who were going through difficult times in their lives. These works were as comforting and healing to others as they had been to her. (See color insert section, Plate 12.)

INSPIRATIONAL HEALING ART

This category includes artwork that is created and given to another person specifically as a source of inspiration, strength, hope, joy and love.

Susanne Pitak-Davis is an art therapist whose work encompasses all of these qualities. Susanne's introduction to using art as a way to help someone else heal began when her twin sister's breast cancer metastasized into her bones and lungs. When the oncologist told Susanne that her sister might have only a month or two left to live, Susanne turned, as she put it, "to the spiritual realm, since it seemed that there was nothing more that medicine could do. I began making angel sculptures reminiscent of the icons of saints I had seen during a trip to South America. These icons were covered with tiny milagro charms, which are believed to deliver miracles to the faithful. I felt so helpless that I feverishly began making these angel sculptures to protect my sister." Then a miracle did occur when her sister, Carol, went into remission. She survived another nine years. But her long-term recovery took a downward turn as leg pain sent Susanne's sister back to the hospital for a month. "During this time," Susanne explains, "I made my sister a small hanging angel wearing red shoes. Carol said she felt that the red shoes were like the ruby slippers in *The Wizard of Oz* . . . a promise that she would return home again. She did return home for a short time but ultimately decided that it was time to go, and she refused any further treatment. It was very hard to let her go," Susanne admits. "On the evening when I finally accepted that she would soon be gone, I created *Angel Leaving Landscape* to show my twin's soul passing into the world of spirit. In the last few days of her life, she reported seeing angels in her room, and it is my hope

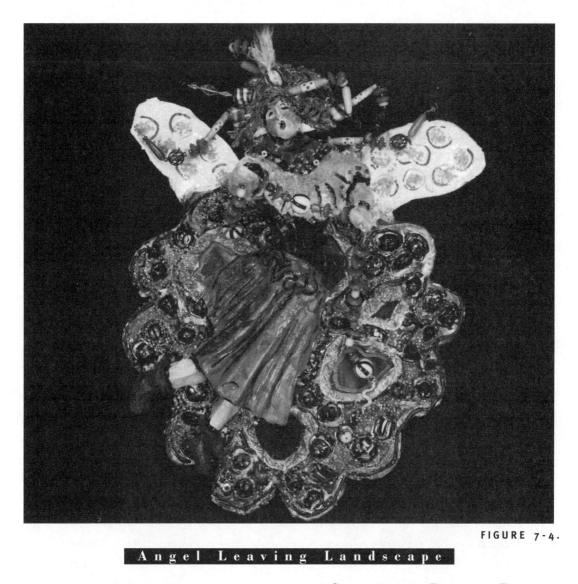

FIGURE 7-4.

Angel Leaving Landscape

SUSANNE PITAK-DAVIS

that they indeed were there to guide her to whatever the next life holds."

Another example of inspirational healing art is the painting by Kathleen Harum, *Alison* (see color insert section, Plate 13). Kathleen is an actor and artist whose artwork has always been a source of personal healing. But more recently, she turned to her painting as a way to help her three-year-old niece through a life-threatening illness.

Two weeks before the crisis began I had visited my sister's family to shoot a series of "fairy" photos of Ellen and her two daughters to use as photo references for my artwork. With an artificial sunflower pinned to her hair, Alison posed as if she were praying in the forest.

Because I had little experience with acrylics (I work primarily in oils and watercolor) and a new daughter to take care of, my progress on the painting was slow. At the time this frustrated me, but I now feel the length of time it took me was meant to be. When I finally gave a print of the painting to my sister and her husband, Alison was well "out of the woods." Had I given it to them any sooner, it may have been too much for them to handle.

Alison's father recently wrote Kathleen to tell her how much the painting had meant to them:

Yesterday as you know was Alison's birthday. She had a great day. After she went to bed, I spent ten minutes just looking at every inch of the print you gave us. I started to cry (I never cry). That print is the most wonderful gift we have ever received. I remember that day the picture for that painting was taken. Your painting captures every subtle moment of that morning and brings it all right back. It also brings me back to the start of the most horrible experience of my life because it was soon after that in the middle of the night that Alison had a seizure. I really want you to know what this painting means to me. Your painting makes me relive those times. At the time Alison went into a coma, I thought that "there is no God and if there is I don't want to meet him, look what he is letting happen to my little girl." After Alison's miracle of recovery, I thought he must be there, he answered our prayers and returned her to us. This print will be in our family long after we are all gone to remind us that God is there and miracles do happen, and we have proof of that. Thank you so much for spending your time and talent on our reminder.

Quite often, art that inspires others to heal is not initially created with that specific intention. Instead, the artist is simply creating art to heal his or her own personal

wounds. But when we heal ourselves, we not only help others to heal through our example but also learn through the healing process. That experience occurred for artist Jo Ann Durham in 1977 when she created a painting that she later called *Angel of Faith and Hope* (see color insert section, Plate 14). She explains what happened in this way: "I was pouring paint for some abstractions and at the same time mourning the death of my son John, who suddenly died at the age of twenty-four. As I poured the paint, this angel appeared. I stopped pouring and placed the work aside. Several days later I finished the painting by airbrushing around the central figure." Another example of inspirational healing art can be found in the next piece (Figure 7-5), by Dennis Eugene Hlynsky.

"In my search for images of caring men I soon discovered that caring was often not grand, forceful, or heroic; those gestures are reserved for the tragic times when the caring has stopped. The big issue of caring for oneself and for others is a design of constant considerations. The act of caring is an extended set of smaller actions, like the labor of feeding a furnace one shovelful at a time. This work was purchased by an elderly woman who had suffered from heart disease. She said she came to the clinic to exercise every day. She took inspiration from this work. Daily feeding the

L a b o r

D E N N I S E U G E N E
H L Y N S K Y

FIGURE 7-5.

furnace; the heart that burns within. When one has heart disease, one needs constant vigilance. The decisions to eat well are small decisions. The exercises are not strenuous but regular to build up tone. A macho man unwilling to alter a lifestyle of cowboy beef, cigarettes and whiskey will certainly die of heart disease. Labor is a kind of shrine to the constant small effort needed to gain health."

Cᴏʟʟᴀʙᴏʀᴀᴛɪᴠᴇ Hᴇᴀʟɪɴɢ Aʀᴛ

Some artists think of themselves as midwives in the healing process as they work together with a friend, relative, loved one, or in some cases a complete stranger to produce a healing art piece. This kind of healing art becomes, in a sense, a real soul connection between the person in need of healing and the creator. Collaborative art is most often inspirational and supportive of the individual's healing process.

Pam Golden is an artist/sculptor who joined forces with her friend Johnna Albi when Johnna contracted breast cancer several years ago. Together they created a series of clay masks. In the following narrative, Pam describes their collaboration: "We began our artistic collaboration as a way to both witness the breast cancer in Johnna's body and to create a visual focus for our prayers and hopes for her recovery. In the spring of 1994, I made a plaster cast of Johnna's beautiful head—without her gorgeous abundant hair—because of the side effects of chemotherapy.

Chemo Warrior

Pᴀᴍ Gᴏʟᴅᴇɴ

FIGURE 7-6.

From this mold we made clay masks. I created *Chemo Warrior* using the shell of a horseshoe crab—a most ancient being—to create a helmet/protection for her head. After she died at age forty-nine, I continued working with Johnna's cast face mold as a way for me to express my sorrow and to grieve. The sculptures evolved in a way I hadn't expected . . . offering grace."

Some other examples of collaborative healing art include the work of photographer Cynthia Katz and sculptor Christiane Corbat.

Cynthia Katz is a photographer whose work centers around her own life and those who share it. The photographs, Figures 7-7 and 7-8, are part of a series she created in collaboration with a friend going through the breast cancer experience. Cynthia titled the series *Deb Has Breast Cancer*. The prints in this series are selenium-toned gelatin silver prints and cyanotypes. Cynthia had this to say about the development and evolution of this project: "It was by Deb's initiative that we began making pictures in August 1995. Photographing in a variety of locations and circumstances, I hope the strength and the fullness of Deb's spirit, and some of the particulars of her experience with breast cancer come through."

It is always interesting and important to know how the recipient of the healing artwork felt upon seeing the final results. But in the case of a collaborative effort, it is also interesting to hear what the experience was like for that individual during the creation of the work. Deb, the artist's friend and cocreator in this series of photographs, was willing to share the following statement describing her experience.

"In August 1995, following surgery in April and four tough chemo treatments, I needed to find ways to externalize my experience. I asked Cyn if we could do some photos. At the second sitting, I looked at the initial set of prints, the ones with so little hair and so much visible pain. As I started to cry, I said to Cyn, 'Well, you did exactly what I wanted you to do.' Then we took more pictures. The depth and breadth of the emotional impact remains overwhelming and feels beyond description to anyone who hasn't dealt with something similar. That the struggle continues so intensely still surprises me. But seeing all the pictures again reminds me how far I have come."

Christiane Corbat is a collaborative artist whose work is dedicated to helping others through the healing process, but the impact of her work goes far beyond the individual for whom each piece is constructed. I have spoken with a number of people who have seen Christiane's work in various exhibitions, and they all report

FIGURE 7-7.

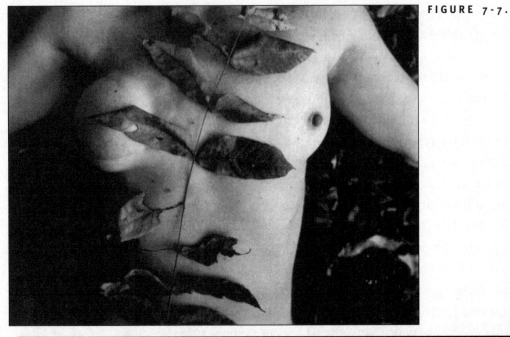

From the Series: Deb Has Breast Cancer

Cynthia Katz

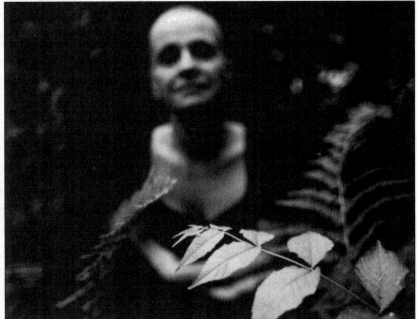

FIGURE 7-8.

being completely moved and transformed by the experience. I admit my own reaction was exactly the same. The first time I saw her complex, life-size sculptural creations, I was completely drawn into the aura that seemed to surround each one. When I look at her work, walk around it, peer inside the openings, and delight in the visually surprising combination of the natural materials she utilizes, I feel as though I have entered another dimension in time and space where I am walking into a fantasy world of make-believe images.

But Christiane's work is not about make-believe. It grew out of a very real personal crisis in her own life over ten years ago. As she learned how to heal herself through her own artwork, she then began to use her artistic gift to help others emerge, just as she did, from devastation to recreation. Christiane has this to say about her work:

> *Art influences and transforms life. I became convinced of this during the time of my own crisis, when I began making plaster castings of my body and transformed them into mythical, dreamlike images that embodied the qualities I wished to have as part of my life. This process not only healed me, it also gave me a tool with which to change my life. I asked friends to help further explore my theory by allowing me to make similarly transformative pieces about their battles with life-threatening diseases or with their deepest fears. Besides breast cancer and other forms of cancer and leukemia, I have made pieces with people who have many other physical and emotional problems. My intent is to create sculpture that pushes through and beyond illness or fear to a place where legends and myths live again and our dreams awaken.*
>
> *Each person confronting a crisis has his or her own special story, yet each one also embodies universal fears, hopes, angers, and realizations. Linking the uniqueness of the individual to global human concerns creates an image that touches many. Identification with the archetype, myth, or dream allows the model and the viewer to accept something too immense or difficult to otherwise grasp.*
>
> *There is a great deal of talk about the piece as we work on it, about the myth involved, the symbolism chosen that best suits the person's situa-*

tion. The way in which I make art, as a type of ceremonial process, creates a special atmosphere that allows us to explain truths about ourselves we don't usually get to share. The metaphor of art allows us to touch profound feeling without being threatened. The symbol which is created helps us to take on the qualities we seek in order to feel healed or whole in spirit, regardless of the state of our minds and bodies.

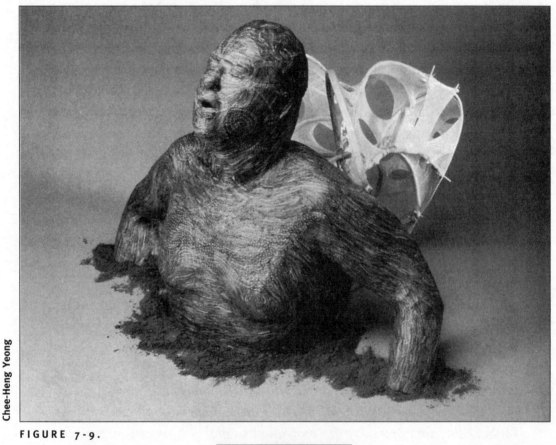

Chee-Heng Yeong

FIGURE 7-9.

Chrysalis

CHRISTIANE CORBAT

"I always tell people who wish to do a piece with me that it is their belief in the power of the creative act that brings about any transformation they seek, also the willingness to face their fear of change. I act as a kind of artist-midwife."

Christiane frequently uses a body cast of the person she is working with and then adds found objects to that sculptural piece. In *Chrysalis,* as shown in Figure 7-9, she did a body cast of a man who was trying to heal a significant loss in his life. The work's title implies transformation, which is the healing intention of this sculpture. The man is depicted as lifting himself from the earth, his head and face posed in a gesture of acceptance and release of his pain and torment. His wings are constructed from bittersweet vines and animal intestines. The body cast is covered with wasp nests, and the surface of the body is painted with the patterns used by Maori warriors. This healing piece symbolizes this man's intention to move from darkness into the light.

Christiane Corbat created a sculptural piece called *Amazon, Night Light* (Figure 7-10) for a woman from Providence, Rhode Island, Pamela Dalziel Cruze. Pamela wanted to share a few words about her experience as both the subject of this healing sculpture and a participant in the process of creating it.

I was familiar with Christiane's work before it ever occurred to me that I would be in that situation myself. When I was, I got in touch with her. Christiane and I discussed the work before she started making it. At that time she said it was difficult for her to find women who have something positive about their experience with cancer to bring to the work. And that, too, was the biggest challenge for me. How do I find something positive in such a terrible experience? I thought that was asking a bit much. But the more I thought about it, the more I realized that really was the challenge of my whole cancer experience, being able to construct it into a positive experience, which I began to see as something I could do just by making a series of choices. I could choose to interpret it in that way—and that I really had to be able to do that. I struggled with it for quite a while, and then I eventually did.

I think the breakthrough moment for me came after a trip I took to Arkansas to dig for crystals. I was down there digging in the mud where these quartz crystals grow. I found this pocket of red clay, and I was poking around with my fingers and I pulled out this absolutely clear crystal. It amazed me that out of this red clay came this little gem, this jewel. And I thought it was like my tumor growing inside me. It, too, is like a little

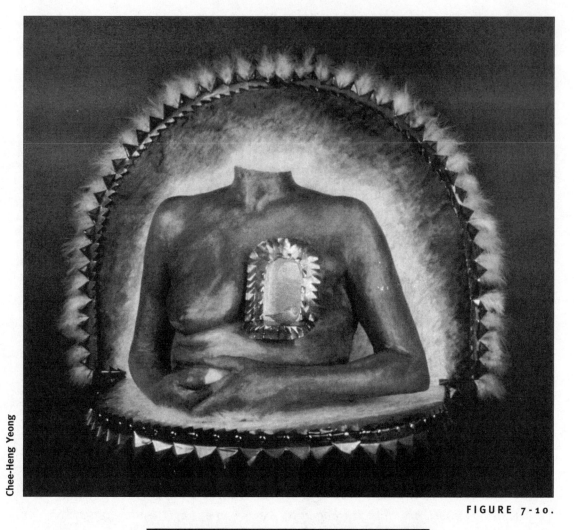

Chee-Heng Yeong

FIGURE 7-10.

A m a z o n , N i g h t L i g h t

CHRISTIANE CORBAT

"This piece is a casting of a woman in her late thirties who had a radical mastectomy in 1991. The image of the flame and of the missing breast as an altar came about from listening to her speak about the need for hope and of giving up a breast for life. There is light in the altar (the heart's chamber), light in her protective hands, and light emanating from her whole torso. The sharp jagged edges of copper and brass change from knife blades to flames of more light. She is the altar. She is the source of light."

gem. And that's how I started to think about it and see it as a jewel. I then took the metaphor even further and began to think of my tumor as a pearl of wisdom, and what good things it was bringing into my life. Being involved in this sculpture really helped me to see this.

I really liked the experience of creating the sculpture. In the beginning of the piece, when we were making it, I was going to be holding a flame that was going to be the Heart Keeper. Then that evolved into a night-light. These ideas came from my affinity for fire, since I'm a double Leo and Aries. I am attracted to fire because of its total mutability. It never holds still, it's always moving—that creative spark. And it is warming. In the actual making of the sculpture you have to sit and be very still while Christiane puts the plaster on. I liked being held contained in this hard plaster shell—it felt very safe and comforting. It was like being held all over. And then I really liked having it broken off at the end—it was like a tremendous release.

When the piece was finished, it came to live with me for a while. At first it was hard to look at, like hearing your own voice on tape. I kept thinking, Is that really me? It was like looking at yourself from a totally new perspective. I remember writing in my journal at the time that perhaps it is too ironic that the place of greatest beauty—my breast—is the part that is cut away. The metaphor behind the keeper of the flame is about keeping my hope alive, keeping it burning. What was most healing for me was having it be there, to see that this altered or damaged form was still very beautiful. It allowed me to get some distance from the experience where I could see it differently.

The sculpture is now in a traveling exhibition, and it is helpful to me to know that other people are seeing it, too. The whole experience was very positive and empowering. This whole cancer experience really was positive because it made me really examine my life and decide what do I need to change to be healthy in both my emotions and my body. And that was the best thing about having cancer.

Pamela was diagnosed in 1991 and has remained cancer free since then.

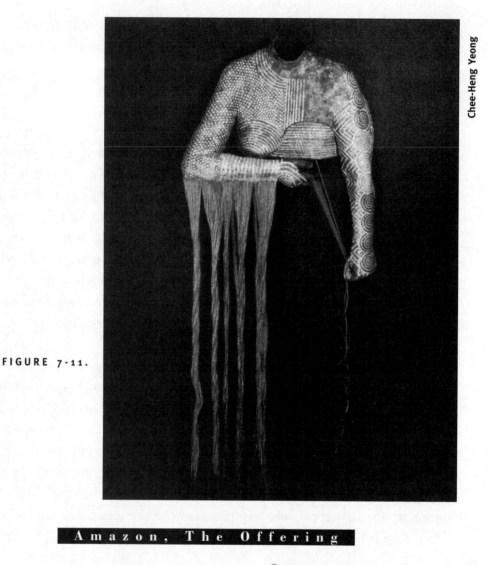

Chee-Heng Yeong

FIGURE 7-11.

Amazon, The Offering

CHRISTIANE CORBAT

"Amazon, The Offering *was created to transform the crisis of mastectomy into an empowering experience. This woman is a musician. I imagined an image of power out of adversity, her scars turned into exciting body ornamentation usually bestowed on warriors who have proven their bravery in war. The sutures are turned into harp strings she can pluck. The right hand offers the lost breast without shame, because she said it took losing it to learn what true giving meant to her. There is strength, determination, and acceptance in her pose.*"

CELEBRATORY HEALING ART

Celebratory healing art is often seen as an artistic form of prayer. It is created to express the artist's grateful appreciation for all the good that life can bring. The artist seldom creates a celebratory piece for any one person. Instead, it is created as a universal healing piece to remind the viewer that there is always a greater force at work that heals us all.

An example of celebratory healing art can be seen in the work of Dolores Marchese's clay and acrylic sculpture of a mother with her child on a swing, entitled *Celebration*. In this piece, the artist personifies her belief, as she puts it, "in something greater than the self—a force of universal love and transcendence, that I call God. In this piece, the child springs from the mother much like the spirit from within springs forth within each of us to symbolize rebirth, hope, and the absolute conviction that everything will turn out well."

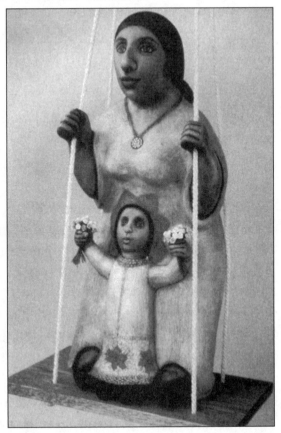

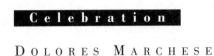

DOLORES MARCHESE

FIGURE 7-12.

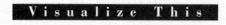

N A N C Y B U R S O N

FIGURE 7-13.

VISUALIZATION HEALING ART

This form of healing art is intentionally created to be used by others as a source for their own healing visualizations. The images the artist selects to use in each piece are specifically chosen for their ability to activate a physical and emotional healing response in the viewer.

Nancy Burson is an artist/photographer whose poster *Visualize This* depicts a magnified unhealthy T cell infected with the HIV virus on the left and a healthy T cell on the right. It is intended for people who are HIV positive to use as a visualization exercise to image their damaged T-cells becoming healthy, thriving cells. The creation of this poster is part of a series of visualization images that the artist produced for a variety of different diseases. The idea for these works were inspired when her mother and a close friend contracted cancer in 1986.

UNIVERSAL HEALING ART

Some artists prefer to create works of art that are not necessarily intended to facilitate healing for any one person, but have a more universal intention in

which the imagery depicted may symbolize different aspects of the healing process, depending on the artist's personal perspective. The imagery in such pieces usually represents whatever the artist deems essential to individual or communal healing, such as emotional cleansing, a balancing of yin and yang energy, symbols of universal love, or representations of living in harmony and balance with nature.

Barbara E. Cunha is an artist whose stained glass work fits perfectly into this category of universal healing art. Barbara was a registered nurse and a nurse practitioner who left her practice frustrated, as she put it, by "too little time with patients and too much pill pushing." For years she struggled with a midwinter depression brought on by a lack of sunlight. After studying stained glass art at Rhode Island School of Design in 1982, she opened her own studio in 1984. Through her stained glass artwork, she discovered that the bright light flowing through her stained glass windows healed her depression. "Illuminated by light," she says, "colored glass provides specific wavelengths of energy for the body; lines and patterns integrate left- and right-brain hemispheres for the mind; and natural images reinforce our connection with all other life for the spirit."

Barbara has trademarked her glass art, calling it *Art with a Healing Intention*™. She is often asked exactly how her sizeable windows, many of which have been commissioned for churches, schools, hospitals, and libraries, facilitate healing in others. She explains that the answer is twofold.

First, the specific elements used in the design are carefully chosen to integrate the body, mind, and spirit of the viewer. Second, I design and produce them with a clear focus of intention for bringing divine healing energy into the completed artwork. It is light that sheds this vibrational energy onto the viewer, thus transmitting it both visually and kinesthetically. Having studied Eastern philosophy at the Traditional Acupuncture Institute, I incorporate into my work concepts from the ancient Chinese Law of the Five Elements with modern principles of left- and right-brain integration. The Chinese observed nature and described five distinct energetic capacities, which allow transformative change. They are Water, Wood, Fire, Earth, and Metal. In order for life to flow and flourish, all five of these energies or elements must be present. To harmonize body,

mind, and spirit, I use color to address the body, crossed lines to integrate
right and left hemispheres of the mind, and images of nature to reconnect
the spirit to all other life. In this way, [my work] facilitates the restora-
tion of wholeness by unifying these three parts.

(See color insert section, Plates 15 and 16.)

HEALING ENVIRONMENTS

This is a rather broad category in which the artist creates an environment that has
healing properties. That environment could be internal or external or a combina-
tion incorporating the two elements. The environment could be made up of art-
work such as paintings and sculptures created by the artist or it could integrate the
artist's work with specially designed healing gardens and architectural structures.
Quite often, several different artists will work together to create a healing environ-
ment. Hospitals in particular are beginning to understand the healing power of art
and are readily employing artists to create environmental murals, gardens, and
healing rooms.

Stained glass artist Barbara E. Cunha also works with two other artists, Gail
Hermann, a designer and builder of water garden environments, and Joan
McLaughlin, a specialist in feng shui, vasta shastra, and Native American princi-
ples as they apply to creating healing interiors. These three artists have formed a
group called the Collaborative for Healing Environments. They recently com-
pleted a healing environment for the lobby of the Program for Women's
Oncology at the Women and Infants Hospital in Providence, Rhode Island.
Barbara Cunha described their creation as "an intentional environment using
color, line, imagery, and elements of nature to catalyze the body's innate healing
system by reintegrating body, mind, and spirit. This environment enhances the
healing potential of all who encounter the space, including patients, staff, visi-
tors, and the community. It holds the possibility of hope for all who are facing a
major life challenge. All five elements from nature are incorporated into the envi-
ronment for balance and harmony."

While some artists create work to heal those who are struggling to survive a life-
threatening experience, others create work to help heal those who grieve when a

loved one departs. Landscape designer Kurt Van Dexter does both. His Rhode Island company, CHILDSCAPES, specializes in the creation of healing spaces for children. Kurt's environmental healing artwork might also be considered collaborative in nature, since he often engages the children for whom his environments are created to become involved in the design and execution of the work. *Jean's Garden,* shown in Figure 7-15, is an example of a healing garden designed by Kurt and a

FIGURE 7-14.

Healing Environment

BARBARA E. CUNHA, R.N., GAIL HERMANN, AND JOAN MCLAUGHLIN, THE COLLABORATIVE FOR HEALING ENVIRONMENTS

"Seated within the healing environment, one is able to listen to the sound of moving water, look at the artwork and plants, feel the light shining through the glass, and breathe in the aroma of lavender."

number of students, teachers, parents, and administrators from the Narragansett Elementary School in Narragansett, Rhode Island.

Kurt explains how the idea for this environment came about:

> *"Jean was a student at a local elementary school who went blind from a rare form of eye cancer when he was three years old. The cancer went into remission, allowing him to attend kindergarten and first grade along with other children his age. They interacted well, and Jean was considered 'one of the gang.' But the cancer returned. And when it became apparent that Jean would not survive, the school principal decided that his classmates needed a positive way to focus their energies as they collectively grieved*

FIGURE 7-15.

Jean's Garden

KURT VAN DEXTER

and supported one another. When Jean died on March 13, 1997, the idea for the garden emerged. It was to be not a memorial garden but a garden to celebrate Jean's life. A site was selected in the school courtyard, near Jean's classroom outside a bank of hallway windows where students could look upon the garden as they passed by. The space was configured to include a small gathering area that could also be used for quiet reflection. A variety of plants was selected that would provide sensory interest throughout the year, and a round concrete table, created by one of the parents, became the focal center. When the concrete table was poured, each of Jean's classmates placed a handprint into the wet cement, and an imprint of Jean's hand was placed in the center. The students had previously done an art lesson making handprints in clay and casting them in plaster, so they were able to use the plaster cast of Jean's handprint to create his imprint in the table. The process of creating this space was a healing experience for everyone involved."

<div align="center">

Exercise 1

</div>

HOW TO CREATE ART TO HEAL OTHERS

To create your own healing art for others involves first setting your intention to define what you hope your healing art piece will accomplish, and second, identifying the person or persons for whom you are creating this piece. After setting your intentions in your mind or writing them down, whichever feels more appropriate, you can then follow the visualization presented in this exercise, which will guide you to focus your awareness on your intention. You will then allow your awareness to move into your heart center, where you will ask to be connected to the universal source of divine guidance. When you sense that you have opened a channel within your body-mind through which divine guidance can flow, ask to receive imagistic messages that will help you create healing images that are in the highest good to assist the healing of a particular person, group of people, or perhaps, like many artists, you would like to help heal an animal or an endangered species of animals or the earth's environment. When you sense that you have received your impression or idea of a healing image or symbol, you can use any artistic medium that seems most conducive to expressing your healing imagery.

Just as prayer sends our healing intentions outward into the universe, creating a healing image or symbol through a tangible artistic form does exactly the same thing. However, I believe that when we create a healing art piece, the power behind our intention is magnified as that intention is converted into matter, which gives the intention itself an energetic anchoring point through which the imagery can then make direct and continual contact with the intended recipient(s).

How to Begin

You may want to begin by lighting candles, burning incense, and perhaps playing some appropriate music, like Gregorian chant. Then close your eyes and imagine placing the person, persons, or whatever it is you wish to help heal in a healing circle of white light. You can use the guided visualization that follows to access your healing image. But I do want to mention that there are a couple of other ways you can approach visualizing the healing images or symbols.

1. *Seeing the wound as healed.* You can begin by imagining that you can see the wound or affliction of the person(s), and then imagine that wound transforming and see it as being healed. You can then create an image of the healed wound.
2. *Visualizing healing color.* Focus on the person or thing you wish to heal, and then visualize or sense what color or colors would be needed to heal your recipient. Then create a work of art using those colors. Perhaps you may want to draw or paint an image or symbol that represents the person or thing you wish to heal, and then surround them or it with an imagistic representation of the color or colors you imagined.

Of course, I believe it is always best to leave the choice of imagery up to divine guidance. The following visualization will guide you to ask for healing images or symbols that are in the highest good of the object of your healing intentions. I suggest you pretape this visualization so that you can fully focus on the process.

GUIDED VISUALIZATION

Focus your attention on whatever person(s) or thing you would like to help heal. Then set or declare your intentions for healing by speaking them out loud or putting them in writing.

Next, close your eyes and sit comfortably. Take three deep, long breaths and exhale slowly. (Pause)

Continue breathing deeply and exhaling slowly. (Pause) *As you do, imagine that each breath entering your body is a gentle cooling and calming breeze moving down your throat, through your lungs, down your torso, into your arms, out into your hands and down into your legs.* (Pause) *As this breeze moves through your body, imagine that it is soothing and comforting each part of your body that it passes through.* (Pause) *Imagine that each part of your body that is touched by this gentle breeze is now feeling relaxed and at peace.* (Pause)

Imagine your conscious awareness to be a tiny bead of light nestled deep within your cranial cavity. Direct this light of your conscious awareness to float downward toward your heart center. (Pause) *Imagine that through the light of your conscious awareness you can see with your inner eyes your own internal source of the energy emanating from deep within your heart center, and then imagine seeing this energy moving from your heart, flowing throughout your entire body, and moving outward from your body, connecting you to the unified energy field that flows to every atom within the universe.* (Pause)

As you sense your energy connecting to the universal source of energy, ask for the light of divine intelligence to flow through this energetic field into your body. (Pause) *Imagine receiving this divine connection as a white light flowing from the universe into the top of your head. Imagine this white light flowing through the top of your head downward through your head, your neck, and into your heart center, where it will be united with your own internal source of energy.* (Pause)

When you feel this unification of your energy with the divine light of intelligence, which is the source of all love and universal wisdom, focus your attention on who or what you wish to heal, and ask this divine source of universal wisdom for images, shapes, forms, colors, or symbols

that represent what your intended recipient of healing needs that is in his, her, their, or its highest good. (Pause)

Be patient as you wait for the image(s), shapes, colors, or symbols to appear within your mind's eye. (Pause) *When you know what images or symbols to use in order to create a healing piece of art, open your eyes and draw, paint, or construct it in any way that feels most appropriate to the expression of this healing imagery.*

The most significant discovery you will make as you engage in the process of creating art that heals another is that you, too, will also be healed in some way through the process.

A Community of Artists

Healing with art is a journey that will take you into the depths of your soul. There you will encounter parts of yourself that you never knew existed. As you create the artwork that exposes these parts of yourself so that you may know and understand them and the mysteries they hold, you will be healed. But the healing experience does not end with the creator. Sharing our healing journeys and the artwork that documents this inner voyage can affect and heal the viewer as well. It is for this reason that I have chosen to feature throughout this book not only the artwork of so many people who are actively involved in using art for healing, but also, whenever possible, I have included their stories.

To bring this book to its conclusion, it seemed important to include in this last section four artists whose work and personal healing journeys have influenced me so strongly that I decided to begin writing this book. I first connected with them in 1994 at a symposium I attended in Fayetteville, Arkansas, where I met Mary Carroll Nelson, author of a book I had read and loved, entitled *Artists of the Spirit* (Arcus Publishing, 1994). This book was the focus of the symposium and the reason I had traveled so far to attend it. I had been impressed with the philosophy Mary Carroll had put forth in her book about using art as a means of healing one's emotional wounds, but I was unfamiliar with her artwork. It was here at the sym-

Our Lady of the Rose Garden

MARY CARROLL NELSON

"It fell to me to see my parents to their deaths, four years apart. They were blameless, prayerful people whose deaths were painful to me. From conditioned respect and a natural reticence to question the beliefs of people I hold dear, I could not comfort them with my image of death, which is altogether different from that of a Last Judgment. My painting is my gift to my parents' souls. It pictures at an unseen level the seven chakras as an arch, covered by the earth as seen from space. Eleven spirits, including one who is descending into life, and ten who are depart-

ing, illustrate the notion that from a spiritual perspective the dying soul is like a blooming flower, so Earth must appear as a constantly changing garden. The souls take their acquired wisdom, symbolized by a moonstone, with them in their chakras as they snap their silver chords. A benign, motherly spiritual presence awaits them with comfort and joy on their arrival at the bardo. Having painted the piece at the urging of a friend, I gained peace from communicating, at last, that death is not to be feared but awaited as a joyous return."

FIGURE 7-16.

posium that I was introduced to her work, which I discovered was a powerful expression of her own struggle with grief and loss.

A resident of Albuquerque, New Mexico, Mary Carroll Nelson is an artist, teacher, and writer whose other published works include *The Legendary Artists of Taos* (Watson-Guptill, 1980) and *Masters of Western Art* (Watson-Guptill, 1982). Mary Carroll has been a practicing artist for many years, primarily focusing her attention on depicting, through her work, a holistic worldview. In 1982, Mary Carroll founded the Society of Layerists in Multi-Media, a national organization set up to provide artists who are working from a holistic perspective with the opportunity to connect with one another and share their philosophies.

Her own personal experience in healing with art is most profoundly evident in Figure 7-16, entitled *Our Lady of the Rose Garden*. She created this piece with plexiglas, ink, gold and silver leaf, glitter and moonstones.

From her own journey into using art to heal the pain of separation from her parents, Mary Carroll Nelson embarked upon another quest to find other artists who shared her holistic perspective on the interrelatedness of the body, mind, and spirit, and the power of art to heal. Her search took ten years as she attempted to locate what she called visionary artists. With patience, perseverance, and what she refers to as "divine guidance," she found these artists—who had no connection to one another—and yet they shared the same vision. This vision not only enabled them to transcend their life's trauma, but as she puts it, "by telling their stories they inspire others to reenvision their own traumatic experiences." The lives and stories of sixteen of these visionary artists were then featured in her book *Artists of the Spirit*.

The 1994 symposium in which I met Mary Carroll along with a number of the artists she had written about in her book was organized by the Society of Layerists. It centered on presenting the extraordinary work these artists were doing in which healing through art was, in one way or another, their primary goal.

Of the many artists whose work, in addition to Mary Carroll's, touched and inspired me during that symposium, I found myself gravitating to the work and healing stories of the three other artists you are about to meet. As I present them and their work, it's interesting to note that each of them has focused their healing intentions on a different aspect of the body, mind, spirit triad. For the first

Through
Generation

Surge

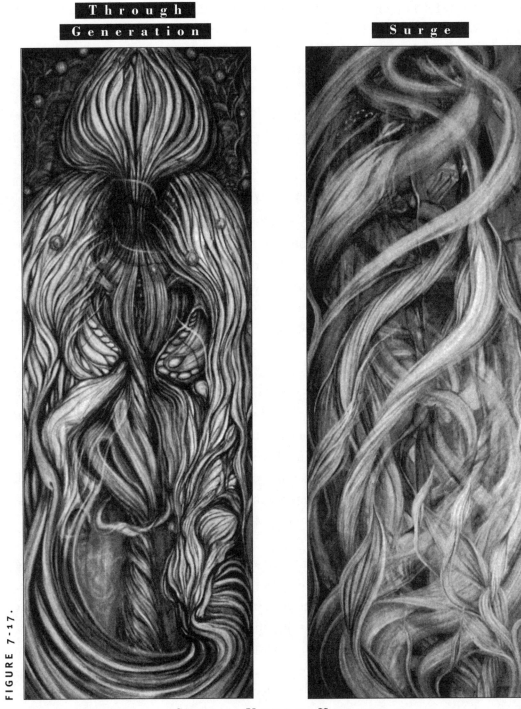

FIGURE 7-17.

FIGURE 7-18.

GILAH YELIN HIRSCH

artist, Gilah Yelin Hirsch, it was her body that demanded her attention. When that part of her was healed, she was free to shift her focus and use her art to explore spiritual questions that revolved around her own feelings of connectedness to all of life—both earthly and divine. The second artist, Richard Newman, had a fear of death, which brought him face-to-face with the overpowering emotions of loss, grief, and a fear of the unknown. And for the third artist, Meinrad Craighead, healing her body and mind began by exploring and healing of her spirit.

GILAH YELIN HIRSCH

In 1980, after suffering a paralysis to the left side of her body, Gilah Yelin Hirsch, artist, scholar, and founding member of the women's art movement in Los Angeles, used her painting to understand and heal her condition. Probing beneath the surface impressions of her outer vision was second nature to Gilah, since she had been working for years exploring the relationship of spirituality to art. "As difficult and painful and often as impossible as it was," she recalls, "I felt it imperative to work within my body. If anyone had any strength over it, I had." Fortunately, since she was right-handed, she still had the ability to paint. She had two canvases made in her body size—five and a half feet tall and a foot across. Lying on top of the canvases, she had someone pencil in her body's outline. Then she began to paint—allowing her inner eye to see what she perceived as "horrendous nightmarish images of demons inside that body form. At times it was impossible to look at the image, it was so horrifying to me. For a year, I painted, compelled to go through color regeneration of my pictured body many times. Eventually, it grew green and fertile with twelve seeds." This painting she called *Through Generation* (Figure 7-17).

Then using the second body-size canvas, Gilah began another painting to explore the resurgence of her soul. This piece she entitled *Surge* (Figure 7-18). Her condition subsided with the completion of these two paintings. From there, she went on to study, through her painting, the relationships between individuals, heaven and earth, humans and nature, which led her to an understanding of human healing. "That ability to heal ourselves and others," she avows, "lies in our commonality, and it is healed through our reflection of each other and the whole of what we create—our connectedness."

House of the Dead

RICHARD NEWMAN

FIGURE 7·19.

RICHARD NEWMAN

Fear of death was the demon that gripped Richard Newman, artist and head of the Creative Arts Department of Bradford College in Massachusetts. But he realized that the way to banish his demon was to face it and use it as a source of inspiration and energy for his artwork. He looked for the irony in our human depiction of death and found it in the images of the gravestone carvings that adorn old New England tombstones.

Using a combination of photography and collage, he began in the mid-1970s to build sculptural monuments and altarpieces that displayed these images from every angle. *House of the Dead*, a mixed-media sculpture he produced in 1978, clearly demonstrates his tongue-in-cheek approach. His intention was to get so absorbed in his fear that it was no longer the enemy; instead it became a friend. In many of these sculptural monuments he included small openings that would represent "safe storage for his memories." When reflecting back on his work, he says, "It has taken me a long time to get over my art school training. I was taught how to make art, but not how to integrate art and life." He believes that "art equips us with a language for communicating our encounter with the world. Life is a mere dress

rehearsal for the most creative moment of all—when we are born into the future through our own death." Richard has discovered the cathartic power behind the creation of imagery and has used it to heal his own "psychic wounds."

MEINRAD CRAIGHEAD

Connecting with her spirit through myth and memory has been the primary focus for artist and author Meinrad Craighead.

"The act of drawing is soul work; a path to the sacred and a movement toward realization, transformation, integration, nourishment, and wholeness." In her self-portrait, When Artemis Hunts, *created with ink on scratchboard in 1991, Meinrad describes the imagery in the following way: "Snake mother lays her eggs in our wombs, the cauldron of our creativity. At any moment, the artist is a cauldron of ripening imagery hatching. Our memories ripen within us, heated by the imagination. We shape them into pictures or poems or music, words or dance. We animate what we remember—what we draw up from the heart—thus giving shape to our own unique stories. The virgin goddess Artemis is the protector of birth, and she protects our multiple creative birthings. She's also a hunter, which I've always considered an apt metaphor for the artist. Because hunting, like painting, is about search. It's not about power, it's not about possession, and it certainly is not about killing. Artemis hunts with her paintbrushes. The object in her left hand is a ritual object—a snake. Through the window is her moon, the virgin moon."*

Meinrad's paintings demonstrate how the act of transformation from human form to spiritual connectedness and consciousness takes place not only for the artist but also for each of us.

My hope is that these artists, as well as all the other artists whose work is shown throughout this book, have been a source of inspiration and encouragement for all of you who are doing your own healing with art. Their work serves as prime examples of how art does heal not only those who create it, but also those who view it. For the creator, art is an expression of emotions, feelings, and perspectives that words cannot convey. For the viewer, art bridges the gap in understanding that

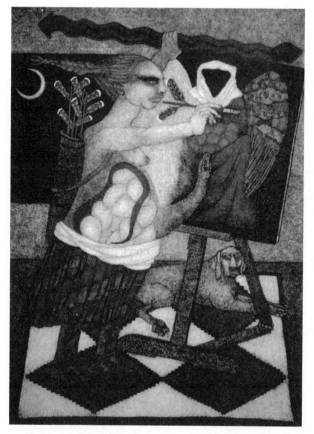

When Artemis Hunts

MEINRAD CRAIGHEAD

FIGURE 7-20.

words can often create. Art allows the viewer and creator to become one in their experiences: to see through the same eyes, and to respond to the same vibratory energy created by color, line, shape, and form. Through its imagery, art opens our inner eyes and takes us beyond the realm of logic and reason into a new dimension where time and matter no longer exist, and what remains is the pure essence of spirit.

Nationwide there is a rapidly growing network of people who are using art for healing. If you would like to know more about these organizations or connect with any of the people whose work appears in this book, then see the two directories in the back of this book. The first lists all of the artists, who welcome your inquiries, and the second is a listing of national organizations dedicated to promoting art and healing, as well as educational institutions that offer degrees and training programs in healing with art. I also welcome your thoughts, stories, and responses. You may contact me at the following address: Art as the Spirit of Healing, P.O. Box 1176, North Kingstown, RI 02852.

Artists Featured in This Book

The following directory is provided to help those of you who may be interested in contacting anyone whose work has been featured in this book. You are invited to write or call any of these artists, if you would like more information about their work.

Asbury, Judy
Artist (slides on request)
P. O. Box 170
Jemez Pueblo, NM 87024
(505) 834-7325

Beam, Mary
125 Cricket Hollow Way
Cosby, TN 37722
(423) 487-3907

Birnbaum, Stephanie, M.A.
Holistic counselor, artist
Counseling work includes: Gestalt, psychosynthesis, and expressive arts
6 Boxwood Avenue
Westerly, RI 02891
(401) 596-5961

Bundy, Lanham L.
304 Wickenden Street
Providence, RI 02903
(401) 521-0791

Burson, Nancy
Artist/photographer
548 Broadway
New York, NY 10012
(212) 925-5359

Chew, Claire
envisions design
1235 N. Gower Street
Los Angeles, CA 90038
(323) 461-2606
E-mail: scarbaby@earthlink.net

Coppola, Maria
6 Brookside Avenue
Lexington, MA 02173
(781) 862-2818

Corbat, Christiane
Artist
32 Cole Street
Warren, RI 02885
(401) 247-2233

Cragin, Kim, M.A.
Holistic counselor
17 Treasure Island Road
Plainville, MA 02762
(508) 695-3547

Craighead, Meinrad
Artist
Casa Alamosa
2712 Campbell Road NW
Albuquerque, NM 87104-3108
(505) 344-7109

Cunha, Barbara E., R.N.
Designer/artisan
Flying Colors Stained Glass
P. O. Box 97
Assonet, MA 02702
(508) 644-2433

Cutler, Carrol
Art Expressions for Healing & Growth: Movement, Imagery & Sound

5318 S. Fox Street, #303
Littleton, CO 80120

D'Alessio, Valaida
Valaida's Valley Lane Studio
917 Valley Lane
Lockport, IL 60441
(815) 838-6710

Doersch, Diane K.
1108 E. Johnson Street,
no. 1
Madison, WI 53703
E-mail: Ddoersch@aol.com

**Durham, Jo Ann,
S.W.A., I.S.E.A.**
4300 Plantation Drive
Fort Worth, TX 76116-
7607
(817) 244-3807
Fax: (817) 737-6520

Flores, Ana
MANOS
MANOS Offers: artist resi-
dencies; experimental work-
shops specializing in
"Milagro" workshop; com-
missioned artwork; slide
lectures; consultations
P. O. Box 96
Wood River Junction, RI
02894
(401) 364-0087

Fox, Susan, M.A.E.
Expressive art
therapist/holistic coun-
selor/artist/author
Workshops in expressive arts

106 Duck Cove Road
North Kingstown, RI
02852
(401) 294-6153

**Gifford, Elaine, M.A.,
M.S.W.**
452 Concord Road
Sudbury, MA 01776
(978) 443-0572

Golden, Pam
Artist
31 Ellis Avenue
Marshfield, MA 02050
(781) 837-0786

Graboys, Lois
Artist
2 Terrace Drive
Barrington, RI 02806

Harum, Kathleen
Artist, actor
30-56 Thirty-seventh Street
Astoria, NY 11103

Hirsch, Gilah Yelin
Artist, author, professor of
art, California State
University, Dominguez Hills
2412 Oakwood Avenue
Venice, CA 90291
(301) 821-6848
Fax: (301) 821-1358

Hlynsky, Dennis Eugene
Artist/professor
80 Armstrong Avenue
Providence, RI 02903
(401) 454-6238
E-mail: dhlynsky@risd.edu

Hughes, Mary F.
Artwork sales and lectures
on themes related to the
psychological/spiritual and
art
3014 Rhodelia
Claremont, CA 91711
(909) 624-9218
E-mail: spock 7@GTE.net

Jones, Ann
Greenspot Art and Healing
P. O. Box 101
Brooklyn, CT 06234
(860) 779-2223

Jones, S. A.
Artist
5905 Kingsford Road
Springfield, VA 22152
Gallery K
2010 R Street N.W.
Washington, D.C. 20009
(202) 234-0339

Katz, Cynthia
Photographer
185 Main Street
Concord, MA 01742
(978) 287-5145
E-mail:
katz@concordacademy.org

Keisel, Betty
7713 Pickard NE
Albuquerque, NM 87110

Larsen, Harold E.
890 Paseo De Don Carlos
Santa Fe, NM 87501

(505) 986-0106
Fax: (505) 984-2113

Leda Shapiro, Ann
Artist, licensed acupuncturist
19001 Vashon Highway
SW no. 208B
Vashon Island, WA 98070
Home: (206) 463-6181
Office: (206) 463-3967

Ledzian, Antoinette C.
Teacher, lecturer, artist,
writer, and creator of hand-
made journals: The Journal
Lady®
283 Greenhaven Road
Pawcatuck, CT 06379
(860) 599-1099

Lehrer, Riva
1044 W. Balmoral
Chicago, IL 60640
(773) 907-9530

Leviten, Riva
Visual artist, lectures on
"Creative Process" and
"Art Process and
Creativity"
425 Benefit Street
Providence, RI 02903
(401) 272-6652

Light, Linda
Workshops and seminars,
"Art for Healing"
Accepts commissioned
paintings to honor
a loved one
Past life guide and facilitator

P. O. Box 31443
Santa Fe, NM 87594-1443
(505) 989-8824

MacDonald-Foley, Robin
75 Elm Street
North Easton, MA 02356
(508) 238-6044

Marchese, Dolores
69 Horseshoe Road
Guilford, CT 06437
(203) 453-9414

McIver, Allegra Kraft
c/o Resnick
Communications, Inc.
1528 Walnut Street
Philadelphia, PA 19102
(215) 893-0204
Fax: (215) 893-0311
E-mail: prres@aol.com

Mills, Susan
Artist
Millay Road
RR 1, Box 2593
Bowdoinham, ME 04008
(207) 666-3029
Fax: (207) 666-3555

Moscartolo, Jon J.
Moscartolo Studio
2 Chartley Brook Lane
Attleboro, MA 02703
(508) 222-2997

Nelson, Mary Carroll
Artist/author
1408 Georgia, NE
Albuquerque, NM 87110
(505) 268-1100

Newman, Richard
P. O. Box 5162
Bradford, MA 01830
(978) 373-3788

Newman, Rochelle
c/o Pythagorean Press:
Artists & Publishers
Artwork available and
workshops held
P. O. Box 5162
Bradford, MA 01835-0162
(978) 372-3129

Newsome, Allison
Artist
Water Street Studio
74 Baker Street
Warren, RI 02885
(401) 245-0260
Fax: (401) 247-2270

Norsworthy, Jeanne
Artist
C/o Maidie Rutherford
4642 Devon
Houston, TX 77027
(713) 439-1143

Perrella, Joseph G.
Artist/educator/curator
Commissions considered
Workshops and seminars on
a variety of topics
2389 Algonquin Road
Niskayuna, NY 12309
(518) 370-2343

Pfeifer, Liese
Home studio: 5958
Cherokee Valley Pass

Waunakee, WI 53597
Museum Shop manager of
Elvehjem Museum of Art
University of Wisconsin—
Madison
800 University Avenue
Madison, WI 53706
(608) 263-2240
Fax: (608) 263-8188
E-mail:
lpfeifer@facstaff.wisc.edu

Pitak-Davis, Susanne
Art therapist and artist
19 Lincoln Avenue
Lambertville, NJ 08530
(609) 397-1766

Sabra
Eclectic Souls
P. O. Box 185
Voluntown, CT 06384

Shepley, Julia
1 Fitchburg Street, C312
Somerville, MA 02143
(617) 628-7623

Siekierski, Kate, M.S.W.
Artist/psychotherapist
250 Fort Pond Road
Lancaster, MA 01523
(978) 537-8231

Smith, Marcia
Artist, illustrator, Arts in
Healthcare consultant
112 Linden Street
Rochester, NY 14620
(716) 461-9348

Taylor, Clytie W.
Experimental photogra-
pher/Mixed-media artist
203 North Park Drive
Salisbury, MD 21804

**Thoma, Ishmira
Kathleen**
Expressive arts
facilitator/visionary
artist/illustrator
33 Windsor Road
Cranston, RI 02905
(401) 785-2272

Van Dexter, Kurt
CHILDSCAPES
Natural Spaces of
Imagination, Discovery, and
Connection!
1740 Stony Lane
North Kingstown, RI
02852
(401) 294-7994

Vivona, Christina
Expressive arts facilitator:
cancer support groups,
workshops for children and
adolescents
114 Girard Avenue, No. 1
Newport, RI 02840
(401) 847-1575

Waxler, Beatrice
13 Lancaster Road
Burlington, NJ 08016
(609) 386-5867

Wilbanks, Mary
18307 Champion Forest
Drive
Spring, TX 77379
(281) 370-7879

Wong, Diana
1547 Sixth Street
Santa Monica, CA 90401
(310) 394-3018
Fax: (310) 395-9969

Resources

The following resources can assist you if you are interested in more information on art and healing workshops, training, and degree programs and organizations dedicated to promoting art that heals. Feel free to call or write the contact people listed, as they will be pleased to answer any questions you may have.

ART AS HEALING
Michael Samuel's Web site
www.artashealing.org

California Institute of Integral Studies
9 Peter Yorke Way
San Francisco, CA 94109
(415) 674-5500

- Master's degree program in the expressive arts, an Expressive arts therapy certification program, and a certificate program in expressive arts consulting and education

Expressive Therapy Institute
P. O. Box 6518
Santa Rosa, CA 95406
(707) 524-4406

- A person-centered approach to expressive arts therapy developed by Natalie Rogers

Healing Slide Registry
Breast Cancer Action Group
Virginia Soffa, executive director
P. O. Box 5605
Burlington, VT 05402
(802) 863-3507

International Arts-Medicine Association
714 Old Lancaster Road
Bryn Mawr, PA 19010
(610) 525-3784
Fax: (610) 525-3250

International Friends of Transformative Art
140626-A North Seventy-eighth Way
Scottsdale, AZ 85260
(303) 927-8027

International Society of Experimental Artists
Jo Ann Durham, president
4300 Plantation Drive
Fort Worth, TX 76117
(817) 244-3807
Fax: (817) 737-6520

Leslie College
29 Everett Street
Cambridge, MA 02138
(617) 868-9600

- Offers bachelor's and master's degree programs in expressive arts therapy

Murals for Healing Environments
Joan Drescher
23 Cedar Street
Hingham, MA 02043
(617) 749-5179

Naropa Institute
Admissions Office
2130 Arapahoe Avenue
Boulder, CO 80302-6697
(303) 444-0202 or (303) 546-3568

- Offers degree programs in art therapy

New York Psychosynthesis Institute
70 W. Eleventh Street
New York, NY 10011
(212) 674-5244

- Offers certification in Clinical Imagery Process™

The Omega Arts Network
Barbara Mathews
P. O. Box 1227
Jamaica Plain, MA 02130
(508) 283-9095

Omega Institute for Holistic Studies
260 Lake Drive
Rhinebeck, NY 12572
(914) 266-4828

Painting from the Source with Aviva Gold, M.F.A., C.S.W., A.T.R.
RD 2, Box 197 A-1
Ghent, NY 12075
(518) 392-2631

Salve Regina University
100 Ochre Point Avenue
Newport, RI 02840-4192
1-800-321-7124 or (401) 847-6650, ext.
2157

- **Graduate Program in Holistic
 Counseling**
 Offers a CAGS (Certificate in
 Advanced Graduate Study) in the
 expressive arts therapies
 1-800-321-7124 or
 (401) 847-6650, ext. 3179

- **Institute for the Expressive Arts**
 Offers a certificate program in healing
 with the expressive arts for medical
 caregivers, psychotherapists, and
 educators

Society for the Arts in Healthcare
45 Lyme Road, Suite 304
Hanover, NH 03755-1223

The Society of Layerists in Multi-media
1408 Georgia, NE
Albuquerque, NM 87110

- A nonprofit national organization
 founded in 1982 by Mary Carroll
 Nelson for artists who take a holistic
 approach to promoting healing

Southwestern College
P. O. Box 4788
Santa Fe, NM 87502
(505) 471-4071

- Offers a master's degree program in art
 therapy and counseling

References

CHAPTER ONE

Halpern, G. R. (1994). "Healing Art: Cross-Cultural Connections." From the exhibition catalog, *Body and Soul: Contemporary Art and Healing,* DeCordova Museum and Sculpture Park, Lincoln, Mass.

Simonton, O. Carl, M.D. (1978). *Getting Well Again.* Los Angeles: Jeremy P. Tarcher.

CHAPTER TWO

Rockwood Lane, M., R.N., M.S.N. (1998). *Creative Healing: How to Heal Yourself by Tapping Your Hidden Creativity.* New York: HarperCollins/HarperSanFrancisco.

CHAPTER THREE

Cook, M. A. (1992). Catalog: Art Therapy Master's Program, Springfield College, Springfield, Mass.

Capasso, N. (1994). "Riva Lehrer." From the exhibition catalog, *Body and Soul: Contemporary Art and Healing,* DeCordova Museum and Sculpture Park, Lincoln, Mass.

———— (1994). "Ann Leda Shapiro." From the exhibition catalog, *Body and Soul: Contemporary Art and Healing,* DeCordova Museum and Sculpture Park, Lincoln, Mass.

Epstein, G., M.D. (1989). *Healing Visualizations: Creating Healing through Imagery.* New York: Bantam Books.

Nelson, M. C. (1994). *Artists of the Spirit.* Sonoma, Calif.: Arcus Publishing.

CHAPTER FOUR

Chopra, D., M.D. (1989). *Quantum Healing.* New York: Bantam.

Northrup, C., M.D. (1994). *Women's Bodies, Women's Wisdom.* New York: Bantam.

CHAPTER FIVE

Chopra, D., M.D. (1989). *Quantum Healing.* New York: Bantam.

Northrup, C., M.D. (1994). *Women's Bodies, Women's Wisdom.* New York: Bantam.

Roth, G. (1998). *Maps to Ecstasy* by Gabrielle Roth © 1998. Reprinted with permission of New World Library, Novato, Calif.

Shealy, N. C., M.D. (1995). *Miracles Do Happen: A Physician's Experience with Alternative Medicine.* Rockport, Mass.: Element Books.

Simonton, O. Carl, M.D. (1978). *Getting Well Again.* Los Angeles: Jeremy P. Tarcher.

CHAPTER SIX

Moore, T. (1992). *Care of the Soul: A Guide for Cultivating Depth and Sacredness in Everyday Life.* New York: HarperCollins.

Siegel, B., M.D. (1989). *Peace, Love & Healing: The Bodymind & The Path to Self-Healing and Exploration.* New York: Harper & Row.

CHAPTER SEVEN

Dossey, L., M.D. (1996). *Prayer Is Good Medicine: How to Reap the Healing Benefits of Prayer.* New York: HarperCollins.

Nelson, M. C. (1994). *Artists of the Spirit: New Prophets in Art and Mysticism.* Sonoma, Calif.: Arcus Publishing.

Nightingale, F. (1860). *Notes on Nursing: What It Is and What It Is Not.* New York: D. Appleton.

For Further Reading

Achterberg, Jeanne. *Imagery in Healing: Shamanism and Modern Medicine.* New York: New Science Library, 1985.

———. *Woman as Healer.* Boston: Shambhala Publications, Inc., 1991.

Alkon, Daniel L., M.D. *Memory's Voice: Deciphering the Mind-Brain Code.* New York: HarperCollins, 1992.

Anderson, Mary. *Color Therapy.* Wellingborough, England: Aquarian Press, 1979. New edition, 1990.

Babbitt, Edwin S. *Principles of Light and Color: The Healing Power of Color.* Secaucus, N.J.: Citadel Press, 1967.

Birren, Farber. *The Symbolism of Color.* Secaucus, N.J.: Citadel Press, 1988.

Brennan, Barbara. *Hands of Light: A Guide to Healing Through the Human Energy Field.* New York: Bantam, 1988.

Capacchione, Lucia. *The Creative Journal: The Art of Finding Yourself.* North Hollywood, Calif.: Newcastle Publishing Co., Inc., 1989.

———. *The Picture of Health: Healing Your Life with Art.* Santa Monica: Hay House, Inc., 1990.

Chopra, D., M.D. *Quantum Healing.* New York: Bantam, 1989.

Cooper, J. C. *An Illustrated Encyclopedia of Traditional Symbols.* London: Thames & Hudson, 1988.

Cornell, Judith, Ph.D. *Drawing the Light from Within.* New York: Wheaton, Ill.: Quest Books, 1997.

———. *Mandala: Luminous Symbols for Healing.* Wheaton, Ill.: Quest Books, 1994.

Epstein, Gerald, M.D. *Healing Visualizations: Creating Health Through Imagery.* New York: Bantam Books, 1989.

Fezler, William. *Imagery for Healing, Knowledge and Power.* New York: Simon and Schuster, Inc., 1990.

Furth, Gregg M. *The Secret World of Drawings.* Boston: Sigo Press, 1988.

Gawain, Shakti. *Creative Visualization.* New York: Bantam New Age, 1979.

Gombel, Theo. *Healing Through Colour.* Saffron Walden, England: C. W. Daniel Company, Ltd., 1980.

Grof, Stanislav. *Beyond the Brain.* Albany: State University of New York Press, 1985.

Harman, Willis, Howard Rheingold. *Higher Creativity: Liberating the Unconscious for Breakthrough Insights.* Los Angeles: Jeremy P. Tarcher, Inc., 1984.

Lusser Rico, Gabriele. *Writing the Natural Way.* Los Angeles: Jeremy P. Tarcher, 1983.

McNiff, Shaun. *Art as Medicine.* Boston, Mass.: Shambhala Publications, Inc., 1992.

Moen, Larry. *Guided Imagery: Volumes I & II.* Naples, Fla.: United States Publishers, 1992.

Moore, Thomas. *Care of the Soul: A Guide for Cultivating Depth and Sacredness in Everyday Life.* New York: HarperCollins Publishers, 1992.

Murphy, Michael. *The Future of the Body.* Los Angeles: Jeremy P. Tarcher, 1993.

Myss, C. *Why People Don't Heal and How They Can.* New York: Harmony Books, 1997.

Naumburg, Margaret. *Introduction to Art Therapy.* New York: Teachers College Press, 1973.

Nelson, Mary Carroll. *Artists of the Spirit: New Prophets in Art and Mysticism.* Sonoma, Calif.: Arcus Publishing, 1994.

Oldfield, Harry, Roger Coghill. *The Dark Side of the Brain.* Rockport, Mass.: Element Books, 1988.

Rhyne, Janie. *The Gestalt Art Experience: Creative Process and Expressive Therapy.* Chicago: Magnolia Street Publishers, 1984.

Rogers, Natalie. *The Creative Connection: Expressive Arts as Healing.* Palo Alto, Calif.: Science & Behavior Books, 1993.

Rossman, Martin L., M.D. *Healing Yourself: Step-by-Step Program for Better Health Through Imagery.* New York: Walker and Company, 1987.

Samuels, Michael, M.D. *Seeing with the Mind's Eye.* New York: Random House, 1975. New edition, 1993.

Samuels, Michael, M.D., Lane M. Rockwood, R.N., M.S.N. *Creative Healing: How to Heal Yourself by Tapping Your Hidden Creativity.* New York: HarperCollins/ HarperSanFrancisco, 1998.

Shealy, Norman C., M.D. *Miracles Do Happen.* Rockport, Mass.: Element Books, 1995.

Shorr, Joseph E., Ph.D. *Psychotherapy Through Imagery.* New York: International Medical Book Corporation, 1974.

Siegel, Bernie, M.D. *Peace, Love & Healing: The Bodymind & The Path to Self-Healing and Exploration.* New York: Harper & Row, 1989.

Sperry, Roger. *Science and Moral Priority: Merging Mind, Brain, and Human Values.* New York: Columbia University Press, 1983.

Index

About the Author

Barbara Ganim, M.A.E., C.H.C., is director of the Institute for the Expressive Arts at Salve Regina University in Newport, Rhode Island, where she also teaches expressive art therapy in the Holistic Counseling Graduate Program.

As an expressive art therapist and holistic counselor at the Center for Holistic Development in North Kingstown, Rhode Island, which she cofounded, her work has been primarily focused on using art, imagery, and visualization to help people suffering from life-threatening illness to heal. She has served on the clinical staff of the Hope Center for Cancer Support in Providence, Rhode Island, for the last eight years, facilitating art and healing cancer support groups. And she is the coauthor of the book *Visual Journaling: Going Deeper than Words to Give Voice to Your Soul* (Quest Publishing, 1999). Barbara currently resides in North Kingstown, Rhode Island.

RD4GG